ROSE WINDOWS

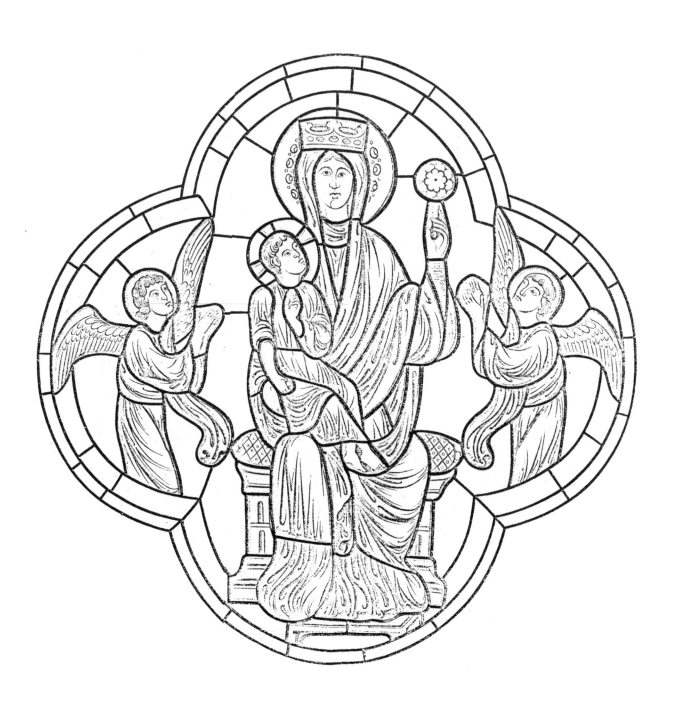

Painton Cowen

ROSE WINDOWS

With 141 illustrations, 59 in colour

Photography by the author

Thames and Hudson

On the title page:
Virgin and Child with rose, from
the Laon east rose window

to my parents

and all my friends who have made this book
possible, particularly Ted Matchett and Guy
and Piera de Vogüé. I would also like to
thank Anne and Alan Nero, Jean-Pierre and Dinx
Rosetti, Surgeon Captain E. C. (Buster) Glover,
RNVR, Roger Godfrey, Lavinia Merton, Peter Lund,
my sister Caroline, the directors of many of the
Departmental Archives in France, and many
others who have helped in differing ways. To Tad
Mann and Quentin Neill I would like to express my
special thanks for their magnificent art work.

For permission to quote, acknowledgment is due
to Faber and Faber and to Harcourt Brace
Jovanovich, for T. S. Eliot's *Four Quartets*; to
Elisabeth Chase Geissbuhler, for her translation of
Auguste Rodin's *The Cathedrals of France*; and to
the representatives of the late Dorothy L. Sayers,
for her translation of Dante's *Paradiso*, published
by Penguin Books.

The photographs in the plate sections are my own,
with the exception of 17 (Washington DC), which
is by Irwin Wensink.

ART AND IMAGINATION
General Editor: Jill Purce

Text © 1979 Thames and Hudson Ltd, London
Photographs © 1979 Painton Cowen

Filmset in Great Britain by Keyspools Ltd,
Golborne, Lancashire
Printed and bound in the Netherlands
by Smeets Offset, Weert

Contents

Let us make a thing of beauty
That long may live when we are gone;
Let us make a thing of beauty
That hungry souls may feast upon;

Whether it be wood or marble,
Music, art or poetry,
Let us make a thing of beauty
To help set man's bound spirit free.

Edward Matchett

The Glaziers' Dream, 1978. Ink drawing by Quentin Neill

Light into darkness

A present from the past

The ability to create beauty is God's greatest gift to man. And the appreciation of beauty – whether man-made or natural – is not only a joy but an active call to something much greater than oneself. At rare intervals in our lives we may experience moments of magic, when a person, a place, a view, an object or a situation seems to transfix us, and we suddenly see the world in a quite different light. Such moments are often accompanied by an equally sudden 'inner expansion' and the realization that there is much more of life to be experienced, much that is unfulfilled. However unexpected the moments may be, they have a feeling of the Absolute about them. They are rare and elusive but leave us with a sense of awe and wonder which we feel is our birthright.

The Gothic cathedrals have imparted something of this experience to many people. Their towering heights, accentuated by the slender ascending pillars interweaving in the vaults overhead, enclose a space that seems to be held under a spell by the tensions of its stone structure, and into this arena is poured light of almost infinite shades of colour, sparkling jewel-like in the sun or glowing quietly in the light of overcast skies.

A valuable piece of writing has come down to us which expresses how one individual, Abbot Suger, felt in 1144 on entering the first Gothic building, the abbey church of Saint-Denis, built to his own specifications. He saw the jewels and coloured glass in his new church as possessing the ability to transform 'that which is material to that which is immaterial. ... Then it seems to me that I see myself dwelling, as it were, in some strange region of the universe which neither exists entirely in the slime of the earth nor entirely in the purity of Heaven; and that, by the grace of God, I can be transported from this inferior to that higher world'.[1]

Suger's Gothic Saint-Denis was certainly an architectural innovation, even though it included a number of features which had already been in use in certain churches in England and France. At Cluny, for example, flying buttresses had been introduced to support the top sections of the walls and vaults of the choir, and at Durham the first rib vault had been achieved by 1104. Cluny had also already introduced pointed arches into its Romanesque structure. Stained glass had appeared in Europe at least a hundred years prior to Saint-Denis, in comparatively small windows in selected parts of certain churches. But when Suger combined all these developments into a single building the effect was magical. No longer did the building convey the massive weight and solidity characteristic of the Romanesque; a new lightness had been found, suggesting a new-found energy, a restless upward striving, as though towards the very vault of heaven.

This energy is symbolized in light. Flying buttresses enabled much of the weight of the vault to be transferred to the ground outside the building, and instead of the painted stone walls of the Romanesque there appeared at Saint-Denis huge areas of glowing coloured light. It was as if matter had been conquered; and light took full advantage of the victory by flooding in in every shape and colour that the architects and glaziers could devise. Nearly every Gothic church built after that date aspired to be the image of

the New Jerusalem of St John's Revelation, whose walls had foundations that were studded with precious stones; this finds its quintessence at Chartres and, in miniature form, at the Sainte-Chapelle in Paris.

Within these images of paradise, which sprang up during the thirteenth century all over France, we frequently find the ultimate jewels – rose windows. They are suspended between floor and vault, as if between heaven and earth, a single beautifully cut jewel containing countless others. They seem almost unearthly, dimensionless, aspiring to something even greater than the cathedral itself. The great rose windows of Paris and Chartres take the breath away with their spectacular webs of glass, lead and stone: a perfection brought about by geometry, which, as Rodin says, 'speaks to our hearts because it is the general principle of things'.[2]

The nineteenth-century French architect Eugène Viollet-le-Duc had such an experience while looking at the south rose window of Notre-Dame de Paris, and in that moment he knew that it was his destiny to help save France's unique and priceless medieval heritage. War, neglect and vandalism had taken their toll over the centuries, and rebuilding and restoring what was lost and damaged became to Viollet-le-Duc a vocation. His work – along with that of many other restorers – is often maligned, but it has to be recognized that without his researches and efforts there would not be much left of many of the great churches and cathedrals in France.

In spite of damage and restoration, the great rose windows can still impart something of the wonder that they must have generated at the time of their creation. This is primarily through the powerful and spectacular *form* which can be generated within a circle, and in which modern designers still find endless possibilities of expression.

The arrival of rose windows in the cathedrals is something of a mystery. They appeared quite suddenly around the year 1200 and within fifty years had diffused right across France. A few appeared in England, Italy, Spain and Germany; but they remain essentially a French phenomenon, and it is around Paris that we find the greatest gems. In all three early large cathedrals around Paris the largest possible rose windows were incorporated from the first on three sides, and in the case of Laon possibly on all four. The reasons for this insistence upon the rose window can be sought in the language of symbolism and in the background of the age.

A symbol of truth

One of Abbot Suger's most important contributions to Gothic architecture was the extensive application of typological iconography, the placing of a New Testament subject next to one from the Old which seems to prefigure it: for example, Jonah and the whale alongside the Resurrection. At Chartres, the north rose with kings, priests and prophets faces the south rose filled with the twenty-four elders of the Apocalypse. This is a typological transformation that takes place across the church: that is across the church as a building in *space*, but also through the Church in *time*.

The building itself is the best guide to this dual role by virtue of its layout, orientated around the end of the Incarnation by its division in *space* into two sides, north and south, which correspond to the division in *time* between Old and New Testaments. Between the two lies the nave forming the Latin cross, derived from the equal-armed Greek cross of many early

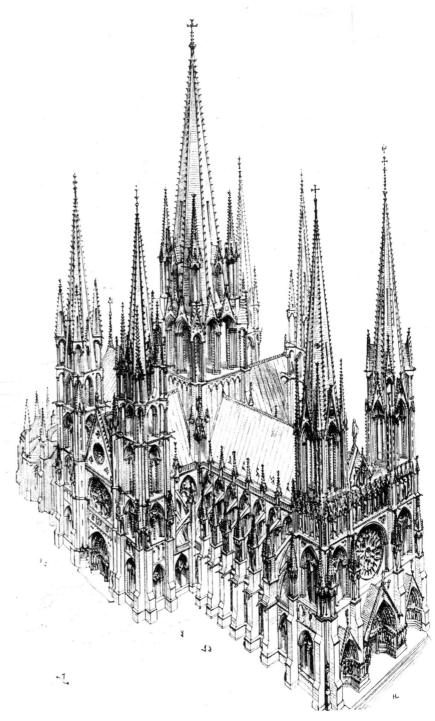

The idealized Gothic cathedral – as envisaged by Viollet-le-Duc – was never achieved. Six of the seven spires and the three rose windows are built on the three façades facing north, south and west. The north was generally associated with the Old Testament, the south with the New, and the west with the Last Judgment

Christian churches. The word 'nave' itself betrays a deeper meaning, as it is derived from the Latin *navis*, 'ship': the Ark of the Old Testament that formerly saved all life from the Flood and has become typologically transformed into the Church of the New. The Ark thus becomes a sort of metaphysical vessel that carries mankind through time, and the rose windows on either side to the north and south are the stars that guide its course.

But there is another Ark, the Ark of the Covenant, or the Law of God given to Moses in trust for mankind. These two Arks are essentially related; for the

Ark of the Covenant symbolizes Knowledge that has to be carried through history. When Christ underwent the trials of the Passion the veil of the Temple was rent in twain, indicating the turning-point in human history at which the Mysteries of the ancient world were no longer to be withheld. They had served their purpose: 'It is finished.'

The rose window as an eternal symbol transcends words. Inside the cathedral we are aware of stone, light, colour and shadow, all manifest in dimension and proportion within the measure of man; they emphasize man's presence on the earth, and the verticality of the nave, choir and transepts suggests an aspiration to something greater. The surrounding stained-glass windows relate stories and parables, the lives of saints and all history relevant to the spreading of the Word of God. But in the rose windows, dimension and measure seem to disappear; it is as though they could be infinitely large or infinitely small. They represent an eternal truth – that of the Logos, the Word itself. In Christianity, Christ is the Logos. He is at the centre of each of the three rose windows at Chartres, each one representing His threefold nature: as a child in the north, resurrected in the south, and in judgment in the west. Each of these directions inside the building symbolizes time, the north being *past* (the Old Testament) the south *present* (the New Testament) and the west *future* (Last Judgment and the creation of New Jerusalem).

Through the Logos all three become fused in an eternal present; and in the rose window, by virtue of its very form, this realization takes place on the deepest level of human consciousness. Rose windows are, to use the term popularized by C. G. Jung, mandalas. Their radial and predominantly fourfold form is that which spontaneously appears in dreams and in art as an expression of the human aspiration towards wholeness and coherence: 'a pattern of order which like a psychological viewfinder marked with a cross on a circle – or a circle divided into four – is imposed on the psychic chaos so that each content falls into place and the weltering confusion is held together by the protective circle'.[3]

Rose windows thus symbolize man's highest aspirations: to know God's order, to become at one with Him, and ultimately to become co-creators with the Creator. As mandalas they perform the first task imposed on those who set out on this quest; they enable them to obey the injunction of Psalm 46: 'Be still and know that I am God.'

The way of the Christian mystic involves study, thought, contemplation and action; it seeks ultimately to understand more fully the teachings of Christ, particularly the words 'I am come that they might have life and that they might have it more abundantly' (John 10:10), life finding its greatest expression in action. For this reason Christian mysticism is 'remarkably and refreshingly earthy, human, passionate and worldly', as William McNamara describes it: a way of discipline that seeks as its goal 'the perfection of charity and not, as in the case with other mystics, a mysterious means of acquiring transcendental knowledge'.[4]

The first requirement of mysticism is to seek the soul through purification, to become 'perfect as your Father in heaven is perfect' (Matthew 5:48). This is symbolized in the Virgin Mary, who is generally portrayed at the centre of north rose windows. She represents the sum of all the past, the culmination and quintessence of the Old Testament, of all that went before Christ. The

perfect geometric disposition of the panels in the window invites the beholder to reflect in the mind the order perceived by the eyes: to become still and at peace with oneself and with the world before acting. In this sense the rose window could be said to be the key to one's own soul, and the rest of the cathedral the key to perceiving a world transfigured by the Word.

But there are dangers here. The anonymous medieval writer of the *Cloud of Unknowing* forewarns his readers that a man ignorant of the soul's powers may easily be deceived in spiritual understanding: mysticism seeks Grace, not as the fruit of effort, but rather as a gift from God. The agent of Grace is the Holy Spirit, which descends to the Virgin Mary as a dove in the north rose window at Chartres, where she is holding the Christ child. As a mandala of exquisite beauty this rose teaches the first requirement of mysticism: an openness that is innocence, 'as little children'. But Grace is also the means of protection for the ignorant soul against evil, against 'the world, the flesh and the devil' as the liturgy and St Paul put it. The mandala form is relevant here also: it symbolizes what Jung called individuation, the process through which individuals and society might 'become whole', and the imbalance in Western culture be rectified: an imbalance brought about by an inability to acknowledge and cope with the unconscious, resulting in a heavily one-sided development of the personality, no knowledge or expression of one's real self, and a constant objectivization and projection of one's own imbalance on to objects and situations outside oneself or on to images that appear from the unconscious. But Jung also pointed to the dangers of misguided individuation, an ignorant release of the powers of the soul. Christianity's fight against the Devil and all his works can at this level be seen to be above superstition as a fight against the 'terrors' of the unconscious, a battle ultimately between sanity and insanity, between knowledge and ignorance.

Jung noted that mandalas tended to appear in situations of psychic confusion and perplexity. In medieval imagery this could be said to be illustrated in the 'psychic confusion' of the Last Judgment, portrayed in the west roses at Chartres [27, 29] and Mantes [65], with the polarization of good and evil above and below and Christ at the centre as mediator. And the twelfth and thirteenth centuries were certainly a time of psychic confusion: the fanaticism of the Crusades, the struggle between faith and reason in the Church and the universities, the growing heresies, the increasing conflicts between Church and State (exemplified by the murder of St Thomas of Canterbury): all contributed to this confused state of the soul of the age. These were events going on over most people's heads, yet all became familiar with the ruthless and dreaded Inquisition. And yet, before this tragic era of the Church's history reached its zenith in Spain and in the Albigensian crusades, cathedral building was well under way, with rose windows appearing all round Paris and then rapidly spreading elsewhere. In Jungian terms they would seem to be an expression of the group unconscious of the age, for Jung saw the spontaneous and even unconscious production of mandala form in art and architecture as the creation of 'vessels', into which each person (artist or beholder) projected his or her psyche, and which could in return initiate a healing or restorative process.

The radiating form and pattern of most rose windows indicate many paths to one centre; and this corresponds to the paths which lead to the

real self at the centre of the soul. It is this journey that is the aspiration of the mystic: to encounter the infinite, in a state of innocence, with the real self. Nor is it a passive process, since each step taken inwardly has to be compensated for in the outside world by some action, followed by another period of reflection and then by action again, and so on, like breathing out and in; a harmonization of opposites not unlike the acceptance of *yin* and *yang* in the Tao of Chinese philosophy. In Christianity the equivalent of the Tao is the Way, exemplified by Christ at the centre of the rose window, midway between heaven and hell.

Queen of cathedrals

Paris in the twelfth century was at the centre of a medieval renaissance, acting as a melting-pot for knowledge from all over Europe and much of the Middle East. This spirit was carried through most of the following century, until plague, war and exhaustion extinguished its flame. After the thirteenth century, in the words of the nineteenth-century architectural historian Henry Adams, 'nine churches out of ten were still-born … church architecture became a pure matter of mechanics and mathematics'.[5]

The church-building activity of this era was prodigious. Henry Adams and Abbé Bulteau estimate that some 80 cathedrals and 500 churches of near cathedral size were started in France alone in the period 1170–1270; and many of these were almost finished within that period. It was an activity that is estimated to have taken up at least one third of what would now be called the Gross Domestic Product. It is a phenomenon that has never really been explained and probably never will be. We can see only that something

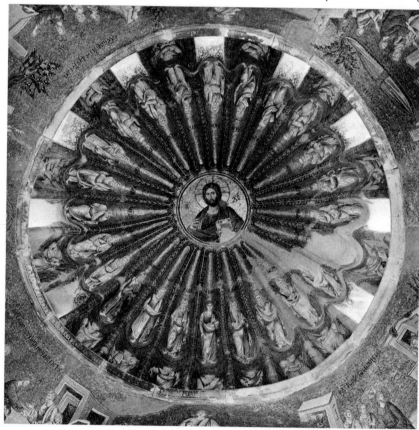

The domes of Early Christian and Byzantine churches, with their mosaic and fresco interiors, often choose a powerful radiating design around Christ Pantocrator or the Virgin and Child. They may well have influenced the concept of the giant rose windows that emerged around Paris following the first three crusades. Twenty-four prophets surround Christ in the Kariye Camii at Istanbul (Photograph courtesy of Dumbarton Oaks Center for Byzantine Studies, Washington, D.C.)

prompted people of all trades and classes to undertake a venture that resulted in workmanship and inspiration of a degree rarely equalled in the history of mankind and acted to weld together communities and to embrace generations. Kenneth Clark expresses the Chartres phenomenon in his *Civilisation*:

> ... the faithful harnessed themselves to the carts which were bringing the stone and dragged them from the quarry to the cathedral. The enthusiasm spread through France. Men and women came from far away carrying heavy burdens of provisions for the workmen – wine, oil and corn. Among them were the lords and ladies pulling the carts with the rest. There was perfect discipline and a most profound silence. All hearts were united and each man forgave his enemies.[6]

And when they had completed their cathedral – or the greater part of it, since few have really been completed – the people must have had a sense of achievement that was inexpressible in words. David Macaulay in his superb book *Cathedral* gives us a glimpse of this:

> Huge banners had been hung from the triforium, and all the candles on the piers were lit. As the choir began to sing, the building filled with beautiful sounds and the people, most of them grandchildren of the men who laid the foundation, were filled with tremendous awe and a great joy.
> For eighty-six years the townspeople had shared one goal, and it had at last been reached.[7]

The twelfth-century renaissance can be compared in originality and energy to that of Florence some 250 years later, for it has left an indelible mark upon Western culture. The early Crusades brought back from the Middle East much Greek and Arab knowledge and inspiration, particularly in the realms of mathematics, building, poetry and philosophy. Aristotle's works had been rediscovered and were integrated with a separate stream of Arab-modified Greek and Jewish thought which had developed in Spain; and some of the monasteries – notably Cluny – had even been studying the Koran. A common language – Latin – linked the entire scholastic community. Bishops, clergy and scholars from France, England, Italy, Germany and Spain often changed places for a time, bringing about a diffusion and modification of knowledge.

Of all the schools which studied and taught the knowledge of the age, one of the most original and influential was that which belonged to the cathedral at Chartres. Its work reflects the characteristic twelfth-century combination of innovatory excitement and respect for tradition:

> We are as dwarfs mounted on the shoulders of giants, so that we can see more and further than they; yet not by virtue of the keenness of our eyesight, nor through the tallness of our stature, but because we are raised and borne aloft upon that giant mass.[8]

These are the words of John of Salisbury quoting Bernard of Chartres, probably the greatest of the chancellors of the School. In the 1220s, a

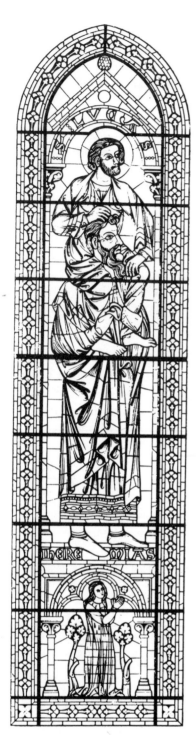

Two of the evangelists on the shoulders of the prophets at Chartres, in lancets beneath the south rose window: St Luke on Jeremiah and St Matthew on Isaiah (from Westlake)

century after Bernard's time, the huge south rose window was installed, above five lancet windows containing the Virgin Mary and the four Evangelists [36], the latter being portrayed as dwarfs – or young men – on the shoulders of giants. A coincidence – or a wish to acknowledge the influence of Bernard and the School? There is no doubt that its work and insights are crucial factors in understanding Chartres cathedral, and all the churches built when the Gothic spirit was active. For Chartres is unique, in that its iconographic programme in glass and stone was probably the most complete of its day, and is still more or less intact.

Friedrich Heer describes the School as 'perhaps the most luminous symbol of the intellectual movement of the twelfth century in all its pristine youthfulness and egregious audacity'.[9] The 'giants' they built on included Plato, Plotinus, Boethius, St Augustine and the Bible. Their free and unprejudiced attitude to the acquisition of knowledge enabled them to develop their Christianity in the light of classical purity, Islamic devotion and Arabian thinking. They followed precisely the advice of the early mystic Hugh of St Victor: to learn all that was possible. From Christian and pagan sources alike they studied the created in order to know the Creator.

Intellectibilitas, writes Heer, was a new word coined at Chartres and reveals its guiding principle: 'God, the cosmos, nature and mankind can be examined, reasoned about, comprehended and measured in their proportions, number, weight and harmony.'[10] One of the School's earliest milestones was Chancellor Thierry's *Hexameron*, or 'Six Days of Creation', built largely on Pythagoras' theories of the meaning of number. It led to an appreciation of God as the form of being in all things: 'All numbers derive from Unity: all things derive from God.'[11] As the twelfth century progressed, the School developed Thierry's concept of the Creation into an understanding of creation in every moment. The works of Plotinus and Boethius were particularly important here in building on the Bible and Plato's *Timaeus* to formulate a concept of nature and wisdom as the creative power of the cosmos; and in Bernard de Silvestris' *De mundi universitate* we meet the goddess Natura as the eternal, fruitful mother of all. As a creative power, Natura became identified (mainly by Alain de Lille, another Schoolman) with the Eros of classical antiquity, which in Christian terms becomes the Love of God. He also saw numbers as the binding power of the cosmos.

The School of Chartres seems to have elaborated a concept of evolution, drawn from all available knowledge, Christian and pagan alike, which embodied the Old Testament, number, geometry, nature, the cosmos, Divine Love and the New Testament. It is essentially the Logos, the Word, of St John's Gospel (John: 1:1) seen in the light of the latest knowledge of the age. St John saw Christ as the Word of God incarnate: or, putting it in another way, as the personification and manifestation of the philosophical concept of the Logos, which in the first century AD was seen by the scholars of Alexandria to be the Creative Principle of the Universe within Absolute Reason, active in all things from stars to snowflakes and ultimately in the affairs of men. This amalgamation of Greek, Jewish and Egyptian thought found its main synthesis and expression through Philo of Alexandria. It was St John who saw the importance of this philosophy, its coincidental timing with Christ's ministry, and the meaning of both for human destiny.

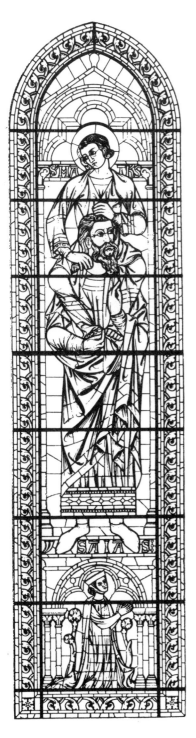

The study of the philosophy of the Logos seems (according to the medieval scholar J. van der Meulen) to have led the Chartres School to see its own work as a constituent of God's order in creation;[12] so that, in accordance with the unfolding plan of evolution, the world was ready to receive new knowledge through the School itself. In so doing the School would have been responding to the promptings of the Holy Spirit, for it saw these studies of the Logos as a basis for the doctrine of Divine Providence;[13] and the agent of Providence would have been the Holy Spirit, Who, as Chancellor Thierry saw, 'loves and governs created matter'.[14]

In the cathedral of Chartres there are two small rosettes high up above the clerestory windows, one in the north transept and the other in the choir [8]. Both portray Christ as the Creator enthroned above the primordial chaos. His left hand holds the globe of the cosmos divided into land, sea and heaven, with the castle of mankind at the centre; His right hand is held up in blessing. It is a direct portrayal of Christ as Logos, the mediator between heaven and earth. The much larger rose windows at Chartres can be seen to be themselves actual expressions of the Logos, one centred on Christ, as the Word made flesh, and the other on His Mother. Each rose window is a *symbol* of love, the universe and eternity, but it is also a *construction* that embodies geometry, number and light; and all these are components of the Logos.

Each of the Chartres rose windows has something special about it (for analysis see pp. 122–26). That of the north transept [6] is constructed according to three sets of superimposed geometry, one of which is based on the Fibonacci series – a mathematical and geometric phenomenon that governs, among other things, the growth and positioning of the leaves and flowers of certain plants. A second geometry incorporates all the major features of the window within a system of equilateral triangles, and a third lines up what is created by the other two. And there is more: for the number 12 that underlies the whole window is the product of 3 and 4, the former symbolizing *spirit* (the Trinity) and the latter *matter* (the Elements). The product, 12, is all the possible combinations of 4 and 3, symbolizing the total infusion of matter with spirit throughout the cosmos – of which the rose window is itself a model. So, too, the agency of the Spirit can be seen in the window as a fourfold or 'four-dimensional' dove, since the Spirit acts continuously through all time and space – it 'loves and guides all created matter', as Thierry put it. And as a symbol of this love the rose is the Eros or Divine Love of the creative power of the cosmos. It is a perfect fusion and manifestation of the philosophy of the School: a thing of great beauty created by man for God.

The Christian embodiment of the ideal of Divine Love is the Virgin Mary. As the mother of Jesus she becomes the Notre-Dame of Christ's Church, and it is to her that most of the great French cathedrals are dedicated. Just as the rose had been the flower of Aphrodite, so too it becomes the flower of Mary. The rose itself is the symbol of love and of union; transferred to the rose window it symbolizes the Love of the Creator. It is a view of the world and the cosmos both *as* and *through* the mandala-rose of wholeness superimposed on the world.

Where shall we begin?

There is no beginning. Start where you arrive. Stop before what entices you. And work! You will enter little by little into the entirety. Method will be born in proportion to your interest; elements which your attention at first separates in order to analyse them, will unite to compose the whole.

In the calm exile of work, we first learn patience, which in turn teaches energy, and energy gives us eternal youth made of self-collectedness and enthusiasm. From such vantage we can see and understand life, this delicious life that we denature by the artifices of our enclosed, unaired spirit, surrounded though we are by masterpieces of nature and of art. For we no longer understand them, idle despite our agitation, blind in the midst of splendours.

If we could but understand Gothic art, we should be irresistibly led back to truth.

Auguste Rodin, *The Cathedrals of France.*[15]

1 **The aspiration of the Gothic was** stretched to its limit at Beauvais, where the vaults reached a towering 66 metres (200 feet). In 1284 the choir collapsed and was rebuilt with modifications. Part of it collapsed again along with the spire in 1573. However, the transepts with their rose windows survive. (Beauvais north, 1537, modern glass by Max Ingrand)

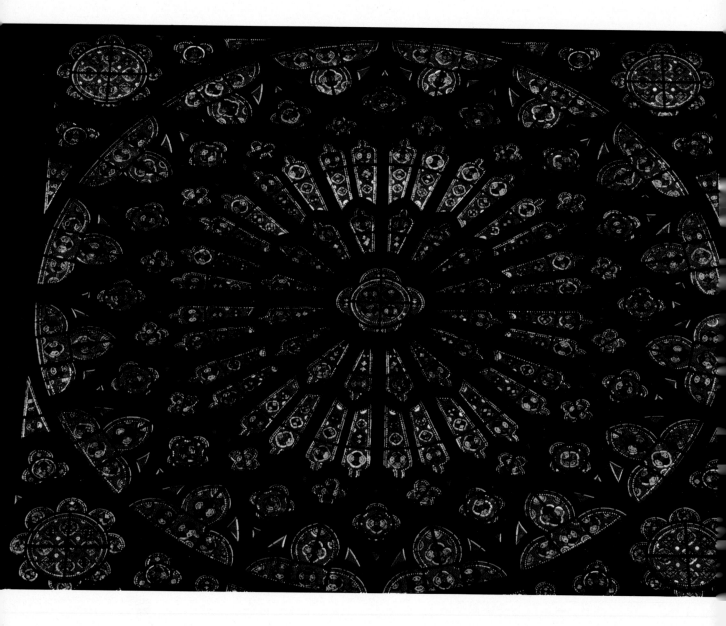

2 **To unite the finite with the infinite through** the square and the circle is an aspiration, common to Christian and Islamic symbolism, which is embodied in a number of rose windows. (Clermont-Ferrand south, 14th c., glass restored 1903)

3 **Light,** to the medieval mind, was a magical substance which contained the power to transform the soul. (Strasbourg west, c. 1318, glass much restored after storm in 1840; see also 79)

Overleaf:
4,5 **Colour,** light and the sun often play strange tricks on the eye: red, in the great west rose at Reims, strongly predominates when the sun is out. Thus, in the sunset, it becomes a consuming ball of fire evoking the End of Time. The subject is the Death of the Virgin, symbolizing the end of the Church as the End of Time, and here she is surrounded by the twelve Apostles and the heavenly choirs. In the outermost circles are the kings of her ancestry, while above the rose in the *tiers-point* Christ, placed between the sun and moon, receives the soul of His mother. (Reims west, c. 1270, much restored)

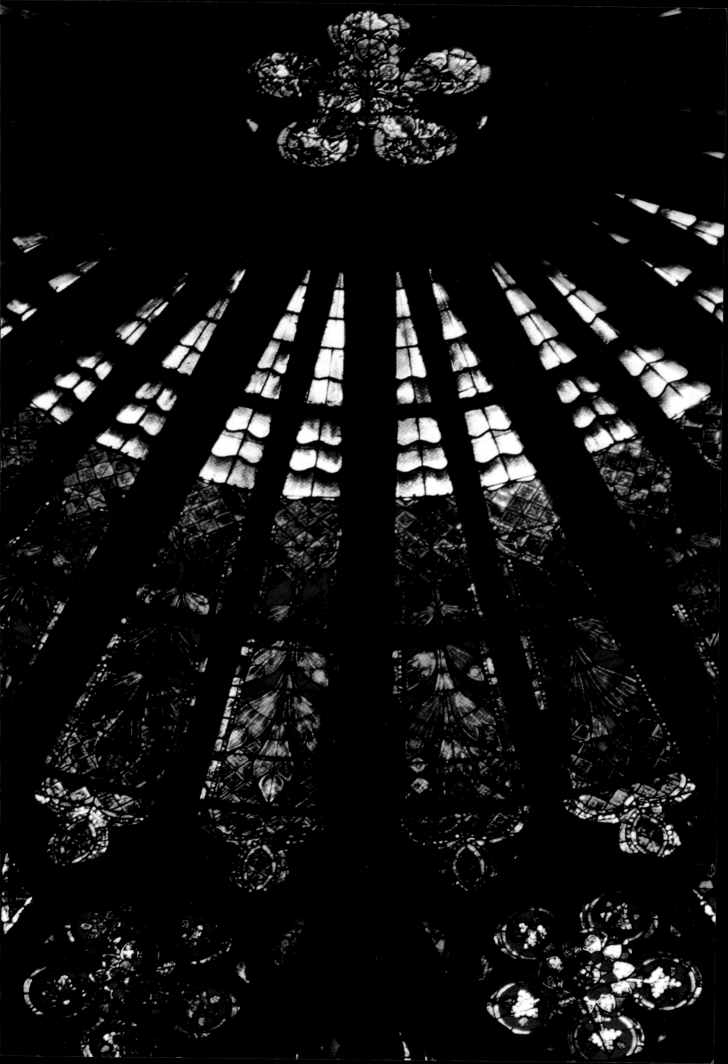

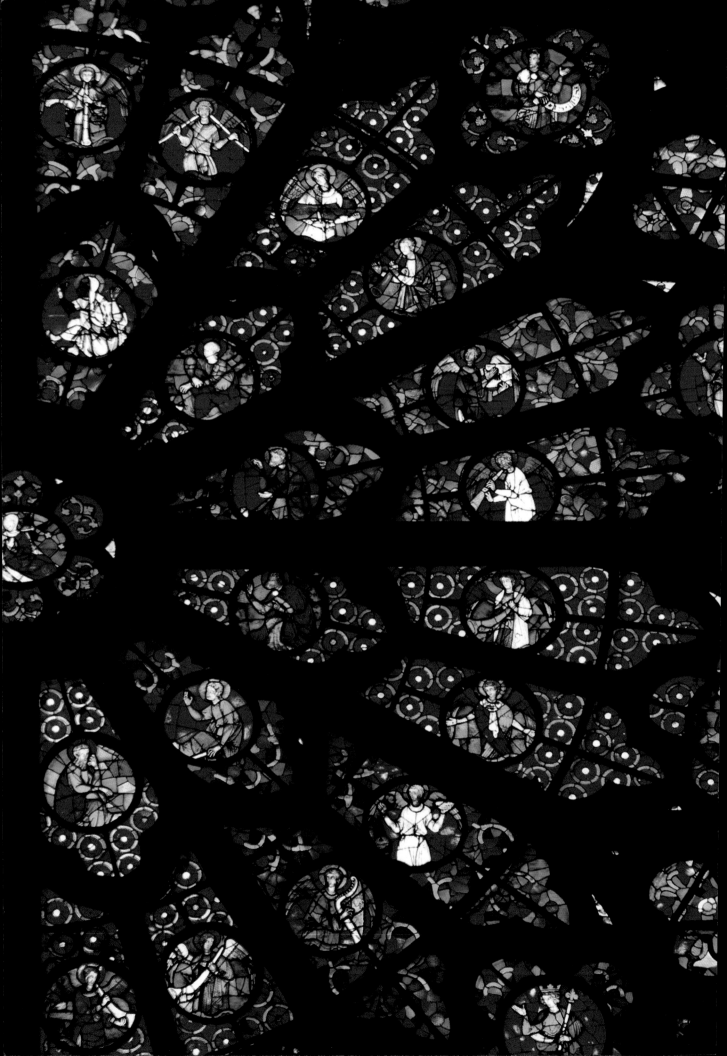

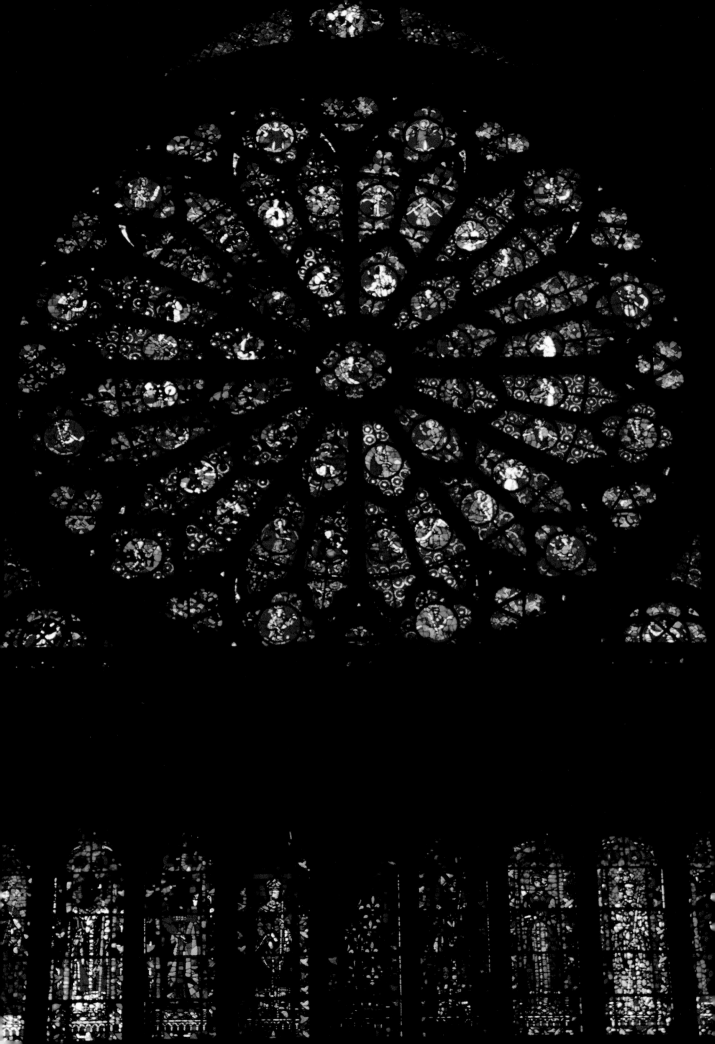

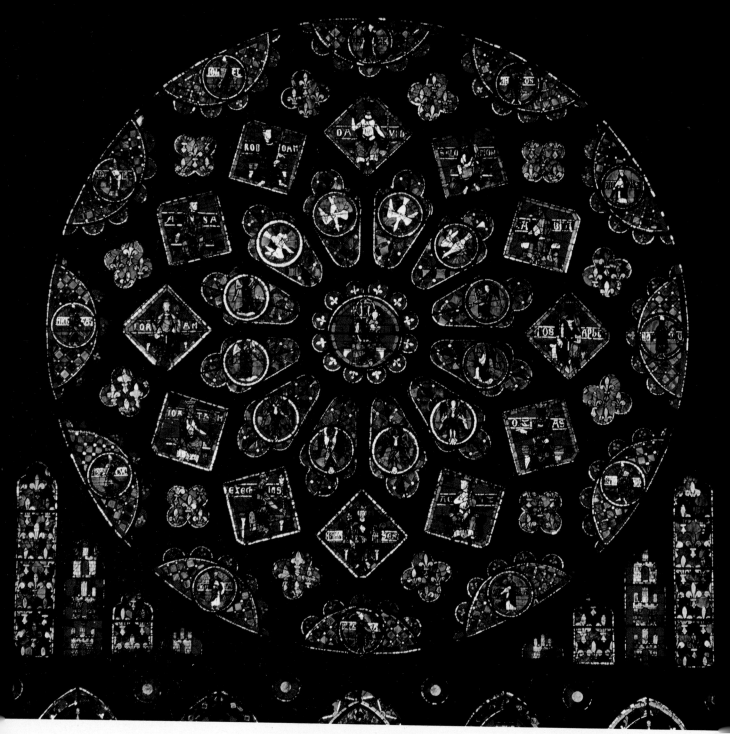

6 **Geometry and** number combine with light and colour in this classic north rose at Chartres – the 'Rose de France'. It is entirely dedicated to the Virgin Mary, who at the centre is surrounded by doves, angels and thrones from the celestial hierarchy. In the twelve squares are the kings of her ancestry – the line of David, as recorded by St Matthew. Beyond are the twelve last prophets of the Old Testament. The fleurs-de-lis are traditional emblems of the Annunciation and of royalty; the window was given by Blanche of Castille, Queen of France. But also we must 'consider the lilies of the field'; for this window is in fact constructed through the number and geometry of the Fibonacci series which underlies the growth of many flowers. (Chartres north, c. 1233; see p. 125)

7 **Perfection.** The doves descending to the Virgin are in fact only one dove, seen from four different directions – above, below and from each side; it symbolizes the omnipresence of the Spirit that 'loves and guides all created matter'. (Chartres north, c. 1233)

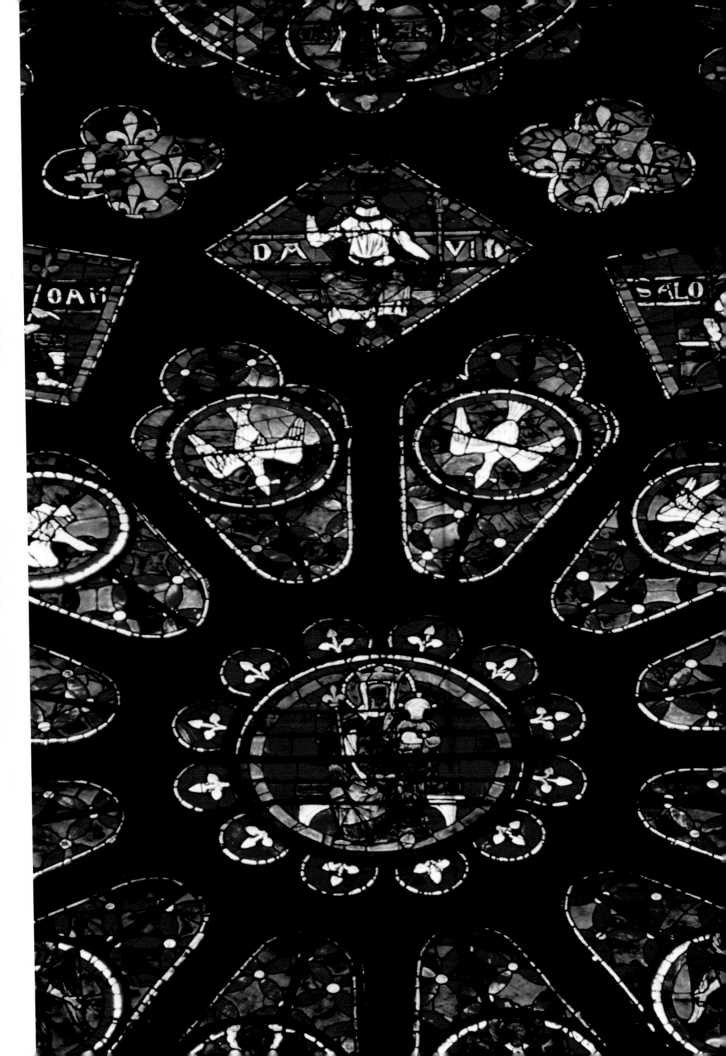

8 The 'order' behind creation in the Platonic teaching of the cathedral school of Chartres is symbolized in this portrayal of Christ as the Logos in a small rosette in the cathedral. Seated upon a throne, His feet on a rainbow, He raises one hand in blessing and with the other holds the earth divided into zones of land, sea and sky on top of which is the castle of Mankind. White and yellow stars surround the moon on the right and the sun on the left – six of which are red, suggesting the planets. On His knees is a half-open book – the Word of God, the Logos. (Chartres, mid 13th c.)

9 The universe is manifested in the form of every rose window, the concentric layers of which echo the spheres containing the sun, moon, planets and stars. Here in the west rose of Notre-Dame de Paris the 'spheres' contain the Zodiac, time (portrayed as the months of the year), the vices and virtues and the prophets; all surround the Virgin Mary. She is symbol and culmination of all time and space – or the history of the evolving universe, which becomes known in the present in perfected labour through the months. (Paris west, c.1220, much restored; see key on p.134)

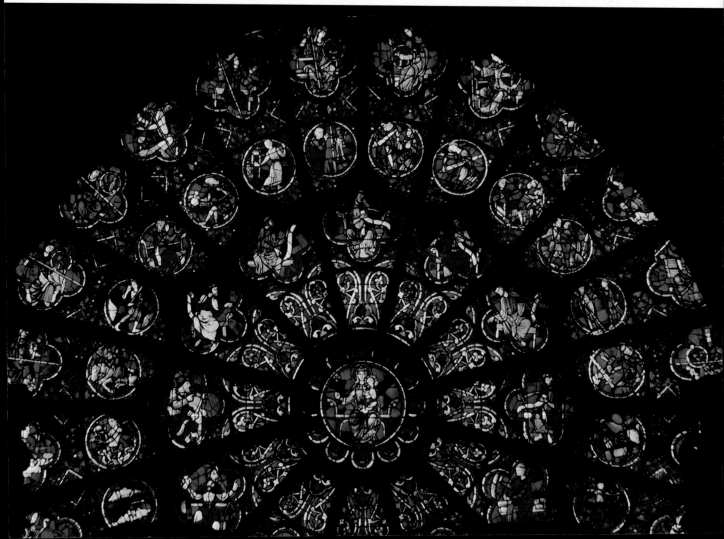

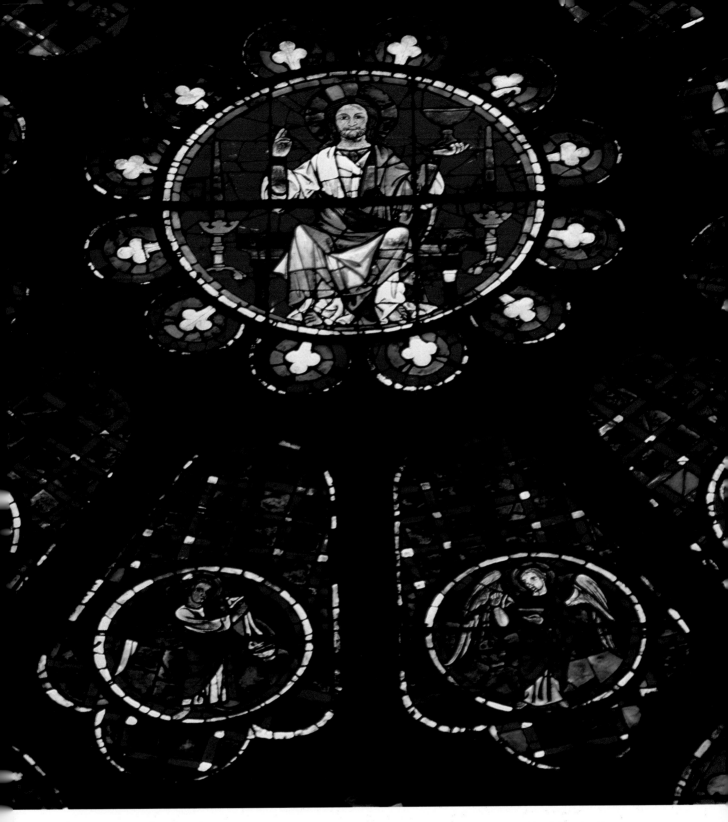

10 The Word, or the Logos: resurrected Christ at the centre of the south rose at Chartres, holding the chalice of the Last Supper. (Chartres south, c.1227; see also 36, 37)

Overleaf:

11 The subtle interweaving of an invisible geometry with the visible creates this magnificent 'Alchemists' Rose', with priests, prophets and kings surrounding the Virgin Mary. (Paris north, c.1268; see pp.127,135)

12 The creative 'order' is embodied in numbers, twelve being the number of perfection, of the cosmos and of Christ. In this south rose at Paris, God was originally portrayed 'in majesty' at the centre, surrounded by the four Evangelists, the twelve Apostles and twenty-four martyrs or confessors. However, the window has been entirely rebuilt twice, in 1726 and again in 1861, and now contains only a few of the (restored) original martyrs and angels. Eight twelfth-century medallions depicting the Legend of St Matthew have found their way into this rose; they are in the small double windows in the second outermost layer, from 2 o'clock to 9 o'clock. (Paris south, c.1260, much restored)

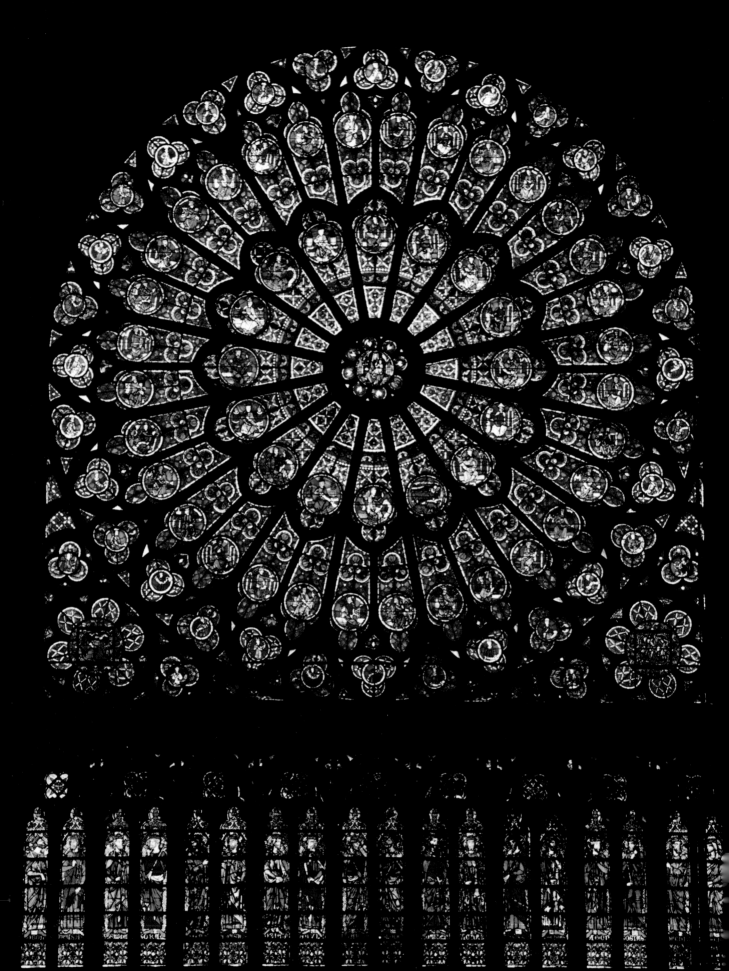

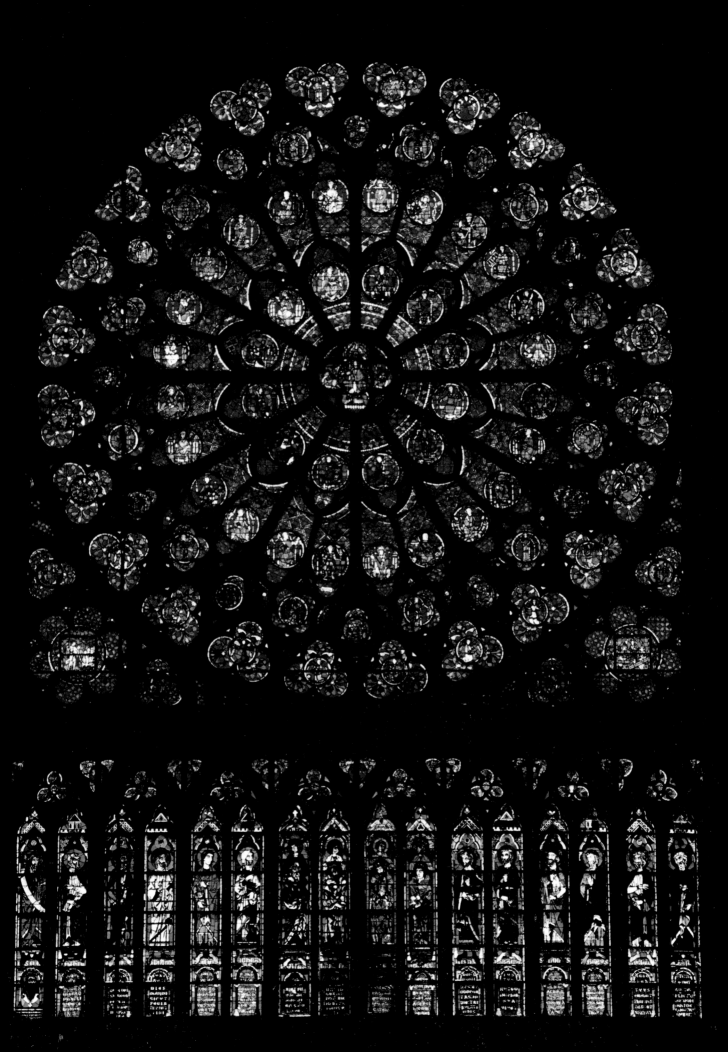

13 **Every rose window, from** the largest cathedral to the smallest chapel, is the symbol of love. Here at Notre-Dame-en-Vaux an early thirteenth-century window on the west façade is placed above three lancets, following the pattern of Chartres and Mantes. (Notre-Dame-en-Vaux west, Châlons, glass mainly 19th c. by Didron)

14 **The perfect snowflake of Sées to** many people is the ultimate in delicacy. It still contains some of the original glass. The subject is the Mystery of the Redemption, with six scenes following the Resurrection. The lancets below contain various saints. (Sées north, c.1270, rebuilt 1877)

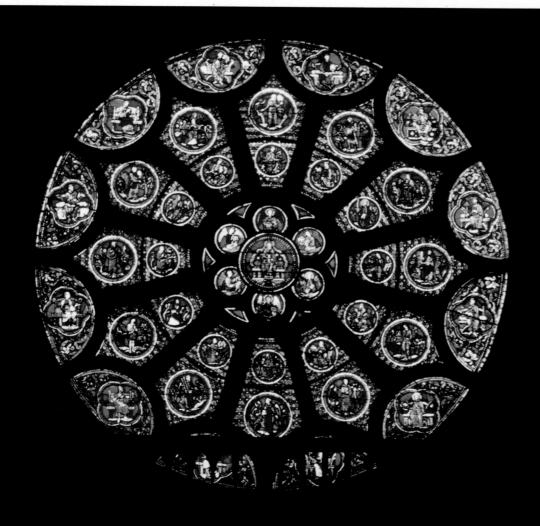

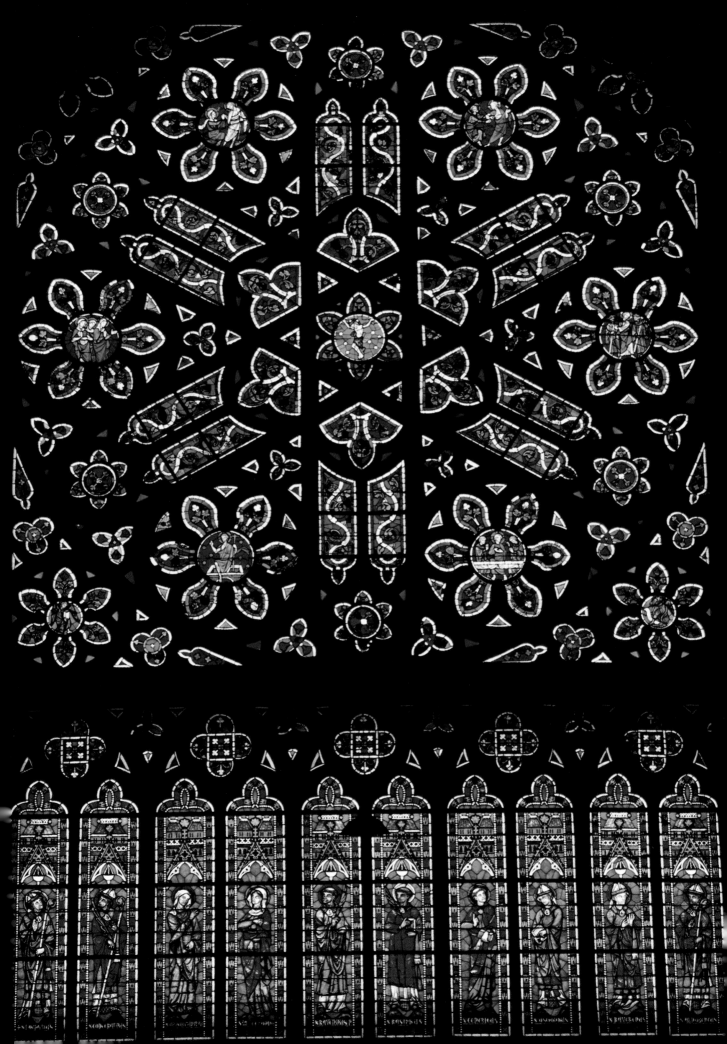

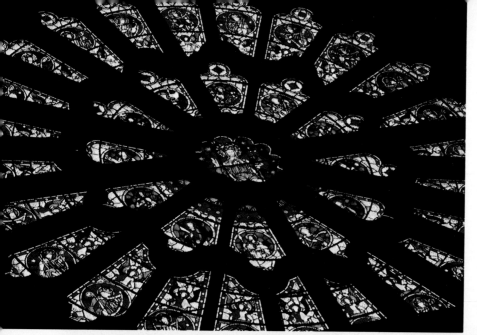

15 **The rose of Durham cathedral and** its tracery date from the sixteenth century, although it was remodelled in the eighteenth and nineteenth centuries. (Durham, 16th c.)

16 **The marigold of York Minster.** The red and white roses interwoven into the twelve petals commemorate the union of the Houses of York and Lancaster by Henry VII's marriage. (York, c. 1515)

17 **The creation is expressed in** the west rose window at Washington cathedral by Rowan LeCompte. (Washington DC, 1977)

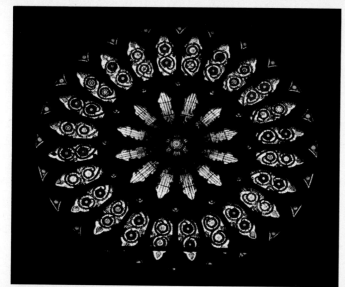

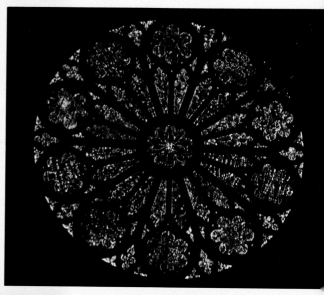

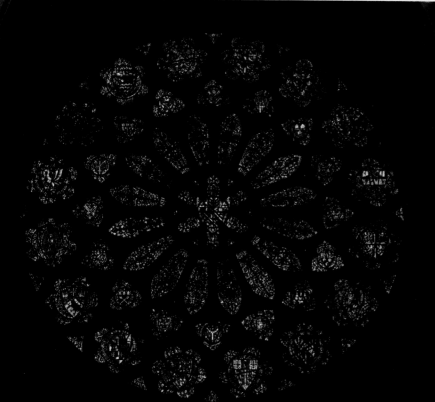

18 **Light and colour** fill the new rose window in Lancing College chapel. With a diameter of nearly 11 metres (33 feet), it is the largest rose window in England. (Lancing College, 1977)

19 **The leaves of the Tree** of Life are for the 'healing of the nations', and the 'Bishop's Eye' at Lincoln depicts two leaves within its circle, and is itself made up of thousands of leaf-like glass fragments. Within the window can also be traced the form of a man, a butterfly, or even two fishes. The leaves are in the *vesica piscis* form, created by equal circles which intersect the rose and touch at its centre. Robert Grosseteste, Bishop of Lincoln 1235–53, was the main exponent of the power of light in nature and the teacher of Roger Bacon. (Lincoln, 13th c.)

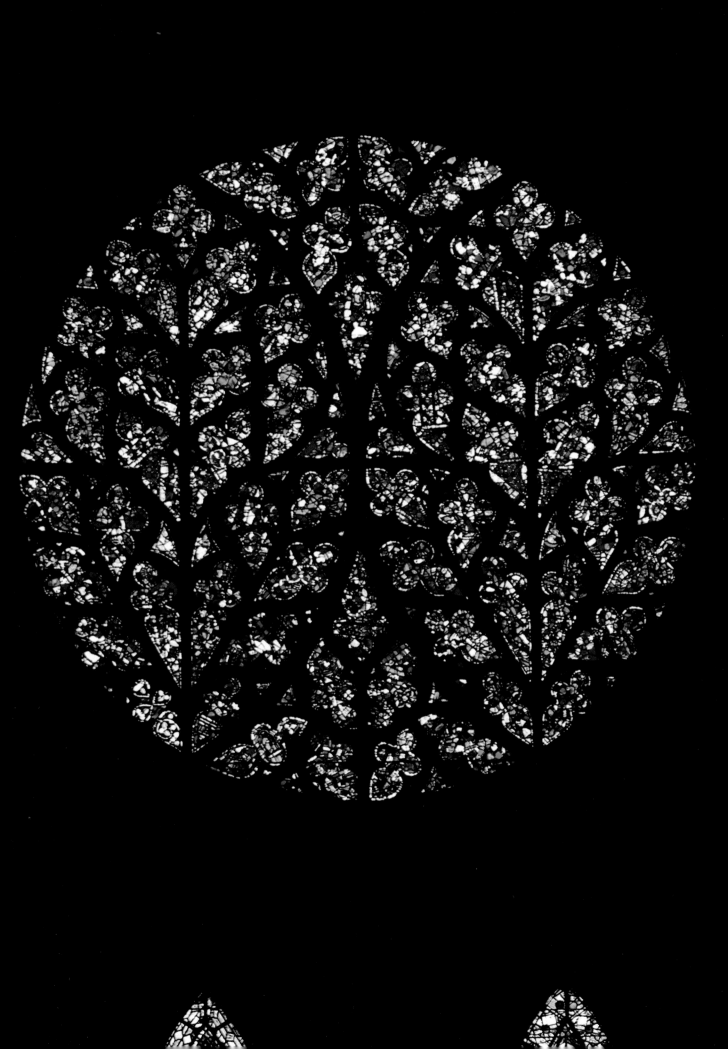

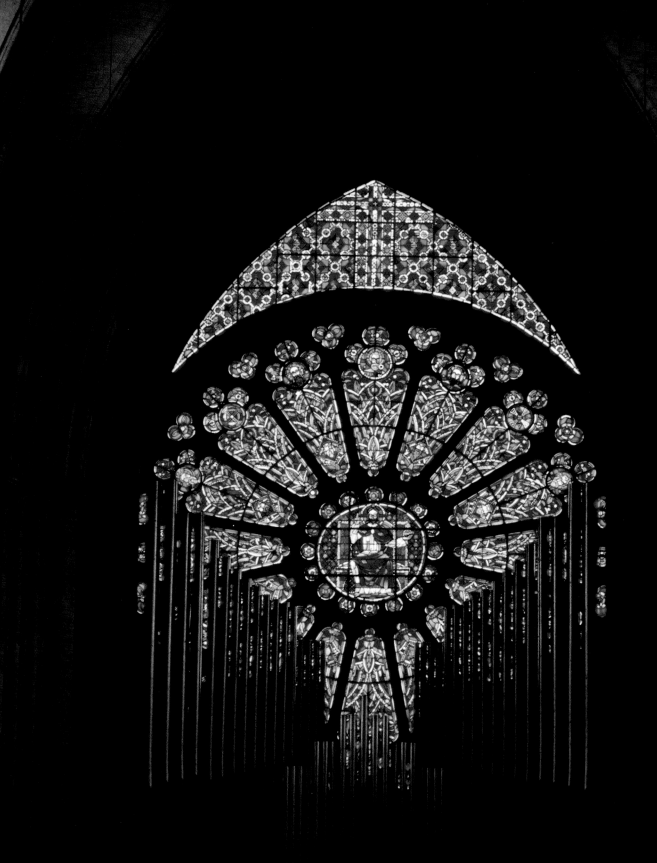

The making
From wheels to roses and to flames

Although they are contemporary with the birth of the Gothic, rose windows find their immediate predecessors in the wheel windows of the Romanesque; and these in turn evolved from the simple round holes – or oculi – that often furnish the west façades of even earlier churches. Many of these ancestors of the rose window can be seen in the villages of the French and Italian countryside, particularly in Provence and Tuscany. Some are decorated with an elaborate circumference of carved leaves with animals and faces interspersed, as at Tarascon where a splendid example is accompanied by the four symbols of the Evangelists. The lion, the bull, the eagle and the angel surround the oculus, set high in the gable of the façade, arranged in the favourite Romanesque disposition of a square around the circle [22].

The majority of these early oculi, however, have little or no decoration, and few of them exceed 1 or 2 metres (6 feet or so) in diameter; although during the second quarter of the twelfth century some larger windows began to appear, notably at Coucy-le-Château, Elincourt and Villars-Saint-Paul. This enlargement of the oculus, for aesthetic as well as practical reasons, led to the wheel window, for as the size increased, in came the extra light – but unfortunately so also did the wind and rain. The simplest solution was to add translucent alabastine or a primitive form of glass and to hold it in position within a frame. The most obvious pattern was the most elementary, that of a cross; there is an excellent example of such a window, from the comparatively late date of the mid twelfth century, at Aulnay [24]. Transition to the wheel was then simply brought about by the addition of a few more spokes.

Nothing in religious art is created for its own sake, and the architectural convenience of the wheel motif had to be confirmed by symbolic significance. The similarity of the cross within the circle to the Celtic cross, and even to the halo or nimbus that always surrounded painted figures of saints, was unmistakable. So, too, the Chi-Rho monogram of the early Christian church resembles a wheel – and is in fact often elaborated into one.

Before the wheel evolved into a full-blown rose it developed some marvellous variations and elaborations. The motif itself was firmly established, with hubs, spokes and bosses being carefully carved into the structure. At the height of the Romanesque the spokes were transformed into miniature pillars, complete with bases and capitals, forming a structure that supported the rim on a series of arches – an idea that carried on into the Gothic rose windows of the following century, notably those of Paris. In Italy the *rosoni* are nearly always wheels, and the finest of them are a paean to the concept of the wheel, with tier upon tier of spokes forming vast complex structures that look almost like circular viaducts. The superb specimens at Orvieto [47, 48], Assisi [46, 49–51] and Todi are probably the greatest of these, and evoke the vision of Ezekiel, where 'their work was, as it were, a wheel in the middle of a wheel' (Ezekiel 1:16), and where the four living creatures (which became the symbols of the Evangelists) came expressly to him, the priest.

Chi-Rho monogram mosaic from the baptistery of Albenga, Liguria

20 **The setting sun and the sounds of music: all are part of the dance of the cosmos and of the creative action of the Logos.** This rose at Soissons was originally built in the thirteenth century, but was entirely rebuilt after the First World War by Messrs Gaudin. It features Christ the King surrounded by prophets and Evangelists. (Soissons west, 13th c., rebuilt 1931)

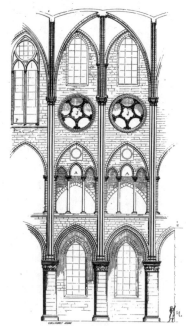

Elevation of the nave at Notre-Dame de Paris, c. 1180. The five-pointed rosettes acted as ventilators for the roof aisles (from Viollet-le-Duc)

With the advent of the Gothic style, around Paris, in the mid-twelfth century, the wheel window took on more elaborate geometrical intricacies to accommodate stained glass, and a metamorphosis occurred: the wheel became a flower. In fact the term 'wheel' continued to be applied long after the transition, probably because wheel elements persisted well into the Flamboyant era. The two forms often coexist in the same window, as at Chartres, where the west rose is externally a massive wheel, but internally has metamorphosed into a perfect flower. It cannot be stated with certainty when the term 'rose' was first used for a window, but it must have occurred fairly soon after the early thirteenth century, when the adoration of the Virgin Mary, whose symbol is the rose, had become well established throughout France.

The immediate predecessor of the first rose window is generally thought to be the wheel on the northern façade of Saint-Etienne, Beauvais [25]. It is in fact a Wheel of Fortune, with carved figures being dragged up one side to pass an ogre-like figure at the top (now, alas, headless) and fall ominously down the other side. The symbolic significance of these Wheels of Fortune is discussed on p. 87; they illustrate an aspect of the early medieval outlook, that life is an endless repetition of night and day, summer and winter, life and death, endless toil and suffering, where all success is transitory. Nevertheless, despite its rather depressing significance, this wheel was to inspire Suger – and the masons of the Ile-de-France – to great works of transformation: from Wheel of Death into Rose of Life.

At Saint-Denis, Suger created a wheel [26] of similar size to that of Beauvais. It is still there today, somewhat restored, placed between the four sacred living creatures that betray its Romanesque origins. The neighbouring cathedrals of Sens, Senlis and Noyon were started soon afterwards; but only the Senlis façade looks to Saint-Denis for its model. Nevertheless, this wheel seems to have set a precedent, for after a delay of about thirty years similar windows began to appear everywhere around Paris. The first really spectacular rose window was constructed in about 1180 at Mantes[65]. With a diameter of some 8 metres (over 24 feet), it is substantially larger than that of St Denis and must be regarded as the first real rose. It still retains many features of a wheel, particularly the enormous, hollow central boss and pillar-like spokes, but these have been reduced in length and the arches expanded to enclose huge panels of glass, each one of which is as large as a moderate-sized medallion itself. Here at Mantes the pillar and arch motif is arranged so that the bases are on the circumference and the arches converge around the centre; in the later roses of Paris they have become reversed, the whole system appearing to support the circumference.

By 1200 the great wave of cathedral and church building was well under way. It was around Paris, on the Ile-de-France, that most experimentation in design took place. At Chartres and Paris itself, the cathedrals were to have giant rose windows on three façades – and on the fourth at Laon. Smaller churches, such as Brie-Comte-Robert, Braisne, Bonneval and Montréal took the idea of the rose/wheel into many charming variations. At Laon the west rose is modelled upon that of Mantes, but its enormous size of some 14 metres (over 45 feet) necessitates a radically different structure [34]. So, too, at Chartres the north and south windows [6, 35–37] have picked up the

Mantes-style circle of semi-circles on the circumference. At Paris there is evidence that there may well have been two Mantes-sized rose windows in the transepts until about 1220; according to Viollet-le-Duc they were dismantled soon after completion. Substantial technical and aesthetic problems appear to have been encountered, both here and elsewhere: at Chartres the west rose is off-centre by about one foot, upsetting the symmetrical aspect of the façade; and at Laon considerable problems arose in the buttressing of the west rose, the solution being camouflaged behind the vast portal.

The next major phase of development in concept and design took place at Paris – again at Notre-Dame, at about the same time as the transept roses were being dismantled. The masterpiece on the west façade is as large a leap in dimensions from the Mantes rose as this was from its predecessors [9]. It dates from about 1220 and measures about 10 metres (nearly 33 feet); but in terms of area of glass it is twice as large as Mantes, since the volume of stone has been pared down to a minimum, leaving a spider's-web frame of great strength. An elaboration of this system was subsequently adopted for the north and south windows in the same cathedral, and it is these – each with twice the area of the west rose – that to many people represent the zenith of the art. The west rose, however, contains the highest ratio of glass to stone of any rose. Structurally it has certainly withstood the test of time: when restorations were carried out on the cathedral during the last century it was found that the only damage to the stonework of this rose had been caused by the installation of the organ a few years earlier. It is built up from two concentric arcades of pillars, which define 12 divisions in the inner layer and subdivide to 24 in the outer, and into which are fitted some 60 panels of stained glass set in iron and lead. It is a masterpiece of design and execution.

In 1216 the cathedral of Chartres, rapidly rebuilding after its destruction by fire in 1194, completed its first giant rose window, that on the west façade [27, 29]. This is the antithesis of the Paris roses, using massive quantities of stone; in fact the whole impression of this rose is that the twelve main openings have been punched through the wall rather than having been constructed within a circle. The 'plate tracery' had been popular in the late twelfth century and can be seen in the rose windows of Lincoln, Lausanne [38, 39] and Laon [28, 30]. The Chartres west rose window, over 14 metres (46 feet) in diameter, is still, to some people, the standard by which all others are judged. It is indeed a triumph in every sense, its carved Béchère limestone tracery creating a wheel that encloses twelve rosettes, while all the main items in the window are defined precisely by geometric considerations (see p. 123). Inside the cathedral, the predominantly red and blue glass colours the twelve suspended stars that surround Christ at the Last Judgment. Nowhere was anyone to attempt anything like this again, whereas the roses of Paris and Laon, and those of the north and south transepts at Chartres, were on occasion taken as models for other cathedrals. Its only close relative is the much smaller north rose at Laon, probably by the same master.

The north [6] and south [35] roses at Chartres, completed in 1226 and 1234, use a much higher proportion of glass to stone than the Chartres west window, but the tracery is still much heavier than the gossamer of the Paris west rose [9] and Reims [66]. At Chartres both north and south windows are

designed to take some of the weight of the vaults, and the internal structure is of sufficient thickness to accommodate this. In each window the intermediate layer containing the twelve major lights stabilizes the whole structure by providing it with off-radial members: squares in the north and circles in the south. (Radial windows have an inherent tendency to rotate at the slightest provocation, and this did in fact occur in the south rose at Paris, which was largely rebuilt by Viollet-le-Duc. At Trieste such a movement seems to have occurred during construction, and to have been compensated for in the rest of the structure.) In the massive west rose of Laon, internal stability is provided by enlarging the central eye considerably and constructing the intermediate layer of twelve windows as pentagons – the most stable shape of all.

The builders' change of mind in the 1220s concerning the Paris transept roses, already referred to, is something of a mystery. The present windows [11, 12] are dated at about 1260 and 1268 for the south and north respectively; the timing would seem to suggest that the Parisians were not to be outdone by their neighbours and set to work to design windows that would at least equal those of Chartres.

These two transept roses at Paris are the ultimate in sheer delicacy, and that on the north has remained almost intact since the thirteenth century. Along with the west rose at Reims, these roses have all but lost the characteristic of a wheel in favour of a network of pillars and arches which transmits all the forces and pressures that arise not only internally, from glass, lead and metal fittings, but also to a certain extent from outside the rose. The weakest areas in any rose window are the centre and the perimeter; a well designed system of trefoils and spherical triangles not only compensates for this but at the same time offers the architect plenty of scope for imaginative design. The rim of each rose is a masterpiece of design, as slender as it can possibly be without weakening the structure.

At the same time that the Chartres roses were being completed, new and smaller designs were making their appearance at Reims, Saint-Germain-en-Laye, Saint-Germer-le-Fly and Saint-Denis. Those of the transepts at Reims are built around an enlarged central boss, with fewer spokes more widely disposed and looking like a circle of shields. Each lobe then encloses a window, so that the rose as a whole becomes an aggregation of shields disposed around the centre. It is a development that is pursued even further in the later roses of Sées [14], Rouen, Saint-Quentin and Amiens, where it reaches its greatest expression at the end of the century. And at Reims there also appears for the first time the large *claire-voie* or clerestory window in the form of a spherical triangle, which resolves the space between the Gothic arch and the circle of the top of the rose [5].

At Saint-Germain-en-Laye the rose of about 1240 is mid-way in date and in form between the west rose of Paris and those of the transepts. It is built up of rectilinear tracery similar to the Paris roses, but in style is similar to the transept roses of Saint-Denis; in fact all these windows were probably designed by the same person, Pierre Montereau. Unfortunately the Saint-Germain rose was bricked up at the time of Louis XIV, but Viollet-le-Duc sees it as an important stage in the evolution of the species, which, by placing a circle half-way along each of the radials, substantially increases the stability of the structure.

Reims north

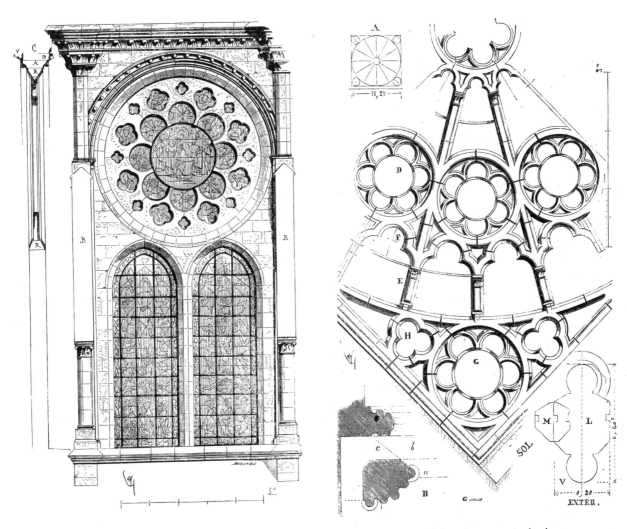

One of the high rosettes at Chartres, above the clerestory windows and just below the vault. Its plate tracery echos the great west rose. Thirty-four of these rosettes lead the eye along the nave to the transept roses and on into the choir, thus linking all the rose windows in the building (from Viollet-le-Duc)

Detail from the rose window in the chapel at Saint-Germain-en-Laye (from Viollet-le-Duc)

The last window in this important line of development is the huge rose on the west façade of Reims [5, 66], which in some ways resembles those of Paris. It is, however, much more robustly built, as indeed is the whole cathedral. Viollet-le-Duc describes it as *inébranlable* – unshakable – an almost clairvoyant insight on the builders' part, since Reims took an unparalleled bombardment during the First World War. The great rose, and much else in the cathedral, survived; this would not have been the case if Paris had been subjected to the same treatment.

The beautiful rose in the north transept of Sées – built about 1270 – is probably the finest representative of an interesting development in design [14]. Its delicate tracery, with hexagonal subdivisions, is reminiscent of a snow crystal. Similar windows can be found on the Calend Portal of Rouen cathedral and at Saint-Germain d'Auxerre. Pentagonal versions exist at Amiens and Saint-Quentin, and an eightfold variant at St Lorenz, Nuremberg. They all attempt to fuse inset medallion windows with the circular form of the rose, but this formula never found its fullest development because of the advent of the Flamboyant rose soon after 1300. At Amiens, for example, the five- and fifteenfold crystalline rose of the north transept has a southern counterpart which is probably the first of the Flamboyant roses [55].

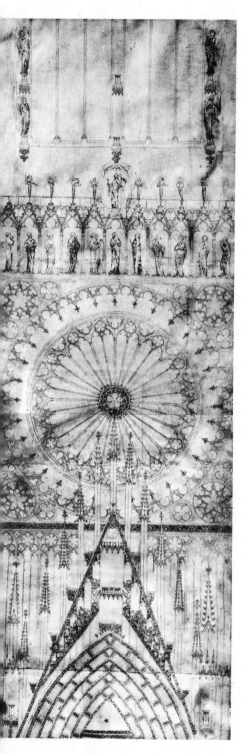

A rare contemporary architectural drawing shows the west façade of Strasbourg cathedral. It shows the linking of the rose window to the portal via the multiple-spired gable: Architect Erwin von Steinbach, 1276

It seems impossible to trace exactly where and when the Flamboyant style was born; but by the mid fourteenth century the style was well established, in rose windows as elsewhere. It is at its best at Amiens, Lieu-Restauré [60–63], Sens [82], Troyes, Auxerre, the Sainte-Chapelle [53, 54] and Beauvais [77]. In all these rose windows there is hardly a straight line to be seen, as the structures are engulfed with weaving and curving stone loops that almost entirely destroy the radial character. Gone is any likeness to either a wheel or a rose. Even the glasswork seems to give the impression of curling flames; the Sainte-Chapelle has a superb example, where fire seems to spread across the rose from the centre. As the fifteenth and sixteenth centuries progressed, many buildings that had been started hundreds of years before were completed with these fiery roses. The Gothic era and its spirit died in tongues of flame.

There are no Flamboyant roses comparable in size with the early roses of Paris and Chartres. On a large scale, curving tracery is successful only when the hardest and most consistent stone is available. Since this is rarely the case, windows after the mid-fifteenth century remain generally small, modelled on the Sainte-Chapelle or Amiens rose. Nevertheless, experimentation and originality are always to be found; and a number of fascinating variations emerged at this time, each a unique gem in itself – in terms of design, that is, the glass work being often somewhat inferior. Some of these – Saint-Bonaventure, Lyon [73], Notre-Dame de la Dalbade, Toulouse [74], Saint-Omer [76], La Rochefoucauld [80] and Saint-Maixent [81] – are illustrated in this book. Two of the most spectacular of these lesser roses are to be found in the transepts of Saint-Ouen, Rouen [57, 58]. Of the two the southern is the more successful, a truly beautiful flower-like construction with six pairs of petals spreading from the centre in jets of stone which endlessly interweave, totally in accordance with the window's subject – the Tree of Jesse.

The patterns of rose windows established on and around the Ile-de-France, in the three hundred years from the consecration of Saint-Denis in 1144, represent the medieval life-cycle of the species. By the sixteenth century that cycle was virtually over.

The Gothic revival of the nineteenth century saw a proliferation of rose windows, but not one that compares with the real thing. Nevertheless, the twentieth century seems to be witnessing another cycle of the rose after a winter of withdrawal, and a number that have appeared since the end of the Second World War have something remarkable about them. At Lancing College in England a rose window [18] has just been completed with a diameter of some 11 metres (36 feet); with over 25,000 pieces of glass, it is by far the largest in England (a position formerly held by Old St Paul's, burnt in 1666, with an east window equal in size to the transept roses of Chartres). In Auckland cathedral, New Zealand, a window has been built in conventional form but with a totally twentieth-century design of glasswork. Probably the finest of all modern rose windows is that of Washington cathedral in the USA [17]. The cathedral was built entirely in Gothic style, using the original building methods, and contains three rose windows, built in traditional form, which exploit to the full the possibilities afforded by modern glass techniques. The west window is an abstract design evoking the Creation

and utilizes chipped nuggets of glass to pick up all the available light on winter days as well as to gleam in the midsummer sun. The result is a Creation very much within the words 'Let there be light.'

The rose in the cathedral

From the very beginning rose windows were to cause problems. The troubles and second thoughts encountered at Chartres, Laon and Paris have been mentioned, but the basic difficulty underlying all Gothic roses was the same: how to incorporate a huge circle, a static form, into a design that is fundamentally vertical in its aspiration. Wheel windows fit happily enough into Romanesque buildings, where they harmonize with the underlying tranquillity of the style. On Gothic façades, however, a circle half-way up tends to halt the progress of the eye which the whole of the rest of the building is trying to emphasize.

Perhaps, however, this was what was intended: a moment's pause, suggesting the need for reflection amid all the vertiginous energy unleashed in architecture by the spirit of the age. Certainly, rose windows presented no aesthetic problem to Henry Adams; nor did he see any difficulty over the inevitable conflict of styles:

> The quiet, restrained strength of the Romanesque, married to the graceful curves and vaulting imagination of the Gothic, makes a union nearer to the ideal than is often allowed in marriage. The French, in their best days, loved it with a constancy that has thrown a sort of aureole over their fickleness since. They never tired of its possibilities. Sometimes they put the pointed arch with the round, or above it; sometimes they put the round within the pointed. Sometimes a Roman arch covered a cluster of pointed windows, as though protecting and caressing its children; sometimes a huge pointed arch covered a great rose window spreading across the whole front of an enormous cathedral with an arcade of Romanesque windows beneath. The French architects felt no discord, and there was none. Even the pure Gothic was put side by side with the pure Roman. ... For those who feel the art, there is no discord; the strength and the grace join hands; the man and woman love each other still.[16]

Nevertheless, some architects clearly felt the discord and did their best to do away with it. In the early Gothic we see a tendency for rose windows to be placed in squares, or built into the façades with no attempt at integration. At Amiens, in the south transept, a pointed Gothic vault is terminated by a pure semi-circular arch on the end wall, so that the rose fits neatly into it [55]. The rose window is most at home on Flamboyant façades, where the restless intermeshing curves of the whole edifice are carried up through the rose; the work of Martin Chambiges at Sens, Beauvais, Troyes and Rouen provides perfect examples.

The rose window was by no means universally accepted in the early days. Following the consecration of Saint-Denis in 1144, six main schools of Gothic architecture emerged, those of the Ile-de-France, Champagne, Picardy, Burgundy, Anjou and Normandy, to which can be added the builder monks of the Cistercian Order. Rose windows were popular with the first two

schools, and to a more limited extent in Normandy, but elsewhere they seem to have been admitted only reluctantly. In England, close to the Norman school, there was plenty of interchange of ideas and styles, but rose windows never really established themselves. The original glasswork of Westminster Abbey and of Old St Paul's may well have included roses that could stand alongside their counterparts in France; but English architects generally preferred the long slender lancets and huge walls of glass that are to be found at York, Bath, Gloucester, Salisbury, Wells and Lincoln. The reasons for this are obscure but may consist – apart from taste – in the different quality of light in England, with its longer twilight and weaker full brightness even in midsummer.

As the thirteenth century progressed, and the Gothic architects pushed the vaults to new soaring heights, problems arose concerning the gap created *beneath* the rose. Above the west porch at Notre-Dame de Paris, the problem was solved externally by including a line of huge statues of the Kings of Judah in place of lancets; internally this created a vast expanse of empty wall which is now very largely concealed by the fig-leaf of the organ. The north and south roses in the same cathedral are placed on top of a whole line of lancets which form a wall of glass over 17 metres (nearly 60 feet) high and serves to fill the major part of the difficult rectangle. At Amiens, where the vaults are a staggering 43 metres (140 feet, compared to Paris's 115) the rose windows take up only 10.7 metres (35 feet). On the west façade a line of statues is inadequate, so a sort of external triforium has been added below, while the porch is extended upwards as high as decency will allow. The result is magnificent, even if somewhat contrived and out of balance.

The *pignon* or gable above the door begins to grow at Paris (on the south façade), and by the time the Flamboyant era arrives it has overlapped the lancets; it reaches the rose at Sens, Limoges and Tours, and at Rouen, Troyes and Auxerre it goes even further, right to the top of the rose. These gables are generally beautifully executed and often contain their own little wheels – as at Sées, Bourges and Tours. They represent a further attempt to bring harmony to the whole façade and to integrate the rose window into the sweeping vertical lines of the Gothic. At Paris the rose motif is carried even further, right up into the roof gable, and at Beauvais for three brief years there was a stone rosette in the spire that soared to over 160 metres (nearly 500 feet) before it crashed down in 1573.

In the final count a successful integration is one in which there is total harmony in the exterior *and* the interior. Whether the rose window inside is a spectacular explosion of light and colour or a tranquil, glowing circle of reconciliation, the effect is to a certain extent governed by the quality and positioning of the rest of the glass in the building. At Chartres, for example, the twelve major lights of the west window seem to be suspended like twelve stars in the heavens, and these harmonize perfectly with the three lancets below (or at least they did until the three windows were cleaned during the period 1975–77, and the subtle irregularities in the glass were largely ironed out). The roses of the north and south transepts are perfectly integrated to the lancets of prophets, priests and evangelists below them: in fact they are haloes of light above these carriers of the Word – their source of inspiration and aspiration. At Paris the two webs of roses and lancets in

The spire that stood over the crossing of the cathedral of Saint-Pierre, Beauvais, from 1570 to 1573

the transepts contain about twice as much glass as those of Chartres but are equally well integrated. These classic windows shine out of the darkness.

Alas, this is no longer the case at most other cathedrals. The ravages of time and man have resulted in the loss of so much glass that the correct conditions no longer exist for viewing those that remain. Lost panels are often replaced with grisaille or even bright glass that creates too much glare for the subtleties of any remaining medieval glass to be fully appreciated. But at certain rare moments the sun still plays patterns on to the stonework in and around the rose, and beautiful effects catch the eye.

At Reims, where much has been lost through war, there is also some of the finest restoration. The west end supports two rose windows, one neatly fitted into the tympanum below the other, and the light from the huge thirteenth-century window above and the modern window by Jacques Simon below blends perfectly with the statues that line the inside face of the wall on either side of the smaller rose [67].

The glass in the rose

Throughout the day, summer or winter, the light is constantly changing, both in intensity and colour, and different windows in the cathedral catch the attention at different times. In fact some windows seem only to come alive at certain moments, often when one is hardly looking. The magic that these windows impart makes every visit to the cathedral a joy, especially when a familiar window surprises us with a new facet.

In the changing light of the day and time of year, the glasswork of the great rose windows is as subtle as elsewhere in the cathedral. Unfortunately it is not easy to see much detail in them, since few are less than thirty feet from the ground. But a good pair of binoculars can be very helpful, and so can a view from the triforium or tribune. Either will reveal that as much care has been taken with these windows as with those nearer to eye-level; even the angels have eyelashes in some, although few people are likely to spot them from the ground!

The art of staining and painting glass expanded considerably in the twelfth century. Large quantities of glass were needed for the new church at Saint-Denis, but previously there had existed in France only a rudimentary craft. Within a few years, however, a number of workshops sprang up around Paris, and Chartres in particular was to become a centre where glass was made for buildings not only in France but in England as well.

Much of the inspiration for this new art came from crusaders and pilgrims returning from the Holy Land. One of the routes passed through Venice and Bohemia, whence came new techniques and materials, and these blended perfectly with the art as it had evolved in France. It was at Chartres, where the river sand was particularly pure, that the finest examples of the art emerged. This glass was to become a legend, surrounded as it was by the 'mystery' of its manufacture. This soon led to the belief that the glass was an invention of the alchemists, which may or may not be true: gold was certainly used in the production of certain shades of red – or ruby – glass. According to the medieval monk Theophilus, glass-making was a rarefied art with closely guarded secrets even in his time (c.1100–55). Details of the methods used in the medieval craft are still very largely unknown – certainly no one has managed to produce anything like it since. There are some

contemporary pictures of work in progress but very little indication of what
is actually going on. Similarly, information on the division of responsibility
between designer and executant is equally sparse; in the case of rose
windows one does not know whether the conception stemmed from the
master mason or from the glazier, or whether each inspired the other.

The stained-glass artist's work could always be superficially imitated and
debased by half-knowledge – as any true craftsman knows – and this is what
did subsequently happen to much of the work after the thirteenth century,
when the 'secret' was lost. If there is any mystery attached to stained-glass
work it probably lies in the knowledge of how to work consistently in a
highly creative state of mind and with infinite care and love. There is
certainly much evidence for the pains to which these craftsmen went in
order to attain consistent beauty and perfection.

Theophilus' account is extremely useful, even though it describes glass-
making some years before the advent of the Gothic and before the

workshops of Chartres were well under way. He describes how glass was cast and the ingredients added at crucial moments during the melt, and how, as the twelfth century progressed, the glass was blown to give a much thinner and more easily handled product. The general formula was to combine two parts of beechwood (or fern) ash with one part of river sand, fusing the mixture into a slightly purple-coloured mass (the colour being due to manganese impurities). Metallic compounds were added during fusion to give the required colour: cobalt oxide (from Bohemia) for blue, copper oxide for red, and silver chloride for yellow. In Theophilus' time this was cast flat to give 'pot-metal', but later it was blown into 'muff' glass in a long cylinder which was then cut open and flattened into a sheet. With a red-hot crozing-iron the sheet was cut up and the pieces of glass chosen for their position in the final composition. The design was drawn out on a whitewashed table and the pieces cut and selected so that the flaws in the glass could be exploited to the greatest artistic effect. In fact it is these very flaws, bubbles, grits of sand, streaks and variations in thickness that give the glass its unique light-catching magic.

Some of this glass was shaped and fitted straight into the window, but much of it underwent further treatment with pigment to bring out the highlights, shadows, lines and other details. The pigment was made up of a mixture of iron filings and resin and was painted on to the glass to create the details before being finally fired.

To obtain certain colours and effects the process of flashing was adopted; this consisted of pasting on to the surface of one piece of glass a thin layer of another, often differently coloured, and refiring. It was done particularly with ruby glass, which tended to be too dark when made to a normal thickness. Ruby was therefore often obtained by building up layers of thin red glass on a clear base, sometimes as many as twenty or thirty, with a firing after every application. (One sample of Chartres ruby was observed to have over forty layers of flashing.) An advantage of this method was that the layers could be ground off to the required depth to give a varying tone within the same piece of glass, and even different colours obtained by subsequent staining, although this is rare in medieval work.

Probably the most remarkable form of coloured glass – if indeed it ever existed – was what Theophilus called his 'most precious variety', obtained by 'placing gems on painted glass'. Suger always boasted that real sapphires went into the melt to colour some of the glass for Saint-Denis, but no one has taken this seriously; perhaps in the light of Theophilus' account we should reserve judgment.

After the thirteenth century, stained glass production acquired different and generally easier techniques; the results become less impressive as the centuries pass by. English glasswork of the fourteenth and fifteenth centuries is occasionally superb, as at Fairford or York, although little of it exists in rose windows. The same is true of Flemish glass of the fifteenth and sixteenth centuries, as used at Toledo cathedral in Spain, where there is a very fine fifteenth-century rose at the west end. French stained glass of the fifteenth and sixteenth centuries displays the much cruder colours of bright enamels painted on to the glass; this achieves a high point of its own in the rose windows of Beauvais [77], Sens [71, 72] and the Sainte-Chapelle [53, 54]. In terms of subtlety and light-play, however, these later windows in no way

Head of an angel in the north rose at Lincoln (from Westlake)

approach those of earlier years. In some of the panels of the Sainte-Chapelle an interesting technique is displayed, that of 'Venetian glass', where two colours are mixed into the same piece of glass so that they metamorphose into one another.

Colour. The thirteenth-century Chartres blue glass is legendary. It pervades the whole cathedral as gold pervades Christian mosaic and icons; both seem to symbolize the Divine Light that streams through the whole universe. Other colours become subordinated to it in practically every window, and even when another colour is predominant, blue is nearly always the background. In the thirteenth century red, blue, yellow/gold and white are the most consistently used colours. Green is common although used sparingly; purple is used even more sparingly, although certain windows seem to make a display of it – as in the north rose at Canterbury. Flesh tones are imparted through a type of smoky purple that has frequently darkened to brown. Viollet-le-Duc classifies thirteenth-century colours in stained glass as follows: 4 types of blue, 3 of red, 4 of purple, 2 yellows and gold, 3 greens and 3 shades of white.[17] It would require a sharp eye to detect most of these subtle variations today.

At the height of medieval glass-making, French glass is particularly characteristic, with red and blue being persistently juxtaposed, the blues being tinted slightly green to reduce the heavy purple that this combination can easily bring. White, often carefully placed in thin bands between red and blue, not only outlines the medallions but to a certain extent prevents halation (the mixing of colours in the space between the window and the observer). The subtle use of white can sometimes produce a most dramatic effect; at Tours, for example, it outlines all the other colours in each compartment of the rose, giving an almost explosive quality to the whole window [85].

Generally speaking, in north light a gentler colouring is used than in south light: at Chartres, for example, in the north rose [7] red and blue predominate, with occasional gold, white and other colours, whereas in the south rose [37] white and gold are used slightly more to impart a quite different effect. This is as much due to distribution as to choice of colour, and even on dull days the impression of the south window is much more dramatic than that of the north. This of course is precisely the desired effect: the north side symbolizes preparation and purification, and the south illumination through the joy of the Resurrection.

Because original glass has disappeared from so many medieval churches, it is not easy to analyse this contrast between north and south more thoroughly. Restoration through the centuries has rarely been sympathetic, and little of the tradition has been passed down. Nevertheless, at Paris, despite numerous restorations, the south window displays something of the same contrast, using more red than that of the north; in fact it is a measure of how well the north window was designed that it maintains its tranquillity in spite of all that the restorers have done to its counterpart. In the rare and superb examples of late medieval rose windows at Tours, the contrast between the windows is very largely lost through the amount of daylight that finds its way into the cathedral [64]. Here the more explosive quality of the south rose is achieved by structure rather than colour: it seems to blow

itself apart over the head of the man on top of the organ, with trefoils and quatrefoils scattering themselves towards the circumference.

Design. The style and design of the glasswork of the thirteenth-century rose windows naturally has much in common with that of lancet windows elsewhere in the cathedral. Each saint, angel, prophet, king, vice or virtue has very little area in which to express himself, and backgrounds are cut to an absolute minimum. The individual subject is nearly always enclosed within a circle which is itself set into the opening of one petal of the rose, the remaining space then being made up of decorative mosaic or leaf-like ornamentation.

The geometric layout of the greatest rose windows is a triumph of design. In the last part of this book (pp. 122–27) the details of some of the more fascinating and subtle constructional relationships are examined. Most windows rely geometrically upon the cross and circle or radiating pattern, with the rose's predecessor the wheel often making itself felt, even in later windows. Rosettes, and the circle-and-square combinations that are so often found in all medieval illustration and decoration, are natural favourites in rose windows, the windows of Lausanne [68, 69] Clermont-Ferrand [2], Paris and Sées [42] being a few of the many examples. And at Canterbury the design of the rose is almost identical to that of the huge Islamic-inspired system of squares and circles in the mosaic behind the altar. (The inspiration is not only Islamic, for this kind of geometric design harks back also to Celtic patterns and even Roman floor tiles.)

The actual design of the window involved a fourfold cooperation between clergy, master mason, blacksmith and glazier to determine the choice and disposition of the iconographic programme. Then the glazier would proceed according to a fairly well-established tradition concerning the details – such as St Peter always with a large beard, St Paul bald or Melchizedek with the chalice of a priest. Sometimes the characters carry scrolls bearing their names, as in the north rose at Chartres. Choice of colour also followed a traditional pattern, with blue generally as the background against which red, green, brown and purple are set with occasional almost violent contrast. Occasionally red is the background; this is nearly always so whenever Christ or His ancestry is the main subject.

But in spite of the many rules and conventions there was ample scope for individual expression. The glazier drew up the layout and the detail, selecting the glass for its natural characteristics, ran the lead lines round the contours, painted in the detail, and after the final firing fitted each piece into the whole structure. It is fascinating to consider that in creating a rose window over 12 metres or 40 feet in diameter – such as those at Chartres and Paris – there was no way of precisely knowing how the window would appear *in situ* until the project was completed. There may well have been periods of experimentation; but it is nevertheless a measure of the amazing skill, knowledge and intuition of these medieval craftsmen that they worked virtually blind on these vast compositions. However much the design was thought out, drawn up and experimented with, it would have been next to impossible to know in advance how such factors as thickness of stone and the angle of the sun at different times of the day would affect the final colouring. The effect of halation, whereby lighter colours tend to spill over

St Bartholomew, from Laon's east rose window. Early 13th c. (from Florival and Midoux)

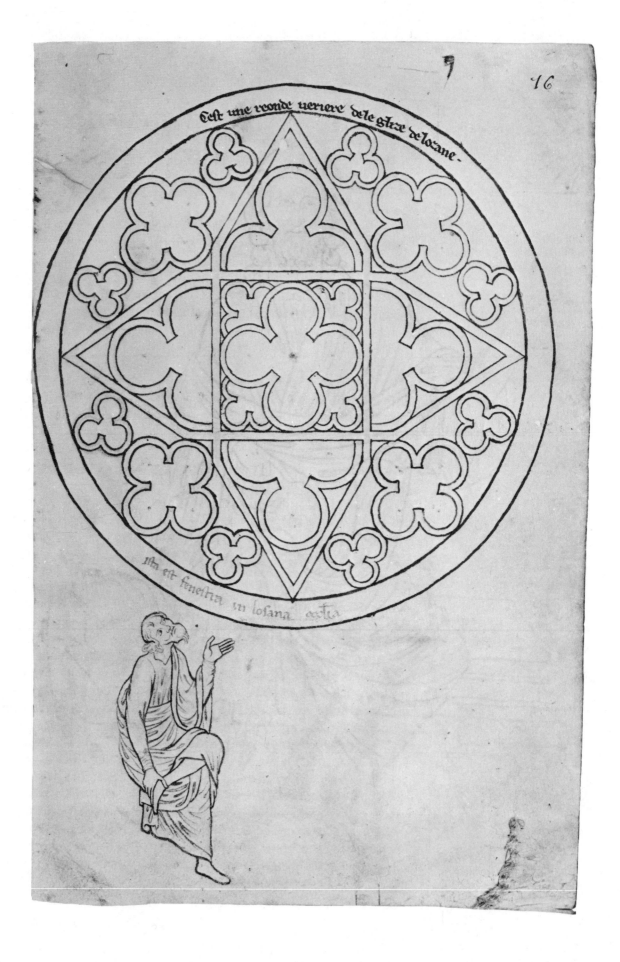

Cest une rconde veriere dele glize de lozane.

ista est fenestra in lozana ecclia

Villard de Honnecourt's sketch, c. 1225–50, of the 'round window' in Lausanne cathedral. As with the Chartres window (p. 93) it is for some unknown reason inaccurately drawn. The figure below is thought to be unrelated

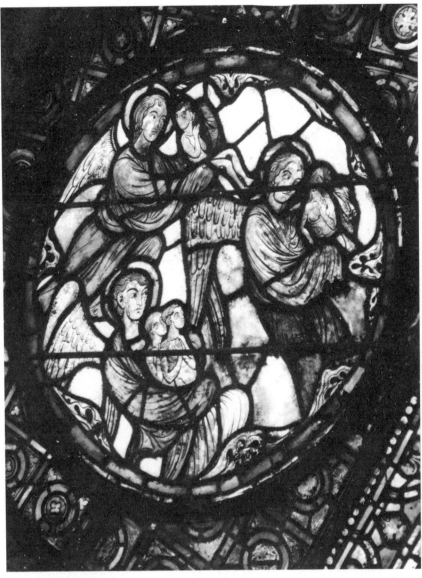

Souls being transported to heaven by angels in the Last Judgment window at Mantes. Early 13th c.

Melun, near Paris

into neighbouring darker tones, often results in a substantial change in the overall colouring of the window when viewed from a distance. Halation also influences the overall colour balance, blue being the most problematical colour, often appearing *en masse* to be darker than would normally be expected from each individual piece. Such effects are also more pronounced when the sun is out behind the window – as the window at Reims shows in the photographs, where the colour balance is changed substantially, and red predominates almost violently in the setting sun.

In the final count a beautiful rose window is one which presents a new face every hour of the day and every day of the year. It is like a truly great symphony, never ceasing to fascinate us, of infinite variety within perfect and cyclic order, of irregular rhythms within regular tempi or of regular rhythms within irregular tempi; of light, shade and colour subtly combined or dramatically contrasted. In these grand works of light and geometry the artist becomes a creator of the spheres, at one with the music and dance of the cosmos.

Why did they build these colossal bulwarks, the Cathedrals?

It was to deposit – in safety as they believed – the imperceptible egg, that seed which requires so much patience, so much care: TASTE, that atom of pure blood which the centuries have transmitted to us, and which, in our turn, we should transmit.

All these proud equilibriums, all these accumulations of stone glorified by genius, that rise to the extreme limit where human pride would lose contact with life, with the species, and would totter in the void, all such is but the tabernacle. Or rather – for this shrine is living! – it is the Sphinx, guardian of the Secret.

The secret is virtually lost, since today only a few can reply to the sphinx crouching on all sides of our French cities.

We should know how to respond to the Gothic sphinx if nature herself had not become for us an incomprehensible sphinx.

'The French Countryside',
from *The Cathedrals of France* by Auguste Rodin.[18]

21 **The gaping hole** in the heart of the façade of Saint-Jean-des-Vignes at Soissons is all that remains of the rose window; a memorial to all that has been lost through the futility of war. For Saint-Jean has suffered over the centuries more than most, first in the Hundred Years War, then in the Religious Wars, again in the French Revolution, yet again in the Franco–Prussian War and finally in the First World War. And yet it still stands: a symbol of man's creative as well as his destructive powers, but always looking to a better, brighter world. (Saint-Jean-des-Vignes west, Soissons, late 13th c.)

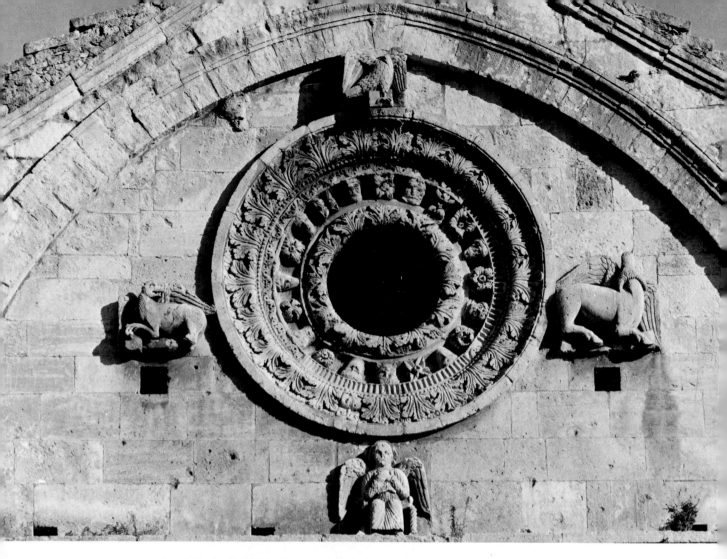

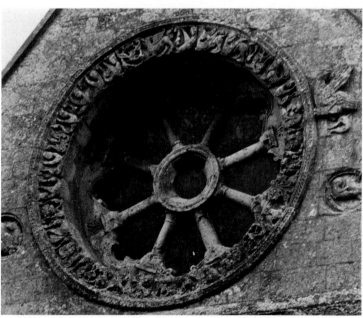

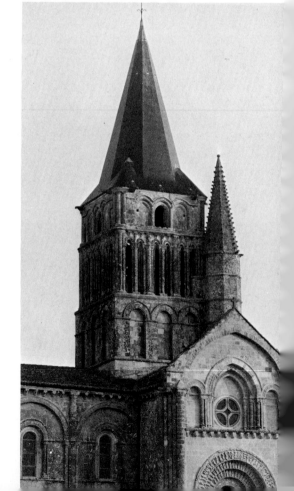

22 **At Tarascon is an example of an oculus,** predecessor of the wheel window. Richly carved round its perimeter, it is surrounded by the four symbols of the Evangelists, facing the setting sun. (Saint-Gabriel, Tarascon, c. 1180)

23 **The ancestor of** the rose window is the oculus, but its parent is the wheel. Here at Barfreston in Kent the circumference of a wheel is enriched with animals, faces and leaves. (Barfreston, c. 1180)

24 **The rosette and** its three little arches above the massive Romanesque door at Aulnay is an example of the form that evolved into the rose some fifty years later – that of the circle and the cross. (Aulnay, c. 1135–65)

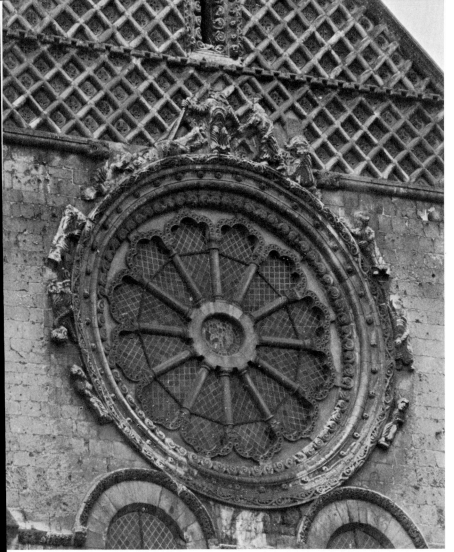

25 **The Wheel of Fortune that evolves into** the rose of life is beautifully illustrated at Saint-Etienne, Beauvais. People are dragged anti-clockwise around the perimeter past two dragons and a headless ogre with a large club. Such wheels can be said to symbolize the transitory nature of worldly success in an ungodly life (i.e. on the circumference) as opposed to life united with God through the centre. (Saint-Etienne, Beauvais, c. 1100)

26 **The first rose window:** this wheel at Saint-Denis is thought by many scholars to be the first rose. It is similar in size to the Beauvais wheel, but was probably the first to be filled with stained glass. The four symbols of the Evangelists – somewhat restored here – can be related to the motif of Fortune via the four fixed signs of the Zodiac (see p. 88). This transformation from the Zodiac to the Evangelists is paralleled in the evolution of the wheel of fate into a rose of life. (Saint-Denis, c. 1144)

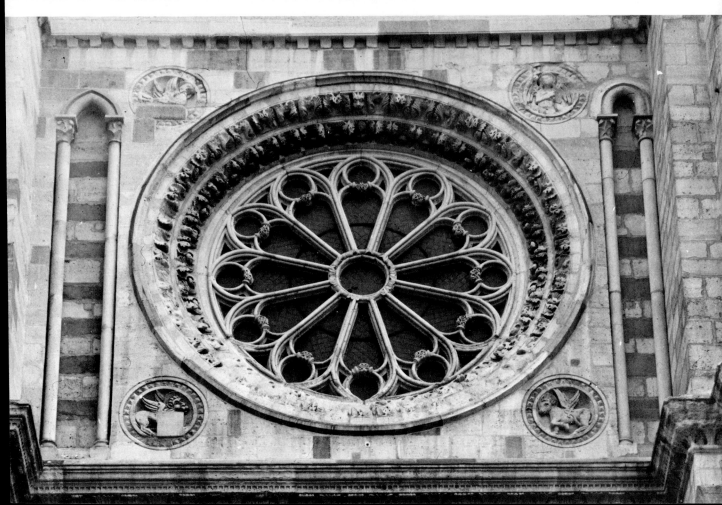

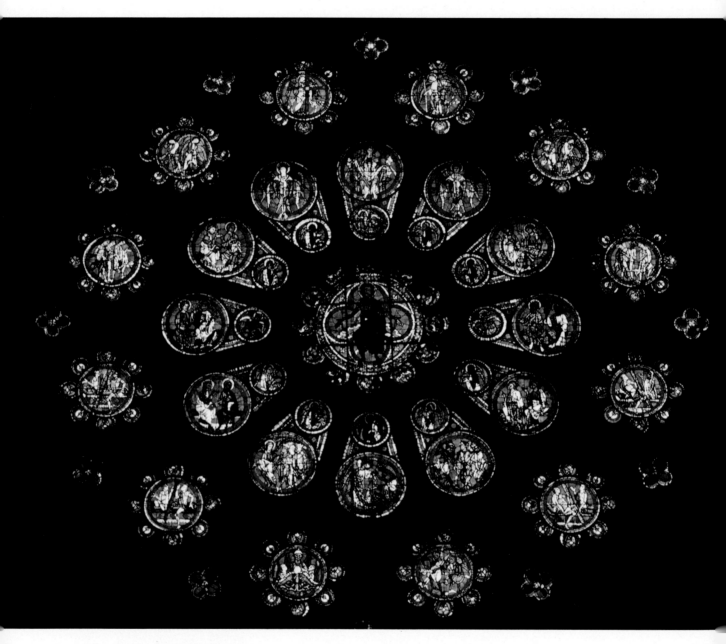

27, 29 **On the west façade of Chartres
and** facing the setting sun is the great
rose of Chartres, 13.36 metres (44 feet) in
diameter: externally a giant wheel and
internally a beautiful rose – a
masterpiece of light and geometry.
(Chartres west, c.1216; see key and
diagrams on pp.122–23, 136–37)

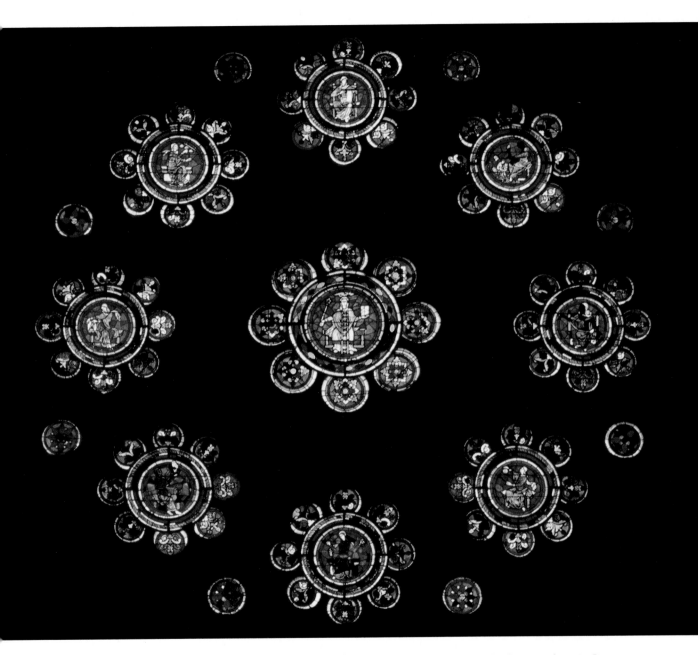

28, 30 **In the north transept of Laon** there is another rose of plate tracery, probably by the same master as its big sister at Chartres. The external structure shows the change of mind made by the architect, abandoning what probably was to be a window of lancets. Internally the eight lights feature the liberal arts surrounding the queen, Philosophy. Starting at the top and descending to the right they are: Rhetoric, Grammar, Dialectic, Astronomy, Arithmetic at the bottom, then Medicine, Geometry and Music. Whether this was the original disposition is unknown, since Philosophy, Rhetoric, Medicine and Music were missing when the window was restored by Coffertier. (Laon north, early 13th c., restored 1856; see also 31)

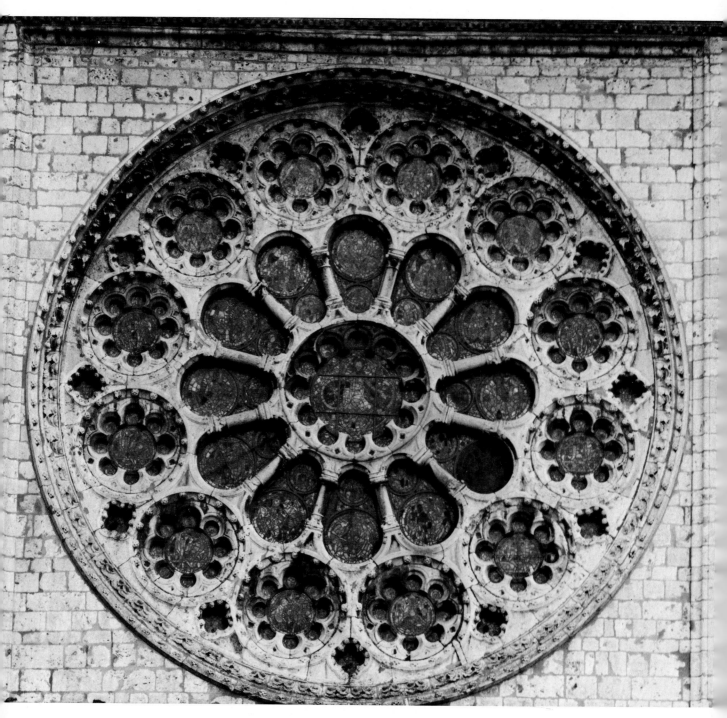

29 See 27

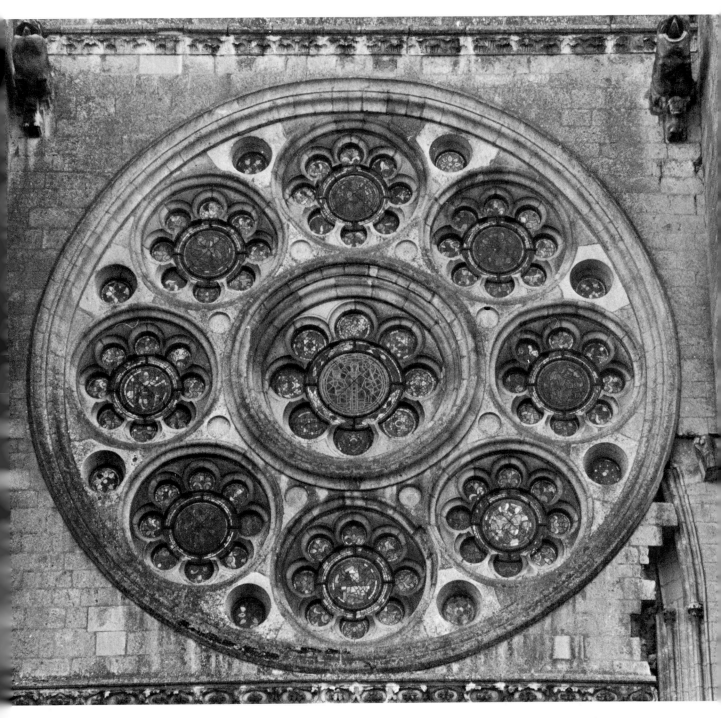

30 See 28

Overleaf:

31 **Wisdom is personified in** the central rosette of the north rose at Laon as a woman seated on a throne – Philosophy – head in the clouds with the sceptre of royalty and a ladder of nine rungs up her front, echoing the nine spheres of the cosmos and the angels, or possibly of the nine subjects that originally comprised the liberal arts in classical times. (Laon north, early 13th c., restored 1856; see 28, 30)

32, 33 **The Logos, as the Word made flesh through the rose;** as foretold by Isaiah and communicated to the world through St John. In the east rose window at Laon, the Virgin Mary with the Christ Child on her knee holds out the rose to Mankind, with St John below left and Isaiah to the right. In the first circle are the twelve Apostles, and on the perimeter the twenty-four elders of the Apocalypse, each carrying a musical instrument and a phial of perfume – symbolizing the prayers of the saints. (Laon east, early 13th c.)

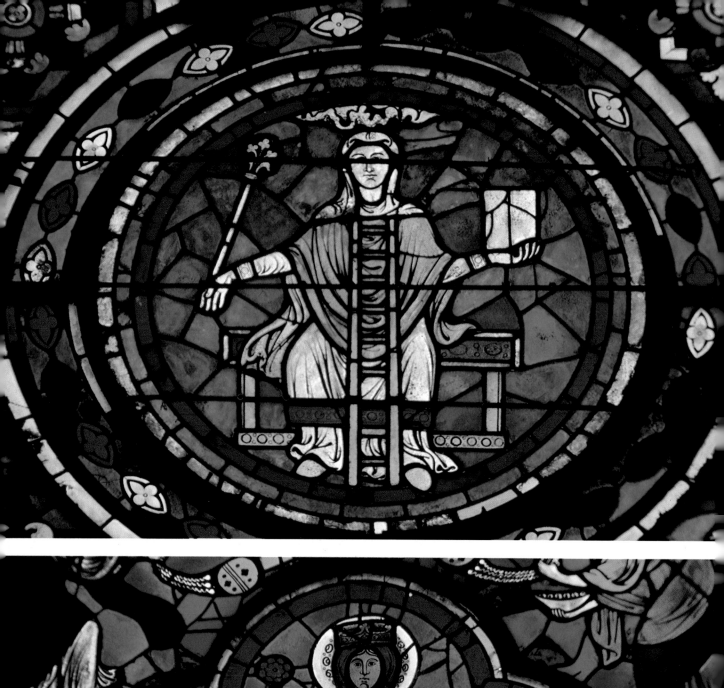
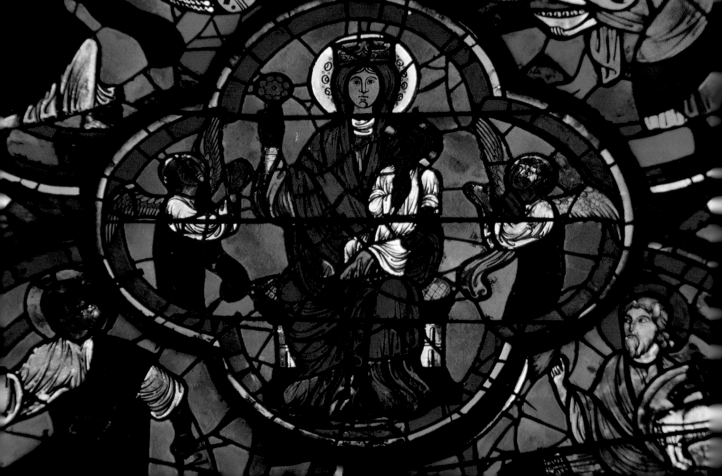

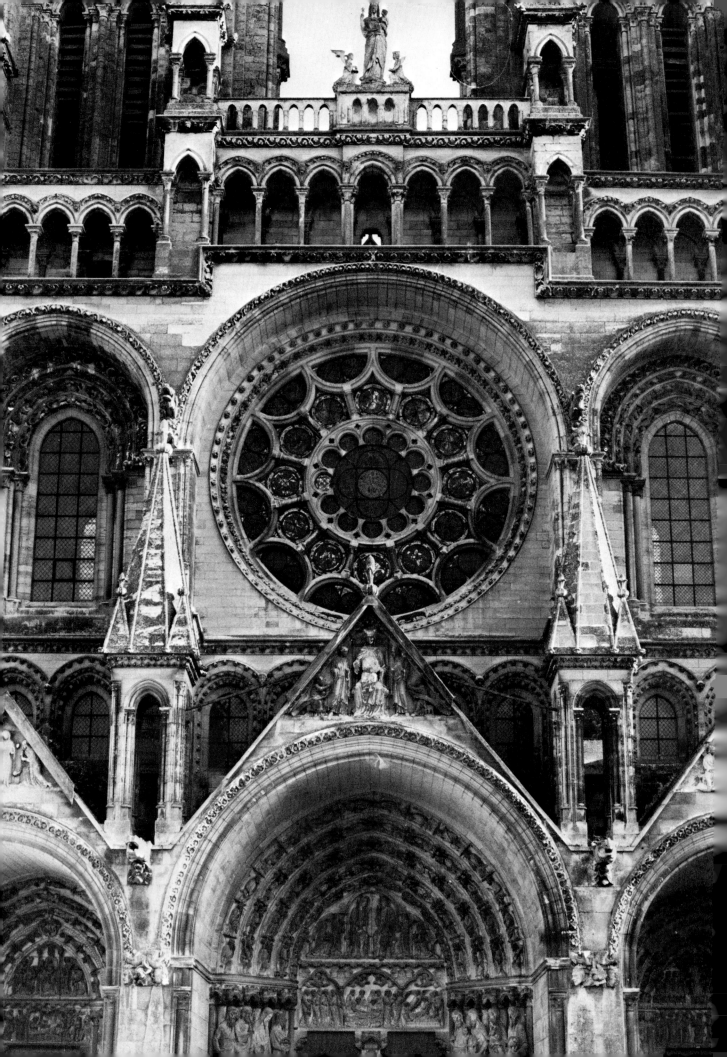

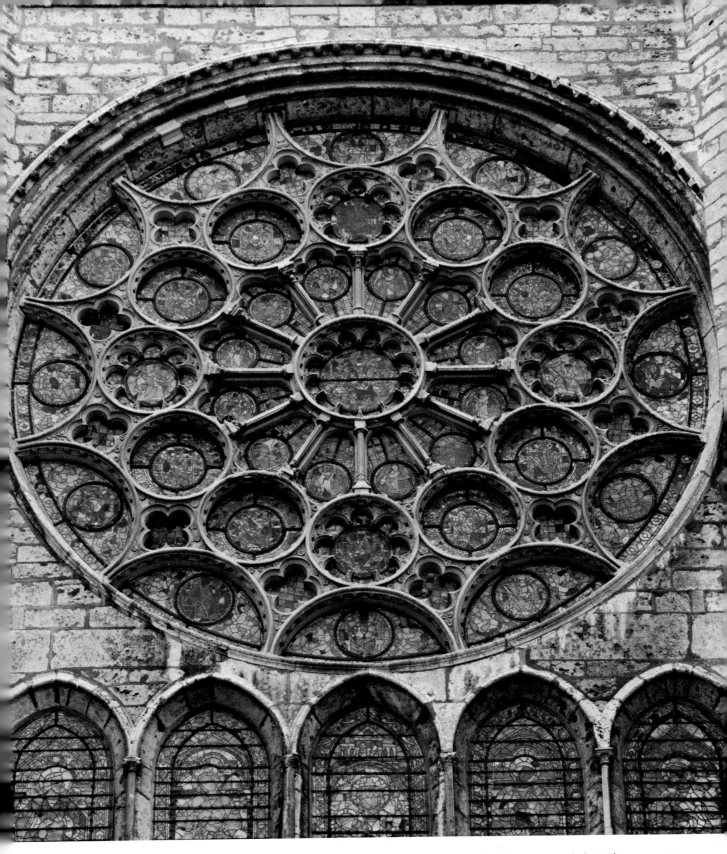

34 At the heart of Laon's west façade is the huge rose window identical in structure to that of the east, dominating the composition above the portal of Last Judgment and beneath the enchanting statue of the Virgin Mary attended by two angels. (Laon west, c.1200)

35–37 Each of the rose windows at Chartres is a triumph of geometry; this stone flower is centred on Christ at the centre in Glory as depicted by St John in Revelation, surrounded by angels and the four symbols of the Evangelists. In the outer circle are the twenty-four elders of the Apocalypse, each with a crown, a musical instrument and a

phial: the crown symbolizing the martyrs who died for Christ. The south portal underneath the rose is dedicated to the New Testament and the martyrs and confessors who have spread the Word. The window was given by the House of Dreux, whose yellow and black checky arms fill the small quatrefoils. (Chartres south, c.1227; see p.126)

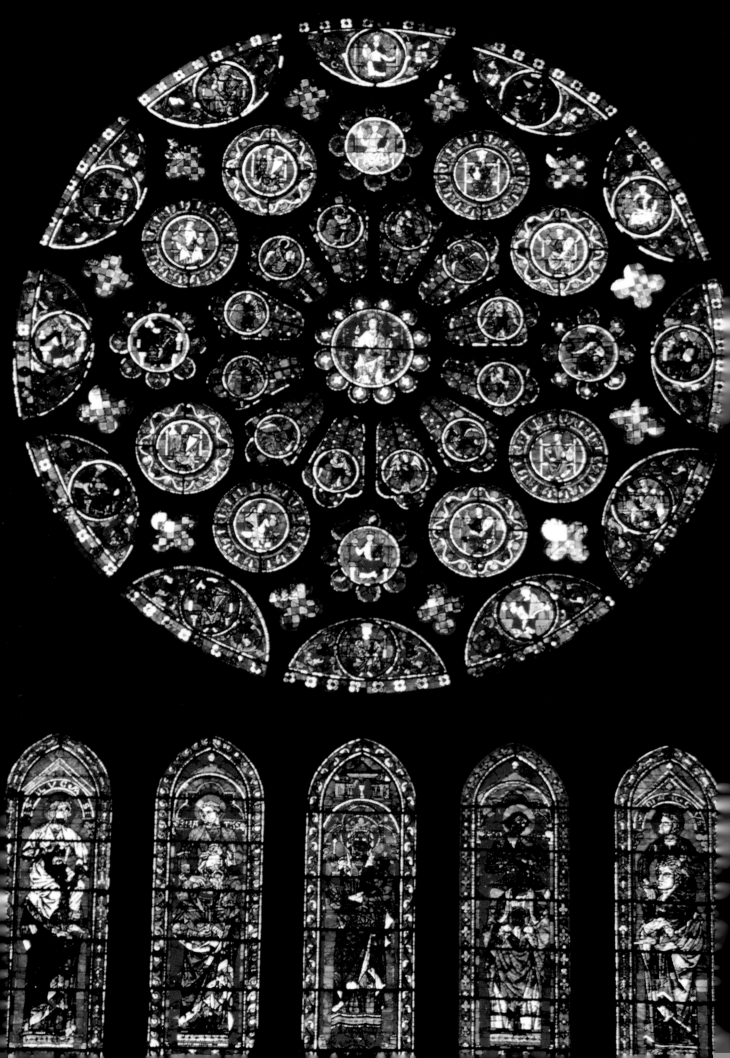

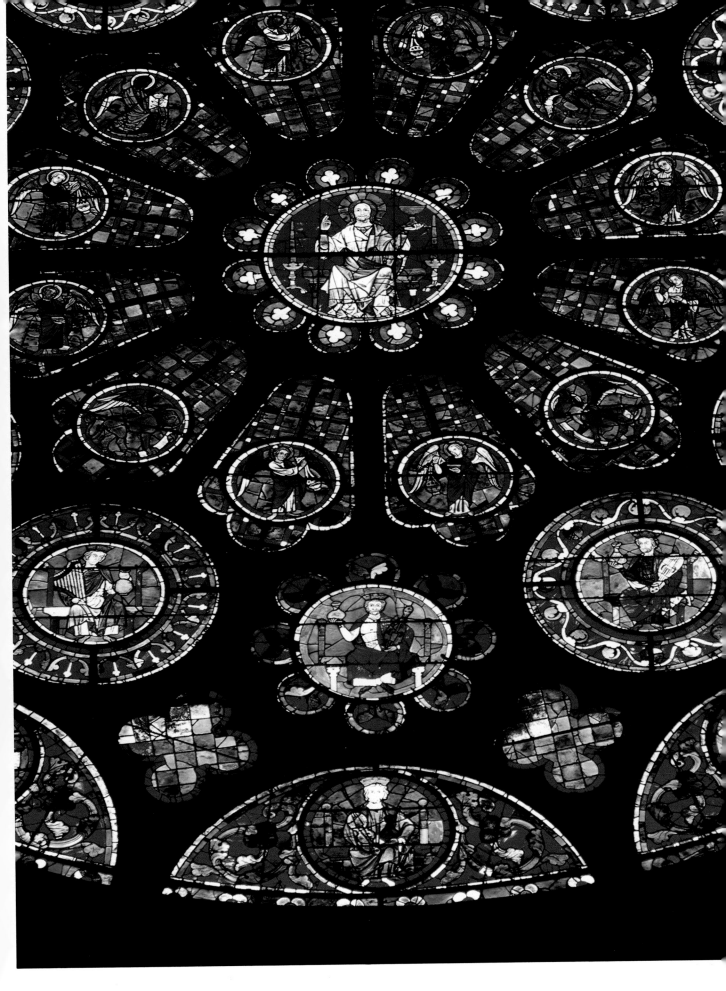

38, 39 **A new world.** Paradise, Time, Eternity and geometry combine in this remarkable rose window at Lausanne, undoubtedly influenced by the School of Chartres. A full description of the way in which the squares and circles of the

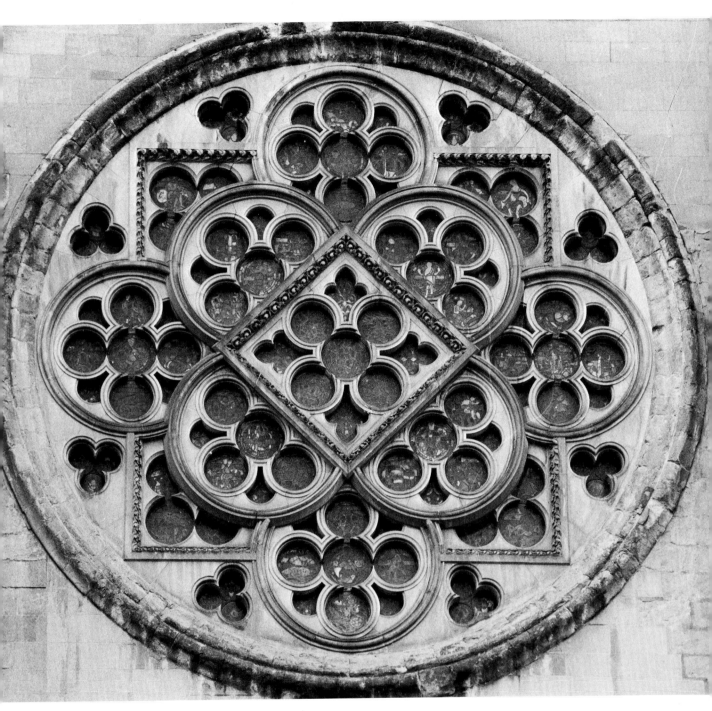

stonework symbolically interlink with
the subject matter is given on pp.
128–31. It was sketched by Villard de
Honnecourt in 1235 and probably dates
from a few years before this. (Lausanne,
c.1230)

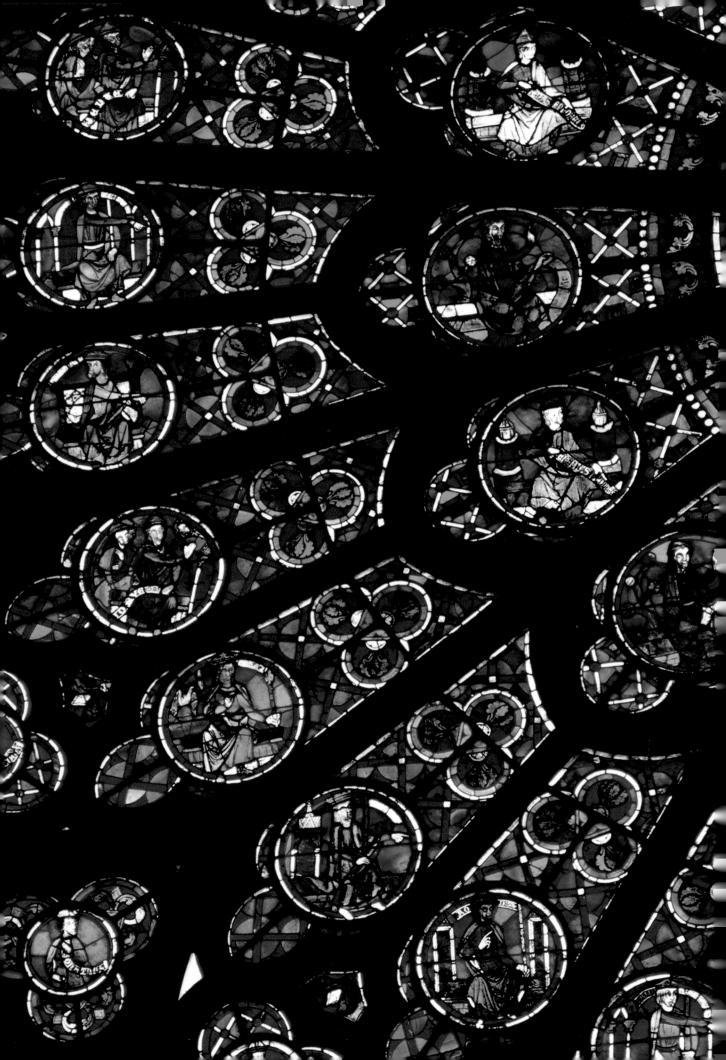

40 At Paris, following the trend set by the delicate west rose (25), the very thin tracery of the north window gives much more room to the glasswork. In this section can be seen the four prophets Elijah, Nahum, Jeremiah and Habakuk (numbers 13, 12, 11, 10 in the key on p. 135), eight other prophets (34–41) and two high priests, Jonathus and Amarias. (Paris north, c.1268)

41 Chartres south rose; see also 36, 37. (Chartres south, c.1227)

Overleaf:

42 The most delicate traceried roses appeared in the mid thirteenth century. Those of Paris became models for a number of other churches and cathedrals – particularly the south window, as for example here at Sées. (Sées south, c.1270)

43, 44 By the fourteenth century, tracery evolved into many imaginative designs. At St Katharina, Oppenheim, two roses were built into the south side of the nave, one on a threefold geometry and the other on five. By the fifteenth century the cult of the rose was well established, and roses completely surround the gable of one of the windows. (St Katharina, Oppenheim, c.1434)

45 New flower-like forms, such as the south window of Saint-Ouen, illustrate the inventiveness of the late Gothic 'Indian Summer'. (Saint-Ouen, Rouen, 15th c.)

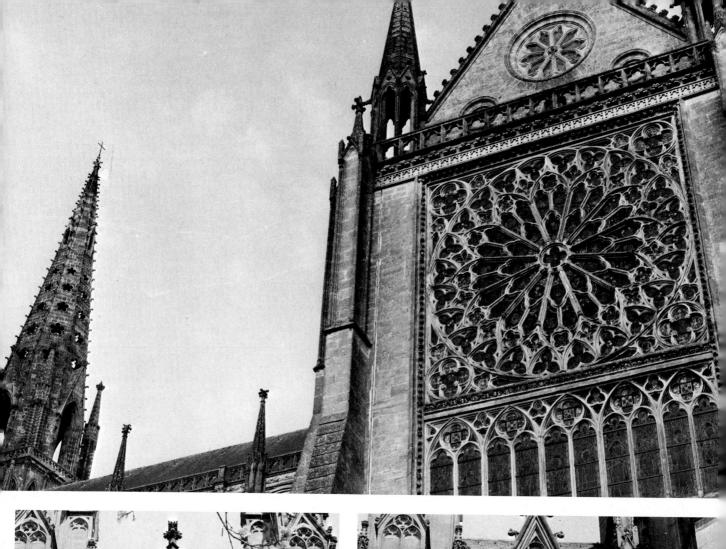

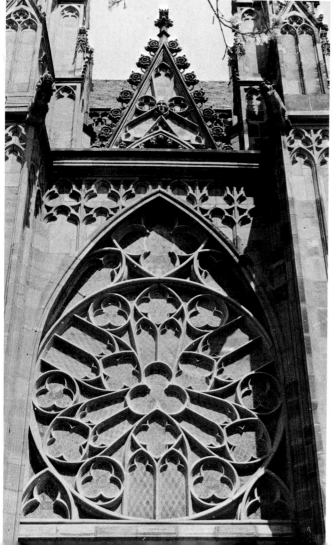

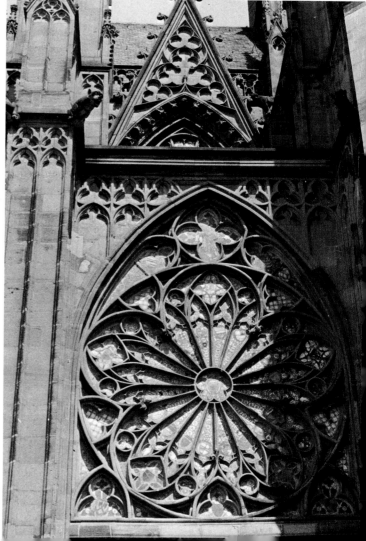

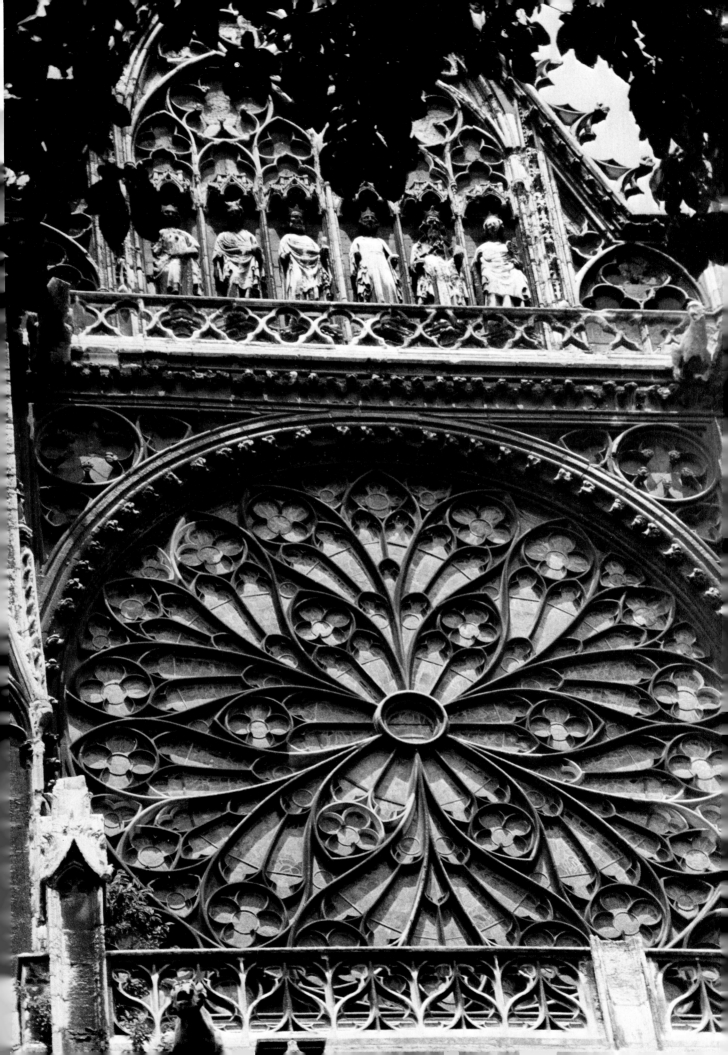

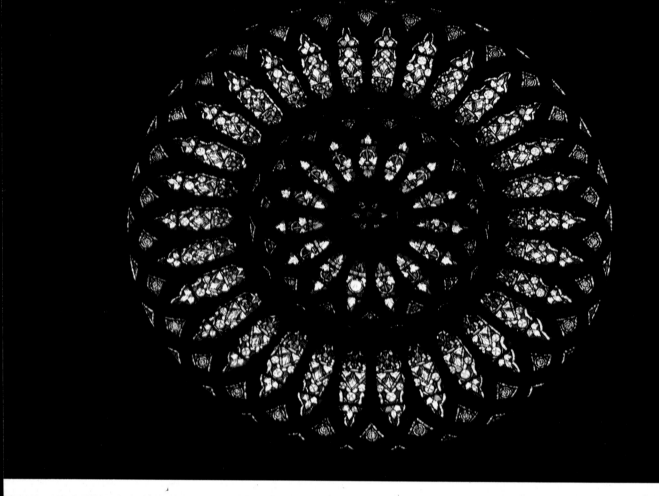

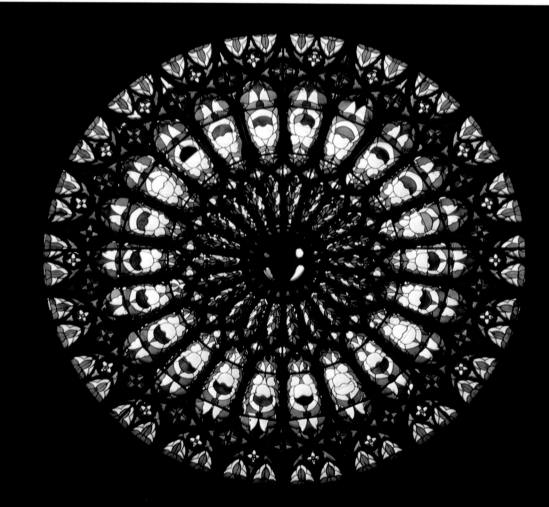

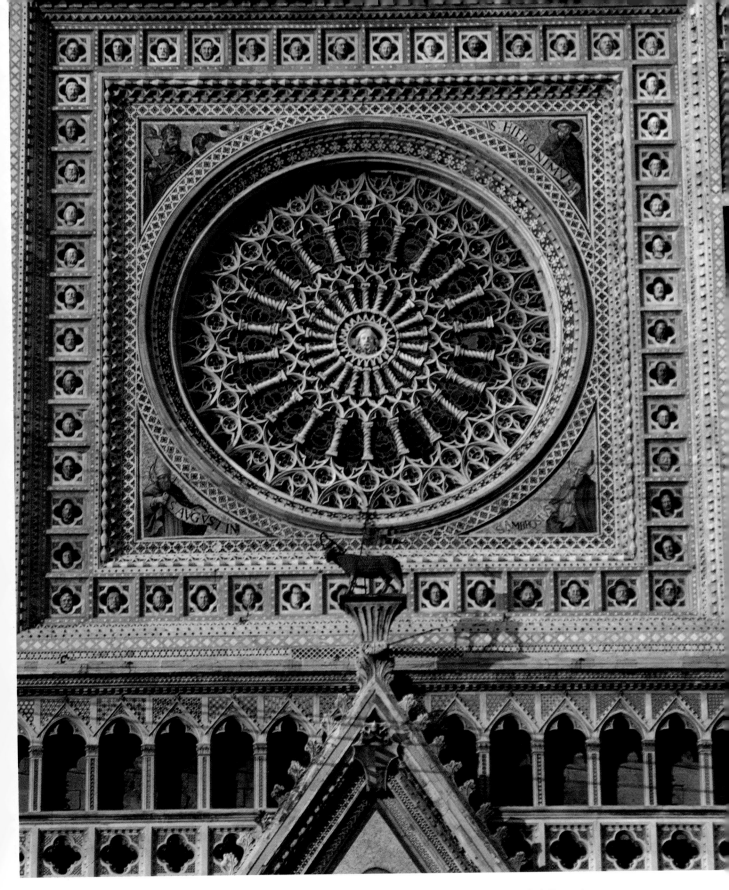

46 **But in Italy the wheels grow bigger and more beautiful.** Here at Santa Chiara in Assisi an intricate double layered wheel has been filled with glass to give a remarkable three dimensional vortex effect. (Santa Chiara, Assisi, c.1257–65; see also 51)

47, 48 **The rosoni on the façades of Italian churches are often** filled with plain glass, but at Orvieto every space and crevice is occupied. This unique twenty-two-spoked wheel is carved into the west façade of the cathedral to capture the evening sun. At the centre is the head of Christ; the square containing the wheel and four of the early Church Fathers is made up of fifty-two heads – presumably one for each week of the year. (Orvieto, 14th c., by Andrea da Cione, alias Orcagna)

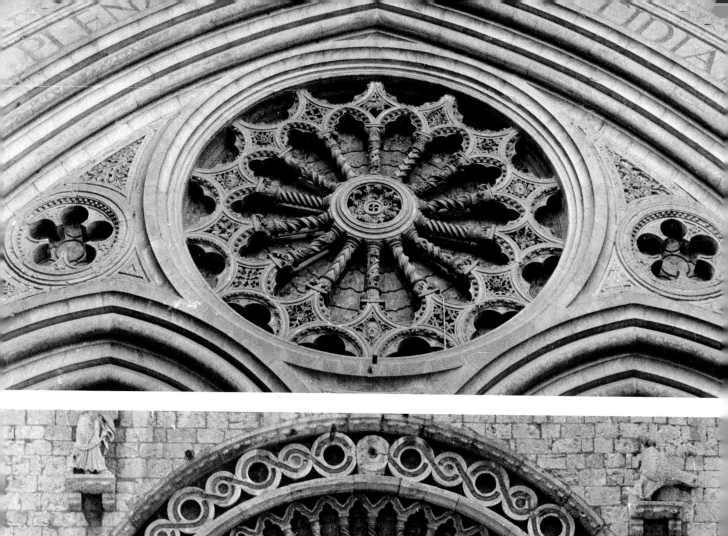

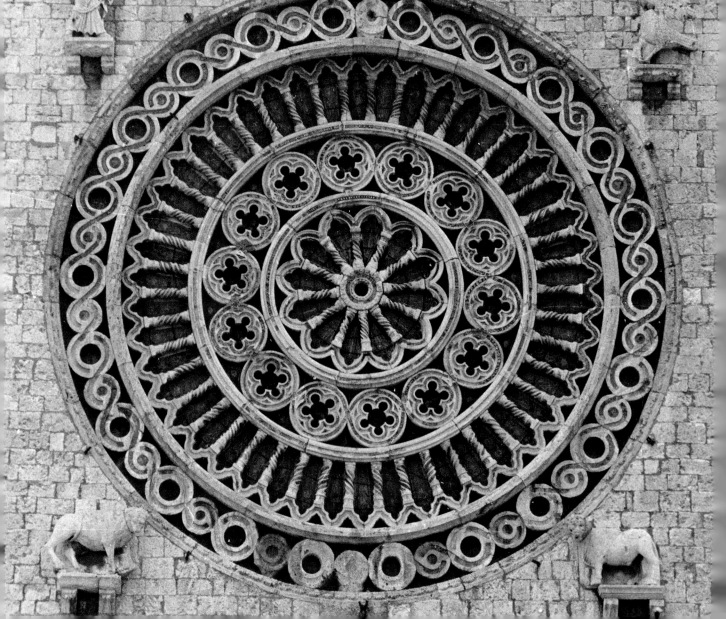

49 Highly decorated simple wheels or rose windows can be found in many parts of Tuscany – there are two like this one on the same building. (San Francesco, Lower Basilica, Assisi, after 1250)

50 Wheels within wheels. Surrounded by the four sacred living creatures, this beautiful wheel on the façade of the Upper Basilica of San Francesco faces the rising sun – exactly the opposite of most other wheel or rose windows. (San Francesco, Upper Basilica, Assisi, c.1250)

51 The wheel finds its greatest expression at Assisi; apart from the three wheels at the Basilica there are three more at the cathedral, three at San Pietro, and this magnificent specimen at Santa Chiara. (Santa Chiara, Assisi, c.1257–65; see also 46)

52 In Italy, where the Gothic style of Northern Europe was reluctantly admitted, the most 'French' cathedral is that of Milan. This almost Flamboyant rose is in the apse, and built with an interlocking tracery of mouchettes. (Milan, 15th c.)

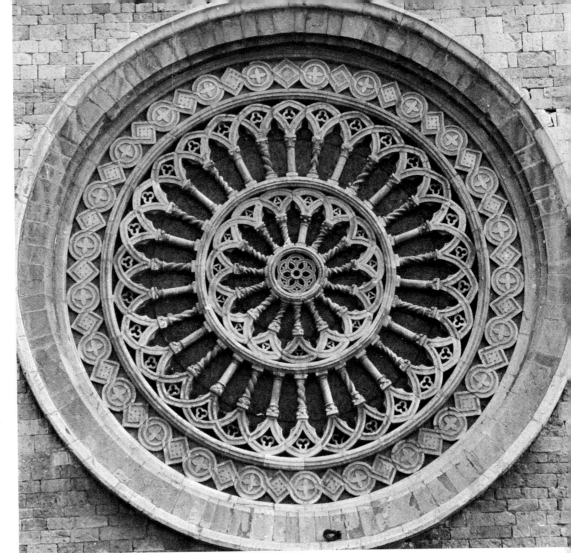

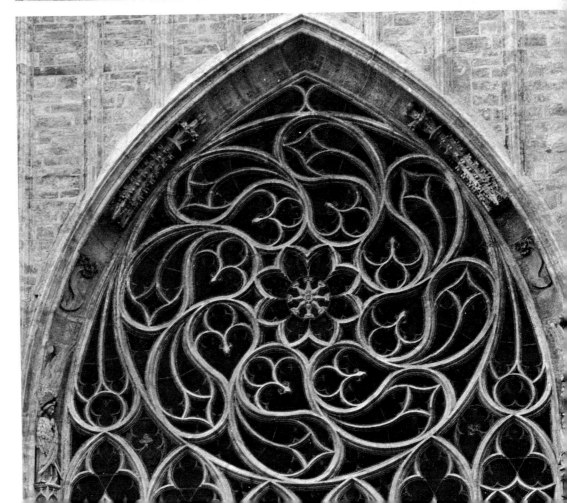

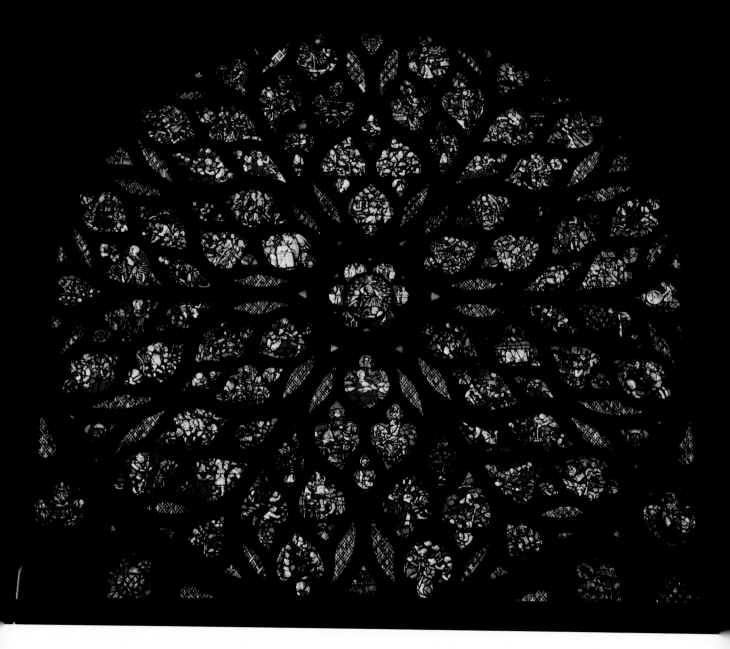

53, 54 **Before the** mid sixteenth
century, Gothic architecture in England
and France experienced a last inspired
burst of energy. The rose of the Sainte-
Chapelle is one of the greatest examples
of the period. It replaced the thirteenth-
century original which may well be the
one illustrated in the Duc de Berry's
Très Riches Heures (under the month
June). A full description of this
Apocalyptic window is given on pp.
138–40. (Sainte-Chapelle, Paris, 15th c.)

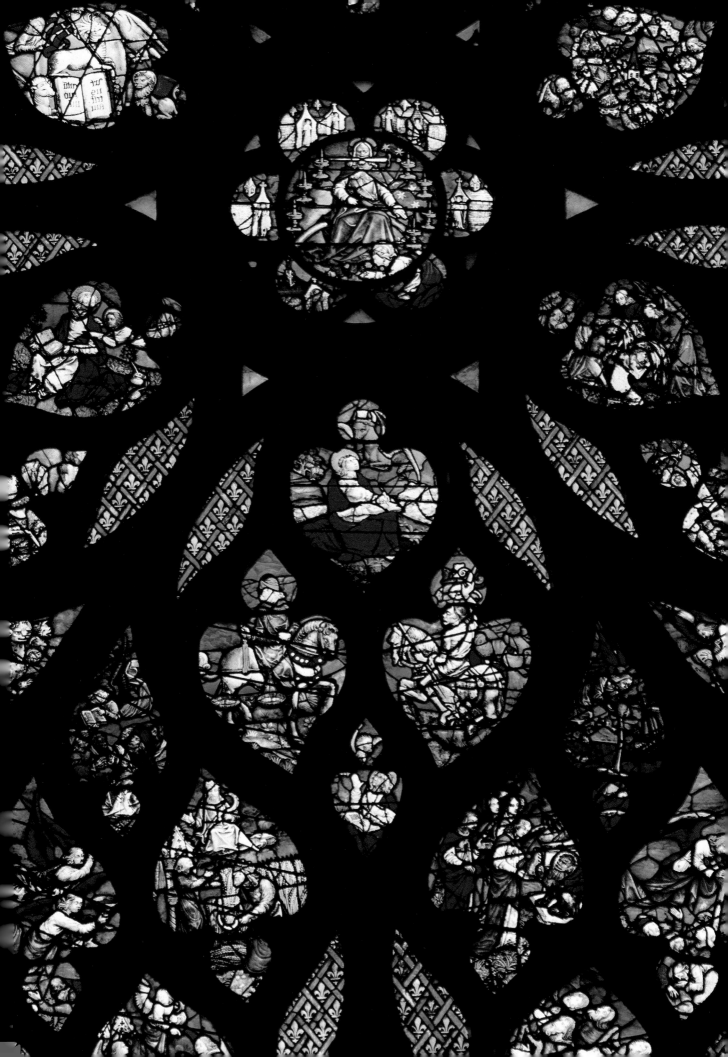

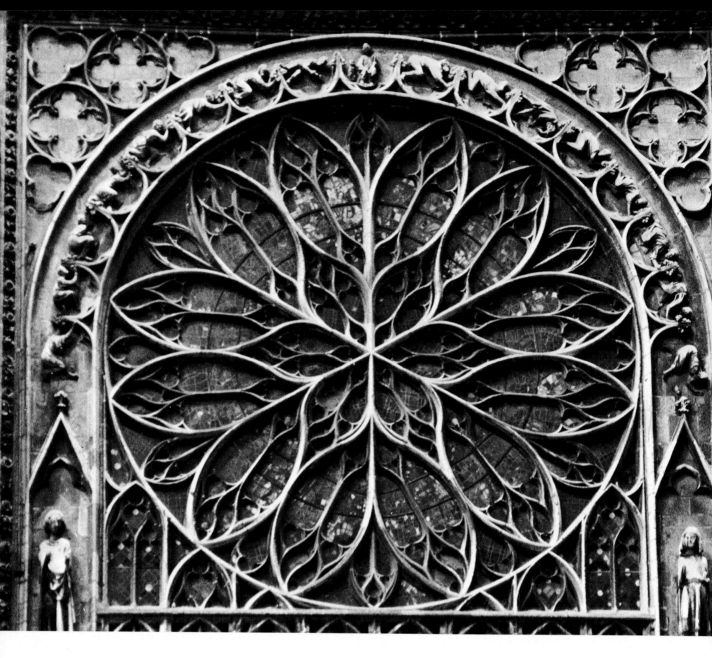

55 **Flamboyant** rose windows became widespread in France after 1450, and this superb example at Amiens may well have been the first of them. It is in one sense still a Wheel of Fortune, with the figures being dragged up one side only to be dropped on to a spike on the other. The whole window is framed with roses. (Amiens, c. 1400)

56 **Rose windows in France had evolved from** wheels, but it was only after years of experiment that they managed to become totally integrated into the general style of the façade. The Flamboyant roses were more easily accommodated, and the lozenge-shaped window of Tours cathedral is one of the most successful. (Tours west, c. 1500)

Overleaf:

57 **The flowing forms of the rayonnant style.** The five-pointed star multiplies to fifteen petals enclosing the *coeur céleste* or Celestial Heart, the pentacle symbolizing in this instance the Crucifixion. The window would also seem to symbolize the macrocosm, with the sun-stars enclosing the angelic hierarchy, and the centre encapsulating the seven lights or suns. The deep red angels at the top may well be the Seraphim – conveyors of Divine Love from the *coeur céleste*, while the blue and gold Cherubim impart Divine Wisdom; the remainder are possibly the Lower Angels. This symbolism of coloured angels belongs more to the Renaissance than to the Gothic. (Saint-Ouen north, Rouen, c. 1440)

58 Opposite in the south transept of Saint-Ouen is the six-petalled rose in the form of a Tree of Jesse, with the Kings of Judah disposed through the interweaving rayonnant tracery, while the doves of the Spirit radiate Light from the six petals and the twelve sub-petals. (Saint-Ouen south, Rouen, c. 1439)

59 **Some rose windows are** neatly fitted into lancets – as is the case with this small example in the nave of Strasbourg; the ring of rosettes is mounted on top of a Last Judgment scene, with angels descending from the rose. (Strasbourg nave, 14th c.)

60–63 **Unforgettable** as it plays with the light is this beautiful and abandoned Flamboyant rose at Lieu-Restauré on the Ile-de-France. (Lieu-Restauré, 15th c.)

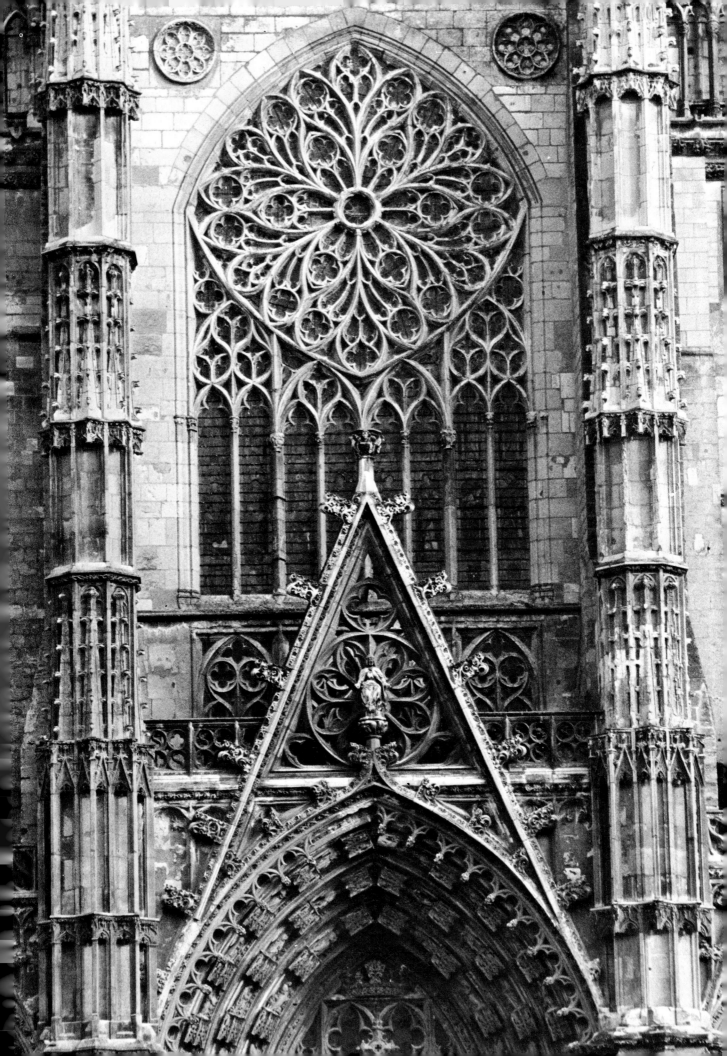

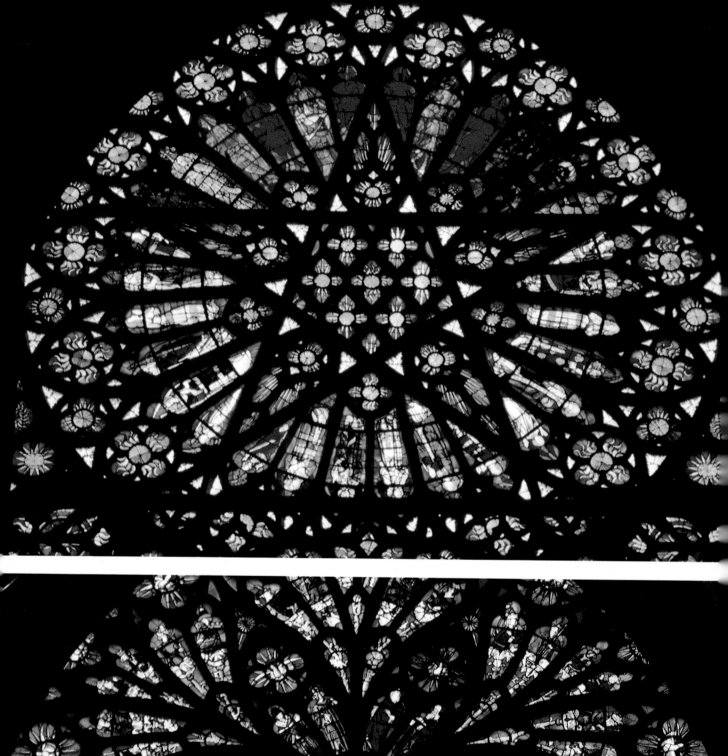
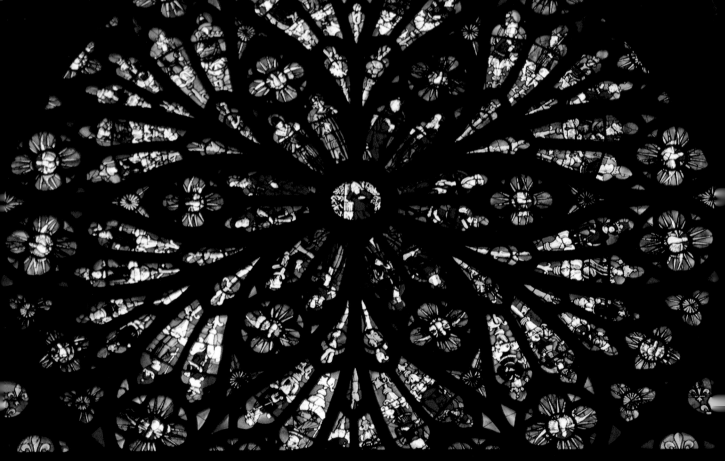

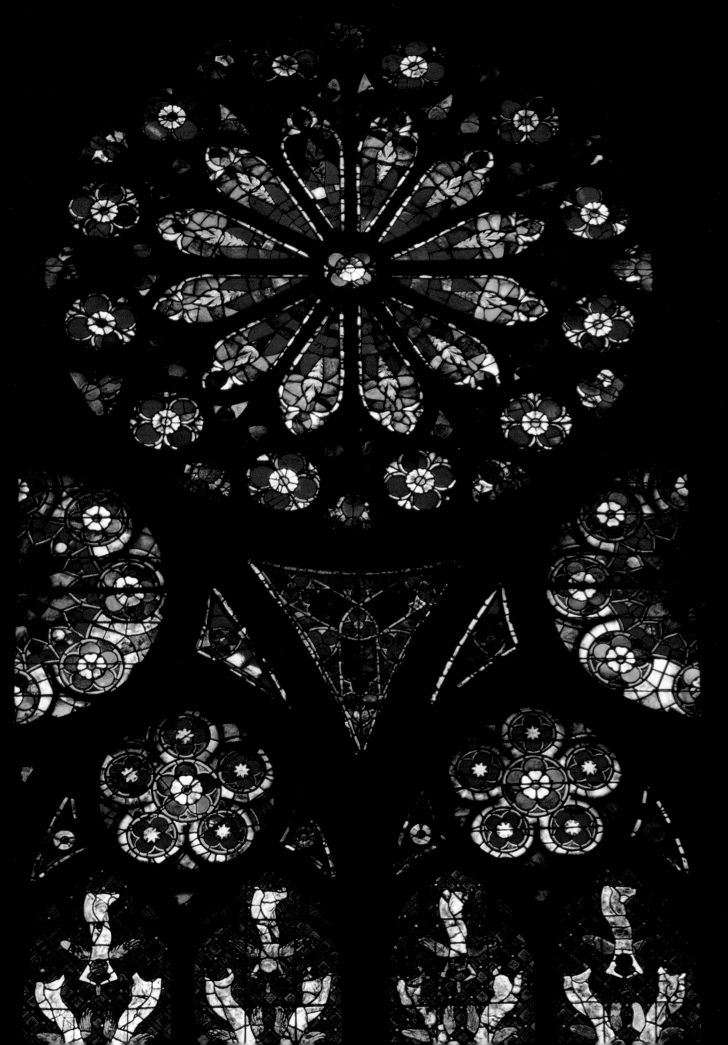

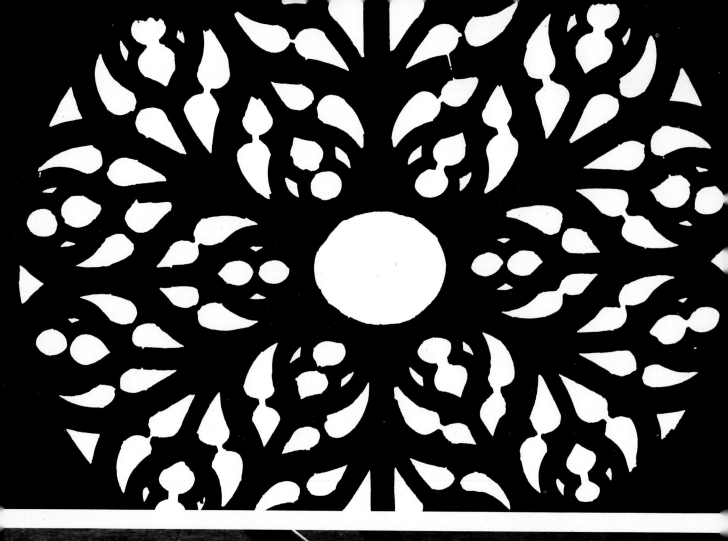

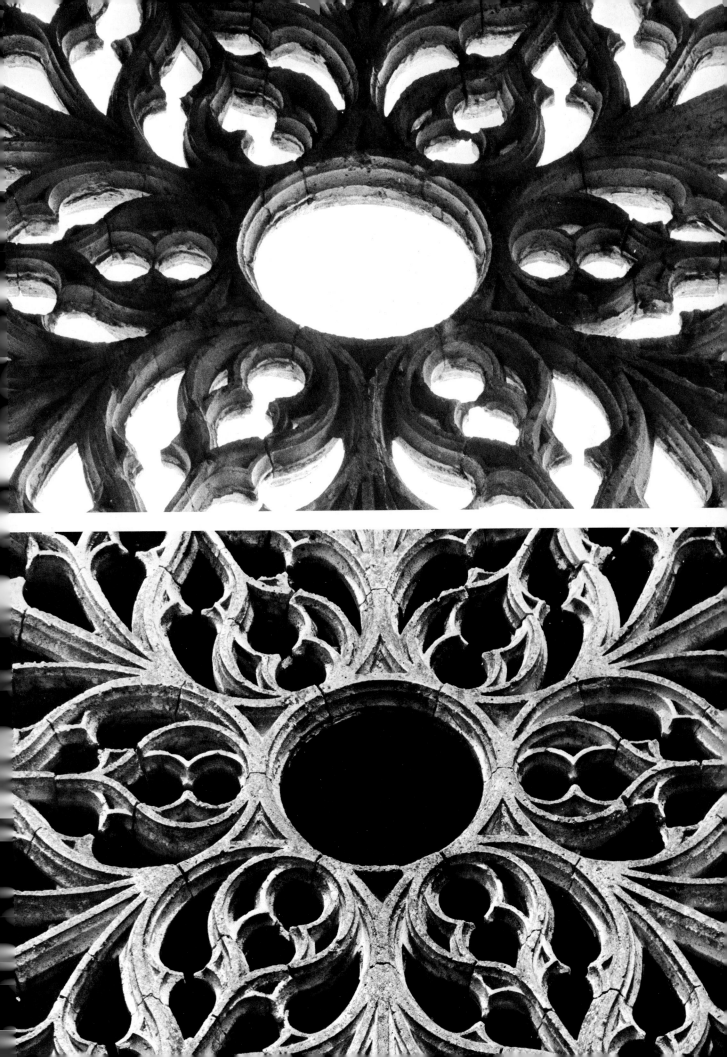

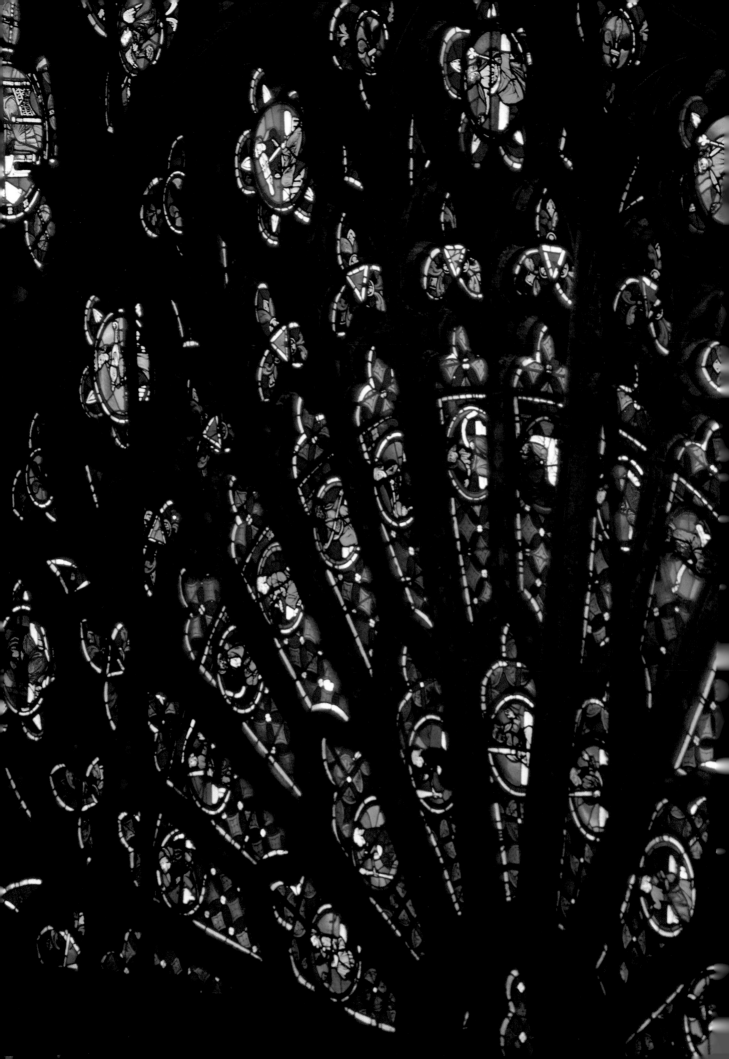

The meaning
Purification: wisdom

'Everything in medieval symbology has hidden meanings: that is, showing men one thing and inviting them to see in it the figure of another.' Thus Emile Mâle very neatly supplies the clue to understanding medieval iconography. In the rose, and in the rose window in particular, there is a mass of symbolism which is as simple or as complex as each individual chooses to make it. Like the flower which the Buddha held up as the sum total of one of his sermons, the rose window is a symbol in itself by virtue of its form, and at the same time presents other symbols – showing men one thing and inviting them to see another. Both the image and its content combine to act as a bridge to deeper meaning; they enable us to see at a glance something which words can only transmit over a period of time.

In any church building, iconography is the key to the Christian view of the world as a *transformed* reality: the truth of the Old Testament revealed in the light of the New. This remains so when the imagery is obscure or even pagan. Medieval philosophers, theologians and cathedral builders translated Christianity into terms appropriate to their age, both in words and in images in glass and stone. They looked back to its roots, particularly to ancient Greek thought and the early Church Fathers, and combined what they found with the knowledge of the day. As at Chartres – where the intellectual light shone most strongly, and they built 'on the shoulders of these giants' – the contemporary view of the cosmos and of life was grafted on to traditional Christian iconography. Thus any set of three rose windows generally portrays the Glorification of the Virgin Mary, the Resurrected Christ and Last Judgment. But within this scheme can be seen a less obvious and deeper meaning, for as mandalas the windows possess the power to bring about a change in thinking, to break down the habitual patterns that govern everyday consciousness. They can open the mind to a new reality, and this is often accompanied by a profound inner peace and reconciliation with oneself. Such an act requires a sincere commitment which Rodin describes as the learning of patience, 'which in turn teaches energy'.[19]

The limitations of the 'everyday' state of consciousness are described by Plato as being due to the grossness of man's senses, a condition that inhibits the Music of the Spheres from making itself heard. But if man could be transported back to his original state, then he would hear the Music again, and in hearing it he could understand nature's deepest secrets. In Christian theology the parallel to this musical image is the Garden of Eden and the Paradise to come: through Christ and His teaching lies the way to a world in which man, in harmony with nature, creates the Eternal City – the New Jerusalem.

In the Gothic cathedrals Christian iconography is infused with classical learning, particularly that of Plato, and with the metaphysics of light that was derived from St Augustine and John Scotus Erigena. All this combines in the architecture and in the iconography to illuminate and lead the way to the Order behind creation: that is, to the Logos.

Before we embark on the wider aspects of symbolism it is important to consider the iconographic programmes of the early cathedrals around Paris, where the rose window evolved; these remain the basic patterns for

64 **Throwing light and colour in every shape and form to every corner of the cosmos,** this south rose at Tours is probably the last of the great windows built, within Henry Adams' 'magic 100 years' of the Gothic after 1170. (Tours south, mid 13th c.)

Philosophy, head in the clouds, holds an open book of learning and a sceptre (now broken). From west portal, Laon (from Viollet-le-Duc)

iconography elsewhere. In *north* windows it is the Virgin Mary who is usually found at the centre, surrounded by the priests, prophets and kings of the Old Testament – as at Paris and Chartres [6, 11]. There are variations however: the Creation at Reims, the childhood of Christ at Soissons, and the seven liberal arts at Laon [28]. In *south* windows Christ is nearly always portrayed in Glory after the Resurrection, and it would seem from this disposition of north and south that the Crucifixion is the dividing point in time. In the *west* Christ presides over the judgment of souls, with saints being led off to heaven and sinners to hell; nowhere is this better illustrated than at Chartres or Mantes [27, 65]. In the west rose at Reims, the Death of the Virgin – the end of the Church of Notre-Dame – again symbolizes the End of Time [4, 5]. Into this fundamental pattern are fitted the iconographic details, different in each church, but nearly always to be found in the same relative positions: priests, prophets and Old Testament characters in the north; Apostles, twenty-four Elders of the Apocalypse, signs of the Zodiac, martyrs and confessors in the south; and the angelic choir, division of souls, vices and virtues in the west. In the rare *east* rose window at Laon there is – almost predictably – an amalgamation of New and Old Testaments, with the Virgin surrounded by prophets, apostles, and the twenty-four Elders [32, 33].

The north rose at Laon [28] features the liberal arts, and would appear at first sight to be outside this scheme, but in fact this points to the integration of classical learning into Christian iconography. The seven liberal arts were originally nine at the height of the Roman Empire, medicine and architecture having been dropped by the Middle Ages. At Laon and Chartres, the seven arts taught in the cathedral schools comprised music, arithmetic, geometry, astronomy, dialectic, logic and grammar. In this rose they are joined by medicine, and all are personified as women surrounding Philosophy, the summit of all learning [31]. They are a good example of Emile Mâle's 'hidden meaning'. For Philosophy is the personified Divine Wisdom, Hagia Sophia, to whom in the Byzantine world great churches were built. By

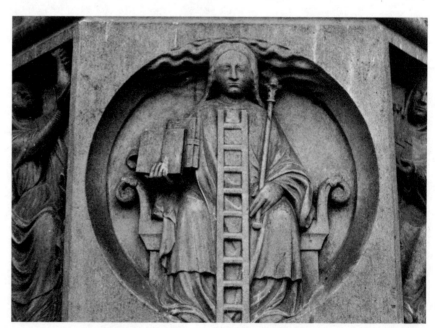

Philosophy in a bas-relief on the west portal of Notre-Dame de Paris. 13th c.

The wheel of learning, with the seven liberal arts, encircling Philosophy, is represented as a circular temple. Socrates and Plato, whom she teaches, are placed beneath her, while the three heads on her crown may represent the knowledge of past, present and future (from Herrad of Landsberg, *Hortus deliciarum*, 12th c.)

Sketches of carvings of the liberal arts from the west porch at Laon: geometry (top), astronomy (centre) and music (bottom) (from Viollet-le-Duc)

the Middle Ages she had been equated with the Virgin Mary, who, to St Bernard, was herself the embodiment of all knowledge and wisdom. Vincent of Beauvais saw in the liberal arts 'a quickening power, and to each of the liberal arts there is a corresponding gift of the Spirit'.[20] They recall the biblical Seven Pillars by which Wisdom 'hath builded her house' (Proverbs 9:1). There is an interesting double meaning here: firstly, an architect in the Middle Ages had to be well versed in the liberal arts before he could be entrusted with building a cathedral: and secondly the Temple of the Spirit is seen in Revelation as being built *within* every man. So too the gifts of the Spirit have a double meaning, outer and inner, the former being charismatic or possibly miraculous (about which St Paul had much to say to the Corinthians) and the latter being gifts of character and moral and spiritual endowments.

Hidden meaning resides in the iconography of a window; there is also meaning in its *form* – its function as a wheel, a rose, a model of the sun, or of the universe, or otherwise. In the east window of Laon [33] meaning is

concealed in form in yet another way. Geometrically the window is made up from twelve pentagons which surround the centre – an echo of the fifth of the Platonic solids, the dodecahedron, the twelve faces of which are pentagons. In the *Timaeus* the four elements earth, fire, air and water, are represented by the solids of the cube, the pyramid, the octahedron, and the icosahedron. They make up matter, which is manifest in time. The fifth element, ether, could be said to be represented by the dodecahedron, 'the whole spiritual heaven', which is eternally manifest.[21] In this Laon rose the iconography confirms this in Christian imagery as the Eternal Mystery, the amalgamation of the Old and the New.

There is a three-dimensional implication in many rose windows, the dodecahedron or sphere of heaven at Laon being a good example. But in some windows this is generated by purely visual means, as in the rose/wheel of Santa Chiara at Assisi [46] and all the rose windows at Chartres. In fact, the north window at Chartres itself [7] tells us explicitly that its image is supposed to be imagined in three dimensions: the four images of the dove descending to the Virgin Mary are so disposed as to give the impression that they come from all directions; one from in front of the plane of the window, one from behind and two from the sides. These are four aspects of *one* dove – as there is only one all-embracing Holy Spirit.

The mandala aspect of any rose window helps us to understand this three-dimensionality and suggests its 'cosmic' significance: the two-dimensional form represents a three-dimensional image which with the imagination takes us to a four-dimensional reality. According to Jung, the healing effect of mandalas, induced by the state of wholeness that they invite, is that they enable us to think and imagine outside time. In Jung's philosophy the process of individuation is achieved by balancing four energies, symbolized in mandala form. In medieval alchemy he found many parallels to the images produced by his patients from the unconscious: in particular, the four elements present themselves as a quaternity which reflects the ordered state of the universe or macrocosm. Within the mind, the elements become qualities of consciousness: thought (air), emotion (water), intuition (fire) and sensation (earth). When all four are held in balance within the psychological viewfinder of meaning, then life is enjoyed in its fullness.

There is one superb rose window exhibiting this quaternary aspect, at Lausanne [38, 39; see pp. 128–31], where knowledge of the world is combined with speculation and myth to present what is without doubt one of the most amazing creations of the medieval mind. As an *imago mundi* – or image of the cosmos – it is a tour-de-force of symbolism contained in a geometric framework that is both real and symbolical. At the centre is the Creation, immediately surrounded by the four seasons and the twelve months of the year, beyond which are the twelve signs of the Zodiac and the four elements [68, 69]. At the edge of this world are the four rivers of Paradise and the creatures that inhabit these remote corners, and outside are the eight winds of heaven. Everything in this cosmos is a part of one totality, of the everyday world cyclically repeating itself through the seasons, yet within an almost transcendent world represented as Paradise. It is a rose that may well have received its physical inspiration from the west rose at Chartres and its philosophical impulse from the School; it is known that a number of canons

from Lausanne visited Paris in the period 1222–24, exactly when both Paris and Chartres were in the midst of designing and building their great windows. Another source of inspiration may well have been the reports of Prester John's kingdom in the East, where a land of milk and honey, ruled over by a Christian king, contained the four rivers of Paradise which gushed forth gold and jewels 'at regular intervals, three times a year'.[22] Emile Mâle, however, sees the rivers of Paradise – represented as turning their urns towards the four points of the compass – as 'symbols of the Evangelists who flooded the world with their teaching, like four beneficent streams'.[23]

The universe; turning to one Every rose window is a symbol and image of the Creation and the created universe. The layers of concentric circles that comprise the great early roses are idealized models of the universe, of the earth at the centre of the spheres. The number varied according to the model that was being considered: Plato's universe had eight, whereas that of Aristotle had as many as fifty-six. In the simpler systems the spheres contained the planets, the moon and the stars, but in the more elaborate models angels, archangels, the elements and even moral qualities had spheres to themselves. In most schemes the outermost sphere was the Prime Mover, beyond which lay the Empyrean of God.

The School of Chartres is known to have possessed a copy of Macrobius' commentary on Cicero's *Dream of Scipio*, which contained the Neoplatonic scheme of the cosmos, based on Pythagoras. It saw Plato's eight spheres of the planets and stars but had an additional three: the world Soul, Mind and the Supreme God. These eleven spheres recall the eleven layers of the Chartres maze, which Keith Critchlow points out as implying that the scheme is a diagram of the 'shells' of reality. He also points to the connection between the maze and the rose window. (This is considered on p. 98.) The combination of 'image of the universe' and 'symbol of the sun' in rose windows is strongly reminiscent of Pythagoras' image of the universe, with its central fire which the last member of his school, Aristarchus, identified with the sun. The Chartres roses seem to possess only three stongly defined layers and a weaker fourth; at Paris there are at least six.

The meaning of different levels in the mandala-shaped rose window may lie in the interpretation of the functioning of the 'invisible universe', or in other words in the angelic hierarchy. The medieval world saw the spiritual world in terms of a ninefold hierarchy inhabiting the spheres between God and the world, passing on by degrees to the souls of the faithful the knowledge and the energy of the Creator. Such an image was used by Dante in *Paradiso*, where the nine spheres of heaven reflect the nine major regions of hell, approached through the seven stages of purgatory. This physically invisible but spiritually visible hierarchy was coupled to the spheres of the planets and the stars in the following way: (1) the Prime Mover, Seraphim; (2) the Fixed Stars, Cherubim; (3) Saturn, Thrones; (4) Jupiter, Dominations; (5) Mars, Virtues; (6) Sun, Powers; (7) Venus, Principalities; (8) Mercury, Archangels; (9) Moon, Lower Angels.

The hierarchy itself does not actually figure in any of the early rose windows – but they are sometimes sculptured into the portals beneath, as at Chartres. It does, however, appear at Saint-Ouen [57], some two hundred

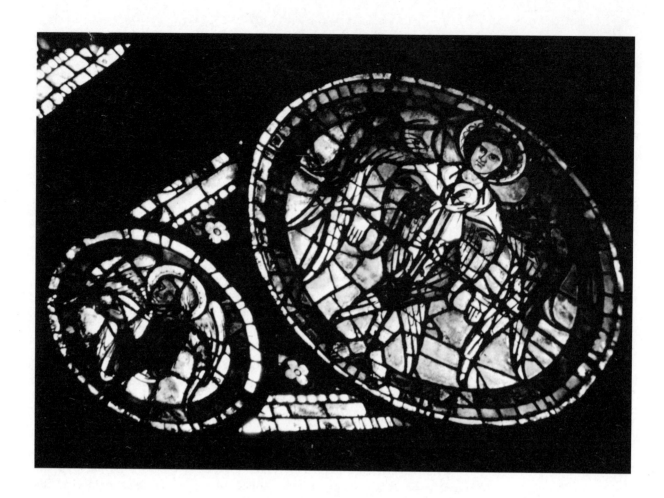

years later; but it may well be that at this late date the essential meaning of the hierarchy had become lost. An equivalent could be said to exist in the 'energy' levels of a mandala structure, which builds up from the centre, the source. This is inherent in the Pythagorean universe with its central fire.

Just as a circle has only one centre, so everything in the universe is subordinated to the one Creator, as the very word 'universe' itself implies ('turned to one'). At Chartres, Christ is at the centre of all of the rose windows as the source of all energy. As the Word of St John, the Logos becomes the sun at the centre of the medieval Pythagorean cosmos. Cardinal Nicholas of Cusa – who was much influenced by the School of Chartres – expresses this idea as follows:

> the universal power of the macrocosm that moves itself and all things is perpetual because it is a round and circular movement, having all movement in itself, just as the pattern of the circle includes all patterns within itself, and man is the microcosm corresponding to this and deriving all knowledge from the central point, which is Christ.[25]

From time to eternity; wheel and rose

The wheel is an almost universal symbol of time, the turning evoking its cyclic nature and the seemingly endless repetition of night and day and year after year. The spokes of the wheel create an image of the sun; and,

86

since the sun's passage through the sky marks out time, the two are related. This image is found in the pre-Christian and Celtic world and in the East, where it symbolizes life and reincarnation. In the Middle Ages the Wheel of Fortune symbolized Fate, and its metamorphosis into a rose seems to occur with the advent of the cathedrals. The wheel also symbolizes deliverance from these cycles, in Christianity through the conquest of fate and in the East through enlightenment.

As a symbol of the Buddha, the wheel represents the passage of the soul through the various forms of existence. Deliverance is symbolized by its transformation into a thousand-petalled lotus. Release and the achievement of Nirvana is sought through training, devotion, certain ascetic practices, through meditation and prayer wheels: OM MANI PADME HUM is the mantra that leads to the lotus, the phrase being repeated to the turning of the wheel. It means: 'God (reverence), the jewel, in the lotus, adoration.'

At Orvieto in Italy the head of Christ is carved on the hub of a 22-spoked wheel on the western façade of the cathedral, a veritable 'jewel in the lotus' [48]. But it also signifies the essential difference between enlightenment in Christianity and in Buddhism; that 'no man comes to the Father but by me'. In the metamorphosis of wheel to rose, deliverance from fate is embodied in the principle of the birth of Christ in the human soul – of which the rose and the rose window are symbols.

Emile Mâle, in *The Gothic Image*, draws our attention to the twelfth-century writer Honorius of Autun, who echoes Boethius in describing fate and fortune thus:

> Philosophers tell us of a woman fastened to a wheel which turns perpetually, so that they say she is sometimes rising and sometimes falling with its movement. What is this wheel? It is the glory of the world which is carried round in perpetual motion. The woman fastened to the wheel is Fortune, whose head alternately rises and falls because those who have been raised by their power and riches are often precipitated into poverty and misery.[26]

The essence of this idea can be seen in what remains of the Wheel of Fortune at Saint-Etienne, Beauvais [25], where people are being dragged round the circumference as though through life, only to descend into oblivion. With the advent of Suger's rose window and the greater examples that were to follow, transformation of the wheel takes place on two very important accounts. The first is that in the rose windows the emphasis is drawn away from the circumference and towards the centre – even though the windows may still maintain a wheel-like structure. Secondly there is the metamorphosis that takes place inside the building, where the wheel becomes a rose of light and colour; nowhere is this better illustrated than at Amiens, where a Wheel of Fortune on the outside of the south façade becomes inside a rose full of fire.

One interpretation of the transition from wheel to rose sees it in terms of Time and Eternity, the rim of the wheel representing time as past, present and future and the centre time as Eternity. Early Christian wheels built on the Chi-Rho monogram impart this message by often being placed between Alpha and Omega, the first and last letters of the Greek alphabet, which

echo Christ as 'the Beginning and the End', outside Time but in Eternity, which is eternally present. Christ is portrayed as the Master of Time by being placed at the centre of the rose and sometimes surrounded by the signs of the Zodiac – as at Saint-Denis, Angers [70] Laon and Paris [9]. Here He is also Master of Fate:

> And he had in his right hand seven stars: and out of his mouth went a sharp two-edged sword; and his countenance was as the sun shineth in his strength.
>
> And when I saw him, I fell at his feet as dead. And he laid his right hand upon me, saying unto me, Fear not, I am the first and the last;
>
> I am he that liveth, and was dead: and behold I am alive for evermore, Amen; and have the keys of hell and of death. (Revelation 1:16–18.)

Christ at the centre of the Zodiac – as in some rose windows – suggests a way of synthesis, a way to unite the higher consciousness with the forces of the unconscious. Astrology at its highest sees the Zodiac as a consistent and thorough framework for embodying knowledge of aspects of a Totality; Jung sees the planets (St John's 'seven stars') as 'symbols of the power of the unconscious'.[27] Christianity has tended to reject astrology, because of the identification of these symbols with polytheism and because of the danger that people will abdicate responsibility for their own fate, taking the easy way out by leaving it to 'the stars'. A more mature view would be to see the signs of the Zodiac as patterns of energy, some of which we know through our own birth chart and others of which we can aspire to know. Hubert Whone echoes Jung and traditional symbolic interpretation when he sees twelve-fold patterns in terms of twelve paths to the centre which correspond for instance to the twelve human types reflected in the signs of the Zodiac: 'Because each being has a unique energy pattern which he acts out to the exclusion of others, his main discipline is to become aware of these others, and to awaken them inside himself so as to become a whole man: this awakening opens the door to his own divinity.'[28]

The word Zodiac originates from the Greek *zodiakos kuklos*, 'wheel of animal figures'. The usual interpretation of the four sacred creatures that often surround Christ (and the early wheel windows) is that of the Word being promulgated by the four Evangelists, who are the typological transformation of the creatures that Ezekiel saw in the fire of the wheel. From another point of view the four creatures are the four fixed signs of the Zodiac – Leo (the lion of St Mark), fire; Taurus (the bull of St Luke), earth; Aquarius (the man of St Matthew), air; Scorpio (the eagle of St John, an alternative symbol for this sign), water – flanking the wheel of fate.

Fate is often portrayed in mythology as a woman spinning, the mother goddess who, in Erich Neumann's words, 'not only spins human life but also the fate of the world, its darkness as well as its light'.[29] She also appears on the tenth card of the Tarot pack, sitting on top of the Wheel of Fortune. After the Middle Ages the Virgin Mary is sometimes portrayed at the Annunciation as spinning; when the Archangel Gabriel departed, it is reported that she continued and finished the work, and it was perfect.

The association with St Catherine gives an interesting insight into the problem of deliverance from the wheel – either as a karmic wheel of

A Wheel of Fortune drawn by Villard de Honnecourt, c. 1225–50, with figures in his typical geometric-based forms. The writing translates: 'Here below are the figures of the Wheel of Fortune, all seven are correctly pictured.' He does not say where this is to be found, but it is interesting to note that it is in rosette form and may be a generalized model

ſeſ la ·ij· teſteſ de ſueltes·

ɣeſſa deſoſ leſ figureſ de le rvee 8
fortune · toteſ leſ ·vij· ı mageneſ

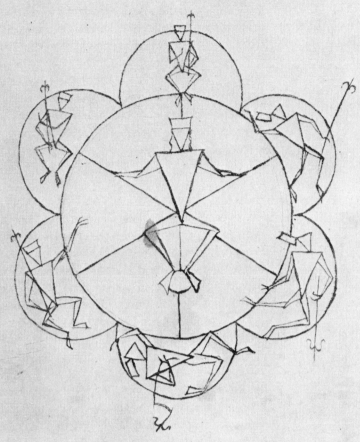

On prent kauſ ɀ tɣeile muliue de paienſ ɀ fereſkume · autre tant
del une cū del autre · ɀ un poı pluſ del tɣeule de paienſ taunt come
ſeſ color uainke leſ autreſ · deſtemprez ce ament doile de linuiſe
ſen pez faire un uaſſel pur euɡe tenir·

On prent uiue kauſ boleure ɀ orpiement ſe lemer on en euɡe bol
lanſ ɀ oile. Ciſt unnemenſ eſt bon poꝛ pail oſtier·

reincarnation or the wheel of fate in this life. Christianity has always denied reincarnation and maintained that each person has only one life in which he has the chance of fully realizing his talents and bringing about the kingdom of God; to lay the problems of life at the door of a 'bad karma' and do nothing about it is an easy way out. St Catherine is generally associated with the wheel because it was on the wheel that she was tortured. But she has also become the patron saint of weavers and spinners; and Fates are often portrayed as weavers and spinners, as they spin out the destiny of individuals and the world. Weaving is also creation; and the warp and woof that creates the material symbolizes the infinite variety of God's manifest world, and its continuous renewal. The wheel in this spinning aspect reflects the Logos as the creative principle constantly active in the world and the universe. As a 'loom of creation', the rose window shows each person the path to his or her own Soul: deliverance from fate through the realization of Christ working in and through everyone, from the centre of the rose towards the New Jerusalem, 'where all things are made new'. Then fate without God becomes transfigured: fate with God.

A key to nature

The world of nature is one of constant renewal: as Goethe observed of plant life, everything is undergoing metamorphosis. Everything in the cosmos evolves in accordance with the Logos – the Divine Reason – which creates every moment, day after day and year after year from the Creation until the end of time. All life and all nature follows this ever forward-moving Reason; everything, that is, except man, who works against nature rather than with it, polluting and consuming his way to oblivion.

The Gothic cathedrals are themselves 'Mirrors of Nature', as Vincent of Beauvais recorded in the early thirteenth century, and they are also 'Mirrors of Instruction'; tree-like pillars thrust upwards and branch outwards into vaults reflecting the uprising and uplifting power of the creative energy of nature. Everywhere vines, leaves, buds, flowers and thistles burst out, adorning doorways, pillars, windows and choir stalls. And in the rose windows, suspended between earth and heaven, we find the ultimate expression of nature's purpose: love and sacrifice, beauty and metamorphosis.

When the rose dies it leaves seeds for renewal, contained in the chalice-like rosehip. At the centre of the south rose window at Chartres, Christ holds the chalice of the Last Supper [10]; the seeds of His Presence are dispersed across the entire rose of the cosmos – to all mankind and all nature. In the east rose window at Laon, the Virgin Mary holds out a rose to all mankind as it faces the rising light [32]; just as the Buddha was to hold up a flower as the sum total of one of his sermons.

In the Tree of Jesse, a favourite medieval portrayal of Christ as the Tree of Life, Jesse can be seen at the base of the stem and the Virgin Mary as the shoot above the royal ancestors disposed along the stem. At the top is Christ as the flower, surrounded (in a lancet window at Chartres) by seven doves symbolizing the seven gifts of the Holy Spirit. These Jesse windows nearly always take the form of long lancets – as at Chartres, Saint-Denis, Le Mans or Carcassonne – but there are at least two examples where the idea has been transformed into a rose window.

At Paris the west rose [9] can be seen as a kind of Jesse window, where the branches of the tree interweave among the medallions leading to the Virgin Mary at the centre. The lineage of Christ has been replaced by the signs of the Zodiac, the labours of the months and the vices and virtues. This iconography is unlikely to be entirely authentic, as the window has undergone many restorations, but it can nevertheless be interpreted as a replacement of the lineage of Christ by the Way to Him through a path of toil, an understanding of time, of the seasons, of astronomy and astrology coupled with a virtuous life. The much later south rose window at Saint-Ouen, Rouen, is a more orthodox Jesse Tree, with Christ at the centre of kings and patriarchs amid the branches of the vine [58]. In this window the tree grows towards the centre, but the lines of the stone tracery and the shapes of the petals create exactly the opposite effect by giving the impression that everything is thrown out from the centre in great pulses of energy: a magnificent evocation of the creative force of nature.

Every one of the Gothic buildings and rose windows that bloomed out of the twelfth-century 'renaissance' individually reflects the forms of nature; what is astounding is that (as both Mâle and John Ruskin point out) the whole epoch of church-building, from Saint-Denis to the sixteenth century, is itself a season of nature. Buds and shoots decorate the early buildings, flowers and leaves adorn the middle era of high summer, and vines, fruit and thistles mark the autumn of the late Gothic; then, in Ruskin's words, 'The Renaissance frosts came, and all perished.'[30] Rose windows followed this cycle, budding in the twelfth century, flourishing in the thirteenth, and consumed in the flames of the fourteenth and fifteenth.

Numbers and geometry of creation

Every rose window is a direct expression of number and geometry – of light in perfect form. At Chartres all of them are divided into twelve segments, the number of perfection, of the universe, and of the Logos. The scholars at Chartres were clearly fascinated by number and its derivative geometry, not as ends in themselves but as keys to understanding nature. They studied Pythagoras to whom geometry was divine and numbers eternal – since all else perished. The fascination of numbers had already entered Christianity with St Augustine, who saw the divine wisdom of the world reflected in the numbers which were impressed in all things. Numbers and geometry represented order; the word *kosmos* means in Greek literally 'order'; so study of the cosmos involved a study of number.

Churches had been built on geometric principles since early Christian times; numbers were more of a medieval preoccupation. Geometry and arithmetic were traditional studies, but with the discovery of Euclid's *Elements* by Adelard of Bath (who was connected to the Chartres school) the subject inspired a new enthusiasm. Moreover, numbers had by the Middle Ages acquired a metaphysical significance of their own, and according to Mâle were thought to be endowed with occult power. They consequently found their way into nearly every aspect of cathedral building, from the numbers of pillars in the choir to the ratio of the levels in the triforium and layout of the façade and, inevitably, to the division of the rose windows.

The numbers one to eight were the most important, together with the all-important number twelve, and each had a geometrical equivalent. *One* represented the unity of all things, symbolized by the circle and its centre; *two*, duality and the paradox of opposites, expressed as pairs across the centre; *three*, the triangle, stability transcending duality; *four*, the square, matter, the elements, winds, seasons and directions; *five*, the pentacle, man, magic, and Christ crucified with five wounds; *six*, the number of equilibrium and balance within the soul, symbolized in the Star of David or Solomon's Seal; *seven*, the mystic number, of the seven ages, planets, virtues, gifts of the Spirit and liberal arts; *eight*, the number of baptism and rebirth, implied in the octagon; *twelve*, that of perfection, the universe, time, the apostles, the Zodiac, the tribes of Israel, and the precious stones in the foundations of the New Jerusalem.

Twelve and twenty-four are the most common numbers in rose windows, particularly in south transepts. Five- and eight-fold roses (and their multiples) are generally to be found on the north side, but it is difficult to make a rule about this. Thus, at Paris, there are sixteen huge petals in the *north* face [11], twelve in the *south* [12]; the same is true at Rouen; but at Clermont-Ferrand [2] and Tours [64] there are sixteen-petalled roses in both transepts. Much more convincing is the placing of five-fold windows in the north facing six (or twelve) in the south – as at Amiens, Sens and Saint-Ouen, Rouen [57, 82].

Rose windows use geometry in three different ways: *manifest*, *hidden* and *symbolic*. All three can be interconnected, linking the symbolic with the real in describing the creative order of the Logos. Otto von Simson points out that it is in design rather than in measure that geometry is generally used in the Gothic cathedrals, reflecting the truth that in the world of numbers everything is relative. In this sense the rose window becomes symbolic of the infinite, dimensionless and all-embracing operation of the Love of the Creator – active from the atom to the galaxy; somewhat akin to the Islamic representation of God in geometric form, which through endless weaving patterns expresses His creative aspect which is infinite.

In the rose window it is primarily this visual *manifest* geometry that makes the most immediate impact upon the eye; the web of complexity and precision within which every space is defined by a yet smaller geometric figure – a trefoil, quatrefoil, rosette, or spherical triangle. And within these elaborate looms of tracery at Chartres, Paris, Laon and Tours can be seen an even finer pattern woven into the glasswork – the red and blue mosaic diaper symbolizing the activity of the Creative Word right down into every fibre and corner of the cosmic rose.

Behind this visible frame is the equally precise *hidden* geometry. In the greatest rose windows it defines the exact position of nearly every major feature, relating the radial elements to the concentric divisions and all to the centre. The eye probably unconsciously picks up these relationships just as it does with the inner geometry of Renaissance painting. In another sense, hidden geometry would seem to be at work in many aspects of cathedral building, for the sketchbooks of Villard de Honnecourt show many geometric forms drawn within people, animals and buildings alike, and his interest in triangles as the basic component echoes Plato's *Timaeus*. These

'Here is the window of the Church of our Lady of Chartres', says Villard. Note the difference beteeen this drawing, c. 1125–50, and the actual window [29]

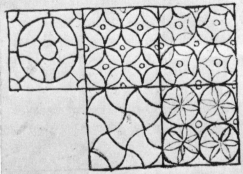

chi prenuef matre don piler
metre a droite loisons

Jeftoie une fois enhongrie la vi ie mes manti
Jor la vi io le pauement vune glize vefi faite
oganiere·

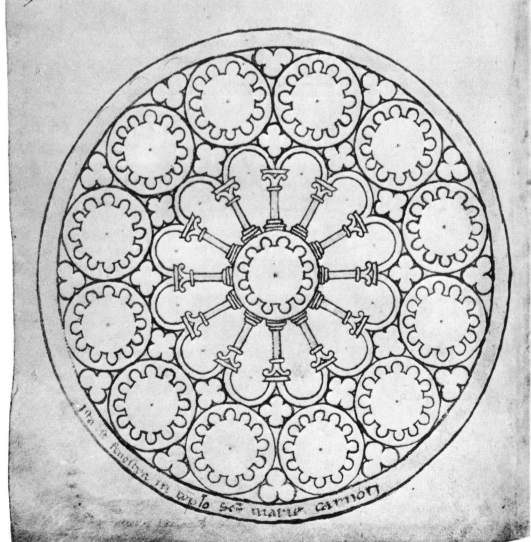

books include two sketches of rose windows, one of Chartres and the other of Lausanne; both for some unknown reason are inaccurate.

In many of the world's religions, *symbolic* geometry is used as a kind of shorthand: circles, squares, triangles and stars, for example, are used to embody a meaning much more profound than they have in, say, a traffic sign or an advertising logo. Squares and circles, particularly, seem to have almost universal significance in symbolizing the finite and the infinite, earth and heaven, or matter and spirit. In Sufi thought, the centre, radius and circumference of a circle symbolize respectively Truth, the Path to Truth and the Law. In Christianity the equivalent is Christ as the Way, the Truth, and the Life, which in terms of the rose window are the path to the centre, the centre and the circumference as the wheel of life. The centre is then the point of balance, the still point, the 'point of intersection of the timeless with time', to use T. S. Eliot's words.[31]

In many rose windows, the finite and infinite are united through the placing of the circular part within a square, as at Paris, Clermont-Ferrand, Sées and many others. When the number twelve is defined within the rose, the union of heaven and earth is symbolically complete. At Lausanne the combination is exploited to the full.

Since early Christian times the circle has signified eternity, God, worship, perfection, the year and heaven. And it is for this reason, according to Vitruvius, that some ancient temples are round, representing the form or figure of heaven. As a symbol of the Temple of Spirit within man, the rose window symbolizes the unity of all things, when opposites are reconciled through the centre. A small rose window in the choir at Auxerre cathedral has the vices and virtues disposed in opposition to each other (like the antithetical signs of the Zodiac). St Thomas Aquinas at the end of the thirteenth century followed Aristotle in a concept of a 'Golden Mean' – not as mediocrity but as a genuine third possibility, free of duality.

Faith and Reason were the irreconcilable opposites of the age, at least until Aquinas. But before he posed a solution the cathedral builders were putting forward their version in the form of a symbol, the rose: a lifeline in the confused waters of the age. Many years later St John of the Cross gave voice to the problems of opposites and of paradox, which Eliot echoed:

In order to arrive at what you do not know
 You must go by a way which is the way of ignorance.
In order to possess what you do not possess
 You must go by the way of dispossession.
In order to arrive at what you are not
 You must go through the way in which you are not.
And what you do not know is the only thing you know
And what you own is what you do not own
 And where you are is where you are not.[32]

Avarice, one of the Vices in a bas-relief at Sens, framed within a rosette and set in a square (from Viollet-le-Duc)

Illumination: knowledge

SOUL: 'Shall I see my dearest Master, when I reach his throne?
ANGEL: Yes, for one brief moment thou shalt see thy Lord. One moment; but thou knowest not, my child, what thou dost ask: that sight of the Most Fair will gladden thee, but it will pierce thee too.'

(Cardinal Newman, *The Dream of Gerontius*.)

The star

Every rose window contains a star, either placed literally in the rose – as at Saint-Ouen [57] and Sens [71, 82] – or implied through the radiating pattern. In the language of symbolism stars have many meanings, but they primarily relate 'to the struggle of spirit against the forces of darkness'.[33] Thus, the five-pointed pentacle is a symbol of magic, the Pythagorean symbol of healing, of the Crucifixion, and at a later date of Man, drawn within the pentacle by Leonardo da Vinci. The six-pointed Solomon's Seal or Star of David is the star of the macrocosm, of heaven and earth united through man, the two interlocking triangular symbols of fire and water forming the perfect union of the conscious with the unconscious.

Every star is a minute point of light in an ocean of darkness, and yet a blinding sun in its own right. In Christianity the Star of David announces the birth of the Divine; it is the speck of 'true Light, which lighteth every man that cometh into the world' (John 1:9). In his gospel St John follows the opening with the account of the baptism of Jesus in the Jordan; symbolically, the lowest point on the surface of the earth – the deepest, as it were, in matter. So, too, the Divine was born at the darkest time of the year – the winter solstice – and it is in St John of the Cross's 'dark night of the soul' that enlightenment occurs.

As stars to steer by, rose windows look down on to the nave – the ship or transfigured ark – and guide it through the waters of time, just as the star guided the wise men. They point the way for each individual to his own soul and guide that soul through the maze of life – which at Chartres lies literally and symbolically beneath the feet. As a symbol and image of the sun, the source of all light, the rose window acts as a screen between man and the real sun which would otherwise blind the eyes after a few seconds. Christ stands before His Father as a screen between the bare soul and the infinite – between sanity and madness. Gerontius in Cardinal Newman's poem is allowed but one brief glance at God, but even that is almost too much. As Eliot put it, 'Humankind cannot bear very much reality.'[34]

Jewelled light

'The light of the body is the eye; if therefore thine eye be single, thy whole body shall be full of light.' (Matthew 6:22.)

The whole of creation is made manifest through light. As an orb of light suspended in darkness, the rose window is a perfect representation of the Creation expressed as 'Let there be light'. It is the universe itself as an explosion created by light and geometry expanding from a single point at the centre (reminiscent of the modern Big Bang theory of creation). In the rose window the Creation would seem to be an explosion re-enacted in every moment; and as mandala takes one out of time, so the eye of the mind becomes 'single', concentrated to a point, and 'Let there be light'

becomes an eternal event (in, as it were, a fusion of the Big Bang into the Steady State).

Light to the medieval mind was symbolic of the divine light to which the whole of nature responded. Light was seen to be the principle of order and value. Otto von Simson in *The Gothic Cathedral* paraphrases the thirteenth-century writer Robert Grosseteste:

> Light is actually the mediator between bodiless and bodily substances, a spiritual body, an embodied spirit, as he calls it. Light moreover is the creative principle in all things, most active in the heavenly spheres whence comes all organic growth here on earth and weakest in the earthly substances.[35]

It is in Dante's *Paradiso* that Simson finds the greatest poetical exposition of the medieval metaphysics of light. Some two hundred years before Dante, however, Suger had seen the importance of light in the architecture of the new age, and had filled his new church with glass. Rose windows are a perfect embodiment of Grosseteste's ideas of the light-filled heavenly spheres, and just as the rays of the sun are focused by a glass lens to produce fire, the rose window focuses the light of the soul to a point as though to announce the Fire of the Spirit.

In the Middle Ages, jewels and precious stones were thought to possess occult power — especially that of healing. Traditionally they symbolize superior knowledge; and the twelve stones on the High Priest's breastplate (Exodus 28:17–21) echo this, representing not only the twelve tribes of Israel but also twelve aspects of one truth. These twelve channels can be equated to the signs of the Zodiac, to the twelve Apostles, and ultimately to the twelve stones in the foundations of the New Jerusalem, symbolic of the new City of God built upon the Truth disseminated in twelve different ways.

A whole cathedral filled with the light of jewel-like stained glass could not but evoke the New Jerusalem; as a mandala the rose window would seem to take this further, pointing to man himself as the ultimate Temple of the Spirit. In this direction — as Jung pointed out — lies the secret of healing through faith. The purpose of individuation is to become whole; here again, rose windows are a guide, for each one gives the impression of being filled with thousands of jewels, but is at the same time one perfect jewel; a unique example of multiplicity within unity, evoking the All in the One – a 'pearl of great price'. Being whole in medieval terms would enable a person to receive light — which is why contemporary pictures of saints always include the halo. The rose window's similarity to a halo has already been mentioned, but the word *halo* and *whole* are etymologically related; and so too are *holy*, *hail* and *heal*. They all lead to 'becoming at one with that which is Holy'.

Union: love
The enlightening rose

As the symbol of enlightenment the rose and its Eastern equivalent the lotus are almost universal, and in flowers and cosmic wheels René Guénon finds the imagery widespread, from Japan, India and China to Europe well before Christian times. In Egypt Horus is born in the Lotus of Isis, and further east Brahma is said to reside at the centre of a thousand-petalled lotus, the goal

of the patient and thorough adept. And, on Mount Olympus, Eros spilt nectar and, it is said, where it touched the ground roses would grow.

In Christian mystical terms, Angelus Silesius in the seventeenth century sees the rose as the symbol of the soul of Christ, while according to Eithne Wilkins the alchemists of the sixteenth century 'have solid tradition behind them when they call the rose the *flos sapientum*, the flower of those who have the wisdom'.[36] In other words they equate, says Miss Wilkins, the rose with the soul perfected through toil – the weaving aspect of the wheel we saw earlier. A medieval adept, Arnold of Villanova, entitled his treatise on the alchemical Great Work *Rosarium philosophorum*, 'Rose Garden of the Philosophers'.

As a symbol of love and beauty the rose goes back at least to the Isis, Aphrodite and Venus of the Egyptian and classical worlds. In the Middle Ages, St Bernard and the Cistercians bring the rose to the fore at the same time as they elevate the Virgin Mary to almost divine status. The rose becomes symbolic of both human love and Divine Love – of passionate love, but also of love beyond passion. All the subtleties are exploited in the poetry of the age, particularly in the Grail legends. For the mystic, love is the search for union with God. The path of knowledge and wisdom led to Philosophy, portrayed as a woman in the Laon rose, but in the path of faith union is inherent in the rose alone, symbol of a simple acceptance of God's Love for the world. These two paths become fused in the rose of the Virgin Mary – the Queen of Heaven – whom St Bernard saw as the embodiment of Wisdom, Philosophy and Love. This is contemporary with that extraordinary phenomenon of medieval life, the Courts of Love, which elevated womanhood to similar heights with an elaborate set of rules concerning chivalry and the conduct of amorous affairs. Under the Courts' first patron, Eleanor of Aquitaine, romantic poetry of love and adventure finds one of its greatest eras of expression.

The *Romance of the Rose*, written around 1250, is contemporary with the death of the Courts' last patron, Blanche of Castille, and, in the words of Henry Adams, 'the death of all good things'. It echoes the feelings of the time as those of a sadness at the end of an age; an age which saw the rose as 'any feminine ideal of beauty, intelligence, purity or grace – always culminating in the Virgin – but the scene is the court of love, and the action is avowedly in a dream without time or place'.[37] In the *Romance*, the rose is described as being situated in the mysterious tabernacle of the garden of love of the *chevalrie*, or knighthood, to which all men should aspire. Some seventy years later the rose appears in Dante's *Paradiso* – a form of garden of love – where Beatrice presents it to Dante on arriving in Paradise – which is itself constructed as a rose. It symbolizes here perfection and consummate achievement, and ultimately the great mystery of the Trinity and the union of God with man.

Even after 1270 – Henry Adams' date for the end of truly inspired cathedral building – the rose remained as powerful a symbol as ever, and many rose windows were built. But the main stream of mystical inspiration went into writing. Dante's work was the supreme example, but there was also that of Meister Eckhart, Petrarch, and St John of the Cross. The rose, however, follows the cultus of Our Lady, and in the fifteenth and sixteenth centuries she was often portrayed amid roses or in rose gardens. But by this

time she has become more human, less of a goddess, someone to whom anybody could pray. It is from this time that the rosary originates, so called because contemporary works of art often feature the Virgin Mary surrounded by garlands of roses, or portrayed in a rose-garden (rosarium), from which the word rosary is directly derived. Eithne Wilkins sees the rosary as a kind of moving prayer wheel, bringing about detachment of mind, releasing the spirit through the repetition of prayers, each bead representing a recitation. The prayer itself is dedicated to the Lady of the Rose Garden. The rosary combines 'verbal, mental and bodily prayer to open up the inner world'; its function is

> both physical and spiritual, sensual and mystical. It may glitter, flash and tinkle; it is in some legends 'fragrant' and sometimes literally so; it moves, it is to be continually touched and handled, and it involves the use of exact number, which pertains to wisdom, power and the very nature of being.[38]

Detachment of the mind, moments 'out of time', and paths to the soul have been alluded to earlier in this book. Rose windows and the rosary share this function. It is unlikely that the windows were *deliberately* used in this manner; but when Abbé Suger talks of transcendence through the senses, brought about by light and colour, his words suggest that the effect was known and recognized. The sheer size and strength of form of the greatest of them cannot fail to hold the attention and provoke a moment's reflection in wonder. To the people who first saw them the impact must have been astounding; even in 'sophisticated' people of the twentieth century, with a lifetime's experience of electric light, cinema, television, neon and extensive travel, rose windows still promote a sense of awe, disturbing our image of the world. Such a disturbance, or even a moment of detachment, can be seen as the beginning of a journey of the soul, a journey that is both exciting and perilous. In this sense the petals of the rose symbolize an unfolding mandala or labyrinth along whose path the journey is made.

At Chartres the great west rose window [27] portrays Last Judgment, with the dividing of souls between heaven and hell, a constant reminder to mankind of the perpetual battle between good and evil which is to reach its climax in the Last Days as related by St John in Revelation. This rose window contains an implication which has been generally overlooked. Below the rose is the labyrinth, set into the nave at such a distance from the west door that if the rose were to be 'hinged down' it would almost fit over it.[39] Labyrinths generally symbolize the path of the soul through life, and medieval pilgrims re-enacted this, following the path of the labyrinth in the cathedral on their knees, symbolizing the journey to Jerusalem. The rose window superimposed on this labyrinth suggests the mandala, the viewfinder of meaning, projected on to life, as a means not only of finding one's way but also of differentiating between the forces of good and evil. In the *Divine Comedy* we can see identical symbolism in Dante's journey through the spheres of Hell, Purgatory and Paradise on a journey that, he himself says, could be interpreted in four different ways, one of which was that of the Christian through life. On arrival at the last circle of Paradise, Beatrice offers Dante a rose; so too at Chartres the labyrinth weaves its way

(there is only one path) through concentric circles and at the centre there is a six-petalled rosette into which the path leads: it unmistakably echoes the rosette at the centre of the rose window that overlooks it. At the centre of the rosette there was formerly (according to Keith Critchlow and Malcolm Miller) a metal plate with an image of a centaur or Minotaur – a clear allusion to the Cretan labyrinth, the walls of which were lined with roses.

Having found the way to the centre of the maze – to enlightenment and to the Minotaur – the searcher has to return to reality. In Christian terms it is the Holy Spirit that acts as Ariadne's thread in the labyrinth of life: union with Christ as the bridegroom through the 'mystical marriage' imparts Grace to withstand the dark forest, the leopard, lion and wolf of Dante, evil and mental disintegration, the Minotaurs of the ancient, medieval and modern worlds. H. Daniel-Rops sees the association of the rose window with Last Judgment and Dante in a similar light:

> Like every cathedral, the *Divine Comedy* is built on the human scale. The Last Judgment over the cathedral door warns the soul of its peril, as does the *Inferno*, and then leads it with an escort of saints to the great rose window where the angelic choirs are arrayed about the majesty of God. The poet is himself directed by our Lord Himself to 'rescue those who live on earth in a state of misery and lead them to the state of bliss'.[40]

The rose and the grail

The essence of Christianity is a hidden truth, the 'pearl of great price' that cannot be imparted in words but must be approached by allusion, parable or symbol, or realized in action. Similarly, the essence of the Gothic cathedrals, the reason why they hold such fascination for so many people, the source of the knowledge that built them, are virtually unanswerable questions. Some clues may lie in the background against which the cathedrals were built, particularly at the beginning of Henry Adams' magic hundred years, 1170–1270. For this coincides, in time and place, with the appearance of the various versions of the Holy Grail legend.

Somewhere around 1180, Chrétien de Troyes' *Compte del Graal* was written; this is the first comprehensive account of a legend which finds its origins in the Celtic world and its Arthurian legend or 'Matter of Britain'. By 1270 a number of different versions had appeared in France and Germany, the last of which, Albrecht's poem *Younger Titurel*, features the Temple of the Grail. The parallel between the legend and cathedral building is alluded to in this poem; A. von Scharfenburg suggests that 'Albrecht had in mind the dematerializing and spiritualizing effect of the Gothic and was able to communicate these qualities to his readers, by means of poetry and mysticism'.[41]

In the differing versions of the Grail legend, scholars have seen much symbolism as well as much romanticized fact. But the essence remains hidden, the Grail itself being variously described as the Chalice of the Last Supper, a stone, a bowl, the Philosopher's Stone of the alchemists and even in one theory a glass lens. Most of these suggestions are mentioned in Emma Jung's excellent study; she summarizes the many properties of the Grail as including dispensing food, preserving youth, radiating a sweet fragrance, and discriminating between good and evil.[42] In Chrétien de Troyes' original version the Holy Grail is introduced as 'a grail', suggesting a type of vessel rather than one particular vessel. He describes it as 'being of pure gold, set with precious stones and with such a brilliant light streaming from it that nearby candles lost their brightness'.[43]

Emma Jung sees the chalice at the symbolical level of the medieval mysteries as the vessel of receptivity that 'signifies the whole psychic man (not his ego) as a realization of divinity, reaching right down into matter'.[44] Elsewhere she recounts the poem entitled 'The Heart of Jesus', written by Hermann Joseph who was born in about 1150. Here the Divine Heart of Jesus is seen, in more mystical language, as 'the temple in which dwells the life of the world, as a rose, a cup, a treasure, a spring, as a furnace of Divine Love, ever glowing in the fire of the Holy Ghost, as a censer and as a bridal chamber'.[45]

Wolfram von Eschenbach's account of the Grail, in *Parzival*, begun in about 1197, is probably the most mysterious of all. The Grail itself is seen here to be a stone rather than a vessel, a supreme jewel surpassing in its powers the virtues of all other gems, and guarded by the Knights Templar, whom some people (such as Charpentier in the *Mysteries of Chartres*) see as being responsible for initiating and continuing the building of the Gothic cathedrals. This Grail was supposed to have a number of strange properties. Apart from suspending old age and physical decay, it produced food and drink in any quantity, and most important of all: 'commands are issued by messages which appear round its edge and vanish as soon as they are read'.[46] This brings to mind the Urim and the Thummim, the two gems on the High Priest's vestment by which the will of the Lord was made known; and also Christ's teaching to his disciples when their faith was on trial: 'take ye no thought how or what thing ye shall answer or what ye shall say. For the Holy Ghost shall teach you in the same hour what ye ought to say' (Luke 12:11).

At the centre of all the versions lies the idea that the search for the Grail is a quest, in which the individual sets out to liberate mankind from a spell. In most versions the Grail is associated with the Round Table, King Arthur

and his twelve or twenty-four worthy knights. Their quest is to restore the kingdom of the Fisher King, who in some versions is just suffering from old age, but more generally has been wounded and needs healing. The Grail itself appears at Grail Castle; whether as a chalice or a stone, it manifests its powers through light to all who gaze upon it – particularly at Easter. Thus it revitalizes the King from time to time; but all mankind awaits the knight who will finally redeem the kingdom and heal the King by asking the right questions of the Grail. The King can be symbolically related to the true self that resides in everyone; the liberating knight (Sir Perceval or Galahad) is the individual consciousness (ego), groping through the world trying to find meaning, making mistakes, and generally failing to learn from them.

In Robert de Boron's version, *Le Quest du St Graal* of about 1220, the Round Table was

> set up on the advice of Merlin; nor was it established without great symbolic significance. For what is meant by being called to the Round Table is the roundness of the world and the condition of the elements in the firmament; and the conditions of the firmament are seen in the stars and in countless other things; so that one could say that in the Round Table the whole universe is symbolized.[47]

Emma Jung – whose words these are – adds that it reminds us of Charlemagne's table of twelve peers – possibly derived from Solomon's table, upon which was defined the cosmos in three circles of the earth, the planets and the stars. These particular aspects of the Round Table are strikingly similar not only in appearance but in symbolical meaning to rose

The Round Table at Winchester with the names of the 24 knights (as named by Malory) and the Tudor rose at the centre. Originally made in the fourteenth century, it was repainted in the sixteenth

windows with twelve radial divisions and concentric layers; mankind and the elements are shown superimposed on to the same model of the universe – all the individual microcosms reflecting the macrocosm. Edward Matchett sees this archetype in all its fullness:

> Around the table are the knights of chivalry, the disciples, the planets, the signs of the Zodiac, or the entire family of nature and man. It is not idle fancy that forms these and many other different representations, but rather the whole cosmos making initial contact with us through a symbol that is its most potent intermediary.'[48]

Merlin's role in the Grail legend is vital. Not only did he set up the Table but he also symbolizes mankind's return to the knowledge contained in nature, without which service to the Round Table – the whole of mankind – is not complete. The key to understanding lies in allowing nature itself to be the teacher, and to do this man has to learn to be receptive in a way that he has probably not experienced before.

The Round Table on the wall of the Great Hall at Winchester Castle is strikingly reminiscent of an archetypal rose window, and symbolically the two can be seen to be sacred and secular counterparts. Painted in Tudor times, it has 25 divisions, with Arthur at the top. The Tudor rose at the centre is a strange coincidence, for the rose and the Round Table would seem to be a fusion of the sacred and the secular in the service of mankind, the deeds of chivalry ideally – but alas not always – serving a higher ethical goal, even if that service involves personal suffering, since the rose is the symbol of suffering as well as of love.

The kingdom of the spirit

In one version of the Grail legend the temple that houses the Grail is a

> chapel of glass (like the Sainte-Chapelle), but a type of glass that can stretch to any extent. If three enter, the chapel is full and all have room; if ten enter it is full and all have room, and so on to infinity. When people leave, it contracts to the lowest limit of three.[49]

Another version sees the Temple of the Grail as being situated in Paradise, a sanctuary at the centre of the world, an image of the cosmos. This idea of a mandala-shaped 'spiritual beyond' in the shape of a castle may well have originated in the East, particularly from the Parsee sanctuary of the Holy Fire at Siz (Gazat), which was 'the pattern of the royal tomb as well as a sanctuary at the centre of the world and an image of the whole universe'.[50] Another similar type of image was seen in connection with the Lausanne rose window: that of Prester John's kingdom, a land of milk and honey with the secret of eternal youth and four jewel-bearing rivers. Here the Land of the Grail (it was Wolfram von Eschenbach who connected the two) has become the land of milk and honey; it strongly suggests mandala form, with its quaternity of rivers. More akin to a literal idea of a Gothic temple is the chapel of glass, capable of stretching and contracting to any extent, but always returning to a lowest limit of three. The tabernacle of God was, according to the Revelation of St John, to be with man, in the first instance within his own soul, and ultimately in the Christian Utopia of New

Vernon, near Paris

Jerusalem, with its fundamental component of the Trinity, but with the whole of humanity as its potential inhabitants. St John describes it as being 'like unto clear glass', with the foundations of the walls being garnished with all manner of precious stones.

The similarities between all these conceptions of the Temple of the Grail, and their appearance in France before 1200, may well have had much influence upon cathedral building, and particularly upon the design of rose windows, built on a mandala-like quaternary structure, jewel-like, representing Paradise. Emma Jung, interpreting the various versions of the Grail legend in the light of the individuation process, connects the appearance of mandala symbolism in many aspects of the legend to the process of the realization, within the individual, of his own soul. She points strongly to the creation of a 'temple within' symbolized in the Grail, for 'when the soul is dead, then "God is dead" too, since it is only in the vessel of the soul that God's activity becomes perceptible to man. Because he did not ask about the Grail, Perceval no longer understands himself and is cut off from the source of his own inner being.'[51]

Elsewhere she interprets the meaning of the Grail in no uncertain terms: 'A vessel is also a material thing, but it serves the purpose of containing other physical substances. This specific function of the symbol therefore indicates that the image of the Self, Christ, is practically non-existent unless it is realized in the human soul.'[52]

Henry Adams sees parallels between the Grail legend and the cultus of the Virgin Mary in the twelfth century: 'Whilst the "Lancelot" gave the twelfth-century idea of courteous love, the "Percival" gave the idea of religious mystery. Mary was concerned with them both.'[53] Deep wisdom has always been seen as a feminine attribute, appearing in men when they come to appreciate the feminine within themselves – and vice versa. The individuation process, by which a person seeks and succeeds in bringing an inner balance to the psyche, extends this to the successful reconciliation of opposing forces to produce harmony within the mind and consequently in the world around us.

Modern psychology is often seen as a substitute for religion – or, worse, as an explanation of it. But in Christianity there is a depth of wisdom that far exceeds that of psychology and psychoanalysis, and breaking through to the depths of wisdom – the well of one's own being – is the essence of all great art and the secret of all religion.

Rose windows are guides – externally in regard to their position in the churches and cathedrals, and internally in their ability to restore inner and outer harmony. It is thus possible to see the Trinity of the Christian faith in an awe-inspiring light. For between the 'passive' role of God the Father and the 'active' role of God the Son lies the Holy Spirit. It is neither active nor passive but is rather the catalyst or guide through the labyrinth of the unknown: it makes itself known to any sincere searcher for truth, guiding individuals in the language that they know, whether it be poetry, music, architecture or whatever – so long as that work is sincere. It is the key to nature that lies at the balance point between the extremities of activity and passivity at the centre of the rose. It is the Way that leads to union and to the New Jerusalem of all humanity: the way of Love, 'the love that moves the sun and the other stars'.[54]

Abbaye de Beaulieu, Caussade, near Lavaur

But to receive the sun, one must have dwelt for a long while in its thrice-blessed courts. One must have gone to meet it for a while, must have long been its student. As to bad monuments, the sun has nothing to say to bad artists whom the open air of the workyards has not prepared with understanding.

Is it possible that everyone is oblivious to, or mistakes, the sun's gifts? Does it not present the universe with majesty, making everything perceptible and living? Does it not inspire the poet, whether famous or obscure? The sun is responsible for the prosperity of the farmers, the joy of animals, the fertility of the land; and man's thoughts perhaps have their hearth in its light and warmth. For a long time man believed he saw God's truth blazing in its fires, and God wishes us to adore the sun. When it shines, the earth is modelled according to its divine flame.

Thus it is allowed, and, by patience and diligence, it is possible, to understand and feel the geometry of light. In this the spirit tastes repose in silence, drawing from it a new energy and generosity.

Auguste Rodin on Mantes, in *The Cathedrals of France*.[55]

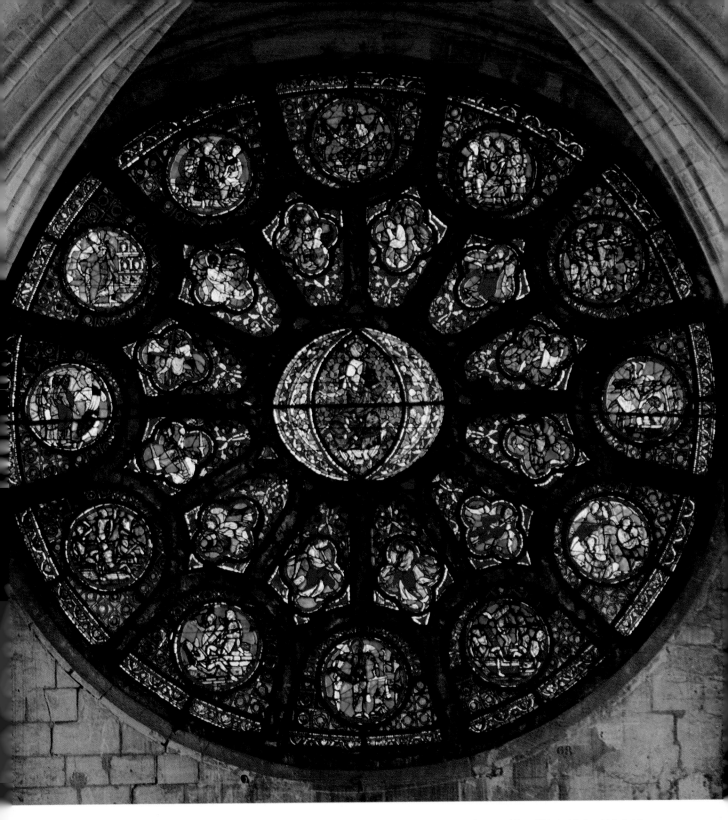

65 Illuminated by the setting sun on the west façade of Notre-Dame de Mantes, this window is the first real rose breaking away from the strictly spoked structure of the wheel. The subject is Last Judgment, strongly reminiscent of the west rose at Chartres, with Christ at the centre surrounded in the innermost circle by angels in adoration and by the Virgin Mary and St John to the left and right beneath Christ. The outermost twelve huge panels depict scenes of Judgment; following the hours of a clock, at 12 is the Bosom of Abraham, here depicted as a white veil enclosing five souls, while the Mouth of Hell (3) has already received three. A demon leads off four unfortunates and among them are a bishop and two kings (2), while others are transported by angels to heaven (4) and (9). St Michael (6) divides the souls who rise from their graves (5) and (7), some of whom ascend to heaven (8), where St Peter guards the gate (10) and four of the Apostles are seated (1) and (11). Unfortunately some of the panels have been interchanged since the nineteenth century (4, 6, 7, 8) and some are new (1, 8, 10). (Mantes west, stonework c. 1180, glass early 13th c.)

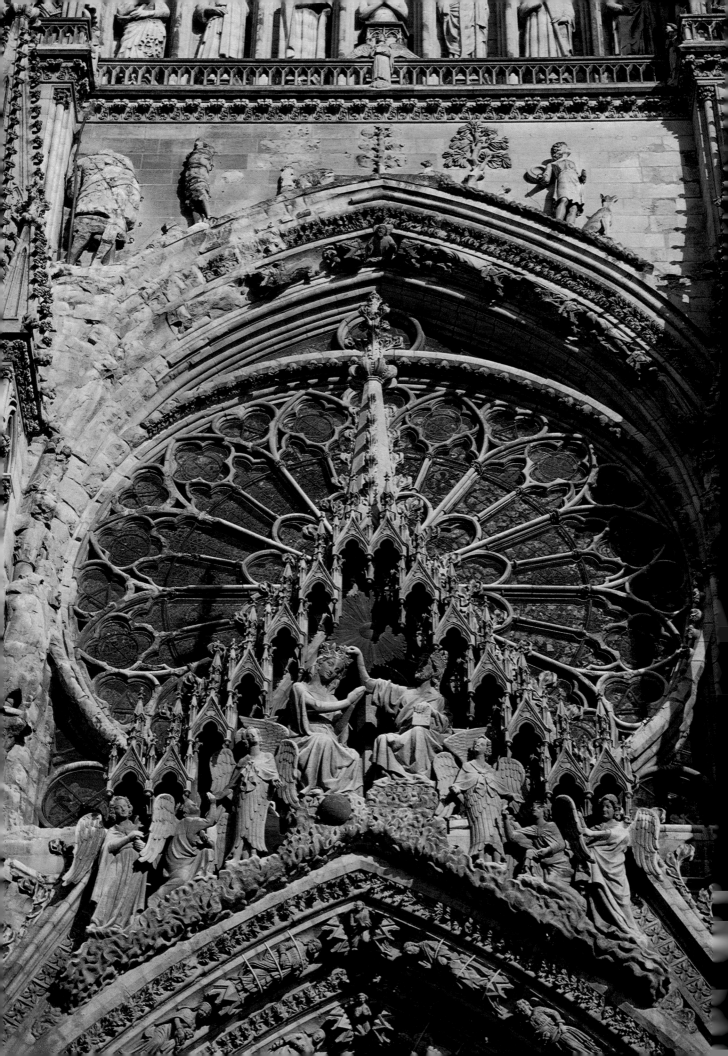

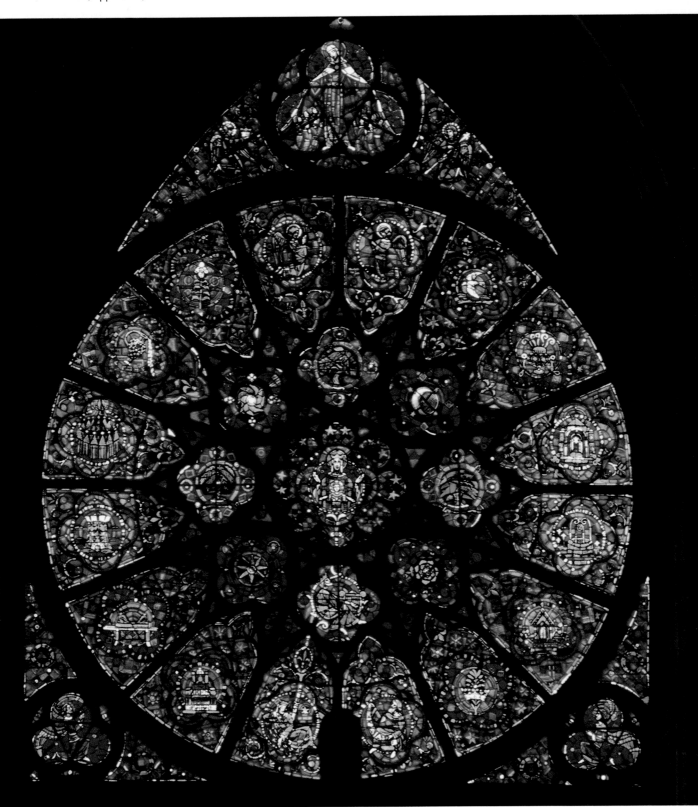

67 **A new rose in the tympanum beneath the coronation of the Virgin.** Reims was badly damaged in the First World War, but this exquisite window featuring the Litany of the Virgin Mary is probably the finest twentieth-century rose. (Reims west, lower rose, c.1260, glass by Jacques Simon, 20th c.)

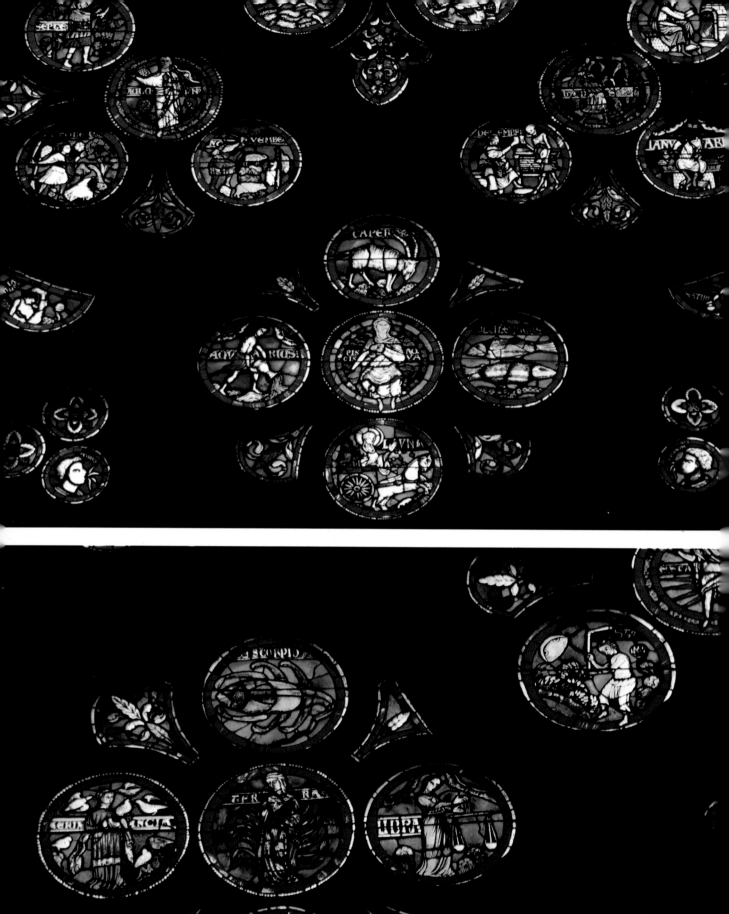

68 **The initial creation becomes constant creation, manifest in every rose window as** light and colour. At Lausanne the cycle of the year, the signs of the Zodiac and the four elements symbolize the forces of creation eternally acting in the cosmos – and through man when he creates in accordance with Nature. (Lausanne, c.1230, partly restored 19th c.; see key on p.131)

69 Earth is surrounded by Scorpio, Libra, Sagittarius and Aeromancy, who foretells the future from seven doves. (Lausanne, c.1230, restored 19th c.)

70 **The Wheel of Life**, often containing the Zodiac, at Angers has twenty-four spokes instead of the usual twelve. The signs are disposed through the upper half of the wheel with twelve of the twenty-four elders of the Apocalypse below, each holding a lute and a vase. (Angers, stonework 13th c., glass c.1463)

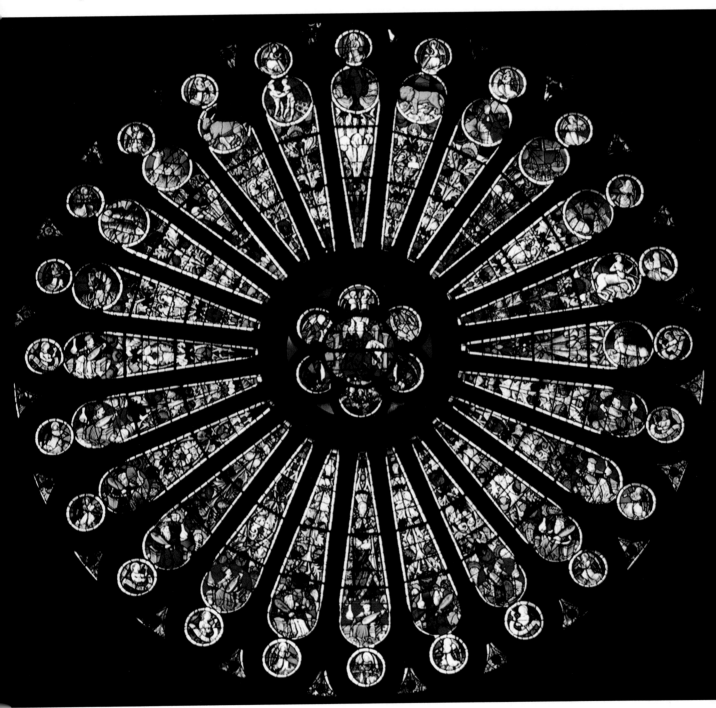

Overleaf:

71 **Generating shapes and forms in patterns of light and** colour, the Flamboyant north rose of Sens places members of the heavenly choir inside mouchettes which seem to swim through space. (Sens north, early 16th c., see 82)

72 **Sweeping across the cosmos:** from the centre of the south window at Sens the mouchettes enclose scenes from Last Judgment portrayed in vivid late fifteenth-century style – intermingled with the arms of Tristan de Salazar, the window's donor. (Sens south, c.1494)

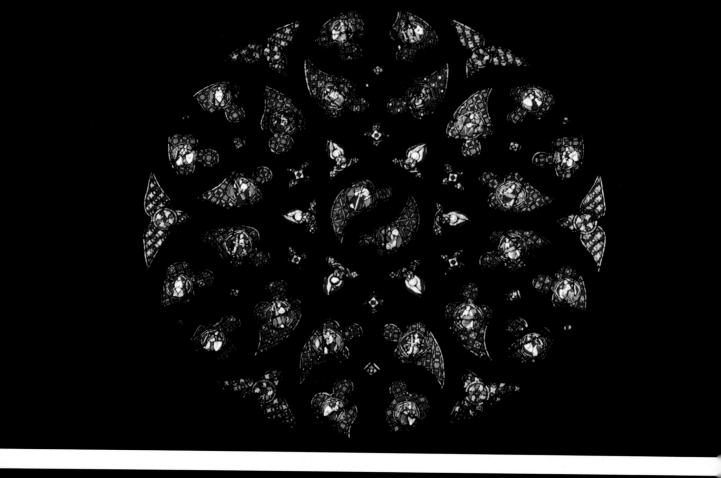

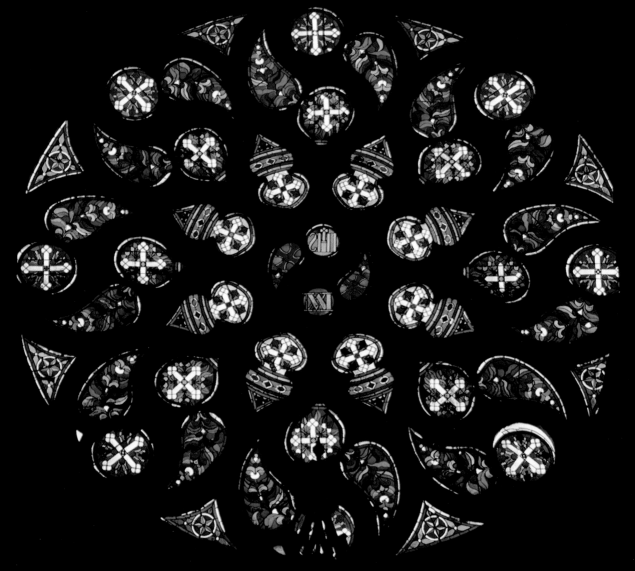

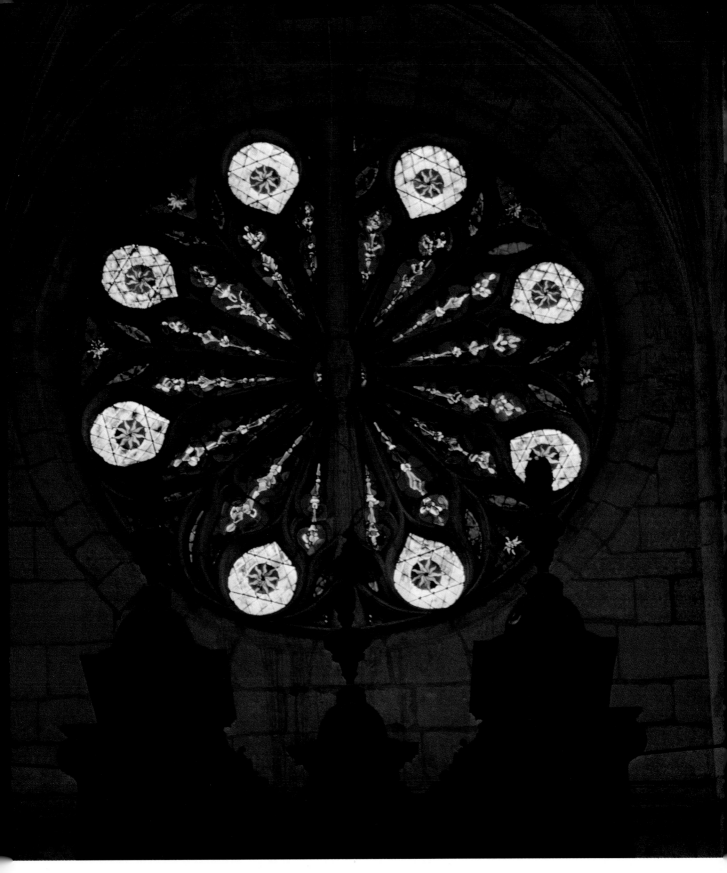

73 **Rose windows seem to generate** motion around their centre in a ceaseless stirring movement. At Saint-Bonaventure this seems to reduce to a Yin/Yang type of arrangement at the centre, recalling the 'breathing' of the cosmos in Eastern philosophy: the balance between active and passive modes of existence. The scene here is Last Judgment, with twenty-four elders of the Apocalypse in six groups of four. (Saint-Bonaventure, Lyon, 15th–16th c.)

74 **Inspired** by the Saint-Bonaventure rose, this window in Toulouse dates from the same period. (Notre-Dame de la Dalbade, Toulouse, 15th–16th c., glass modern)

75 **Tongues of flame,** of the Spirit, the Sun and Last Judgment, at the little church of Houdan near Paris. (Houdan, 15th c.)

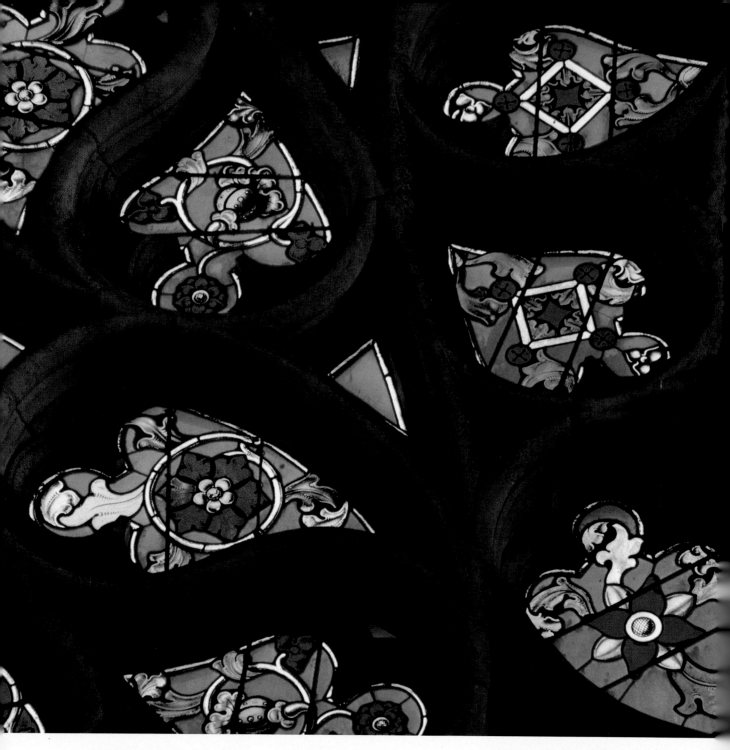

76 **The Spirit of Life**, interweaving all creation, transforms stone into coloured glass in the late fourteenth-century rose window at Saint-Omer. (Saint-Omer, late 14th c.)

77 **Bringing the creation into** an eternal present is superbly demonstrated through cyclic form in this late rose window at the cathedral of Saint-Pierre, Beauvais. (Beauvais south, c. 1548; see key on pp. 132–33)

Overleaf:

78 **Every moment** of history is symbolically contained in a rose window. 'The fire and the rose are one', in T. S. Eliot's 'Little Gidding' and in the rose window, fusing all past, present and future into the Eternal Present. As the Alpha and Omega, the beginning and the end, of St John's Revelation, Christ is at the centre of this south window at Sées, surrounded by the twelve Apostles, the four Evangelists and the twenty-four elders. (Sées south, c. 1270, glass restored)

79 **Through light and colour in** concentric bands, the great west rose at Strasbourg suggests the different 'energy' bands of the mandala that focuses the mind to a point at the centre of the window. (Strasbourg west, c. 1318, glass much restored; see also 33)

80 **A myriad forms.** (La Rochefoucauld, 16th c.)

81 **As a 'viewfinder of meaning'** the cross-and-circle pattern of the mandala represents order and healing in macrocosm and microcosm alike. (Saint-Maixent-l'Ecole, 15th c., rebuilt 17th c.)

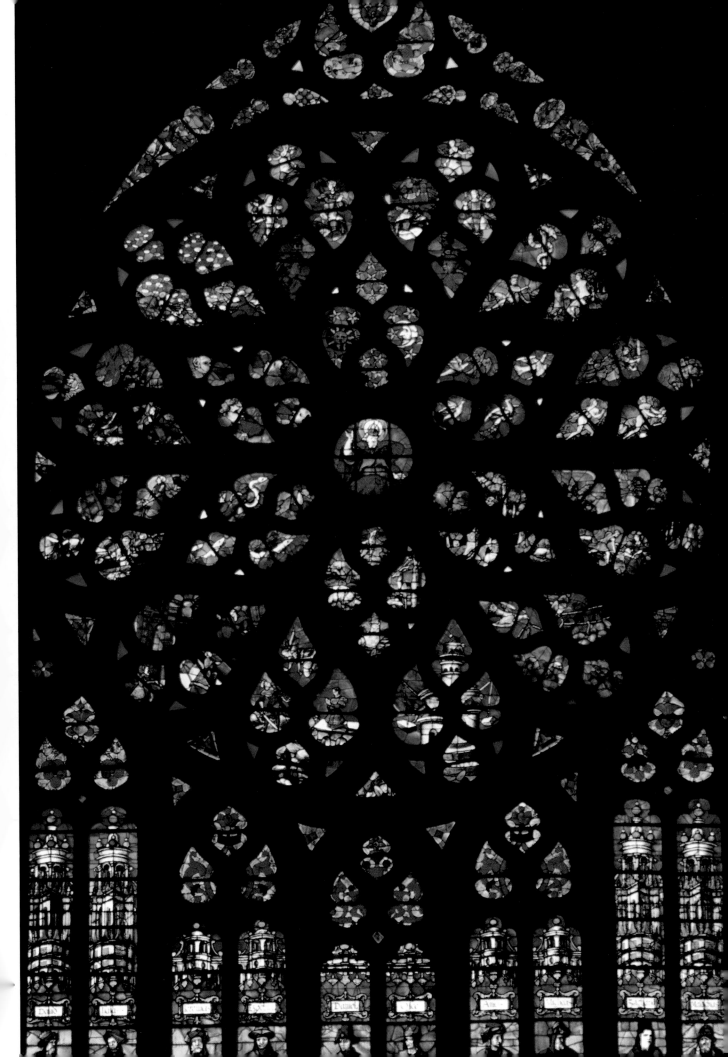

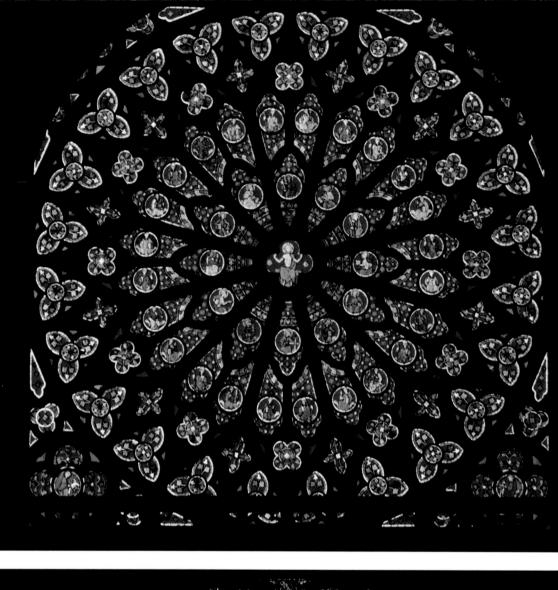

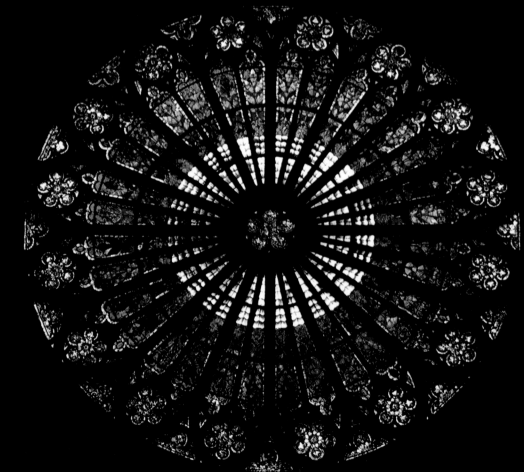

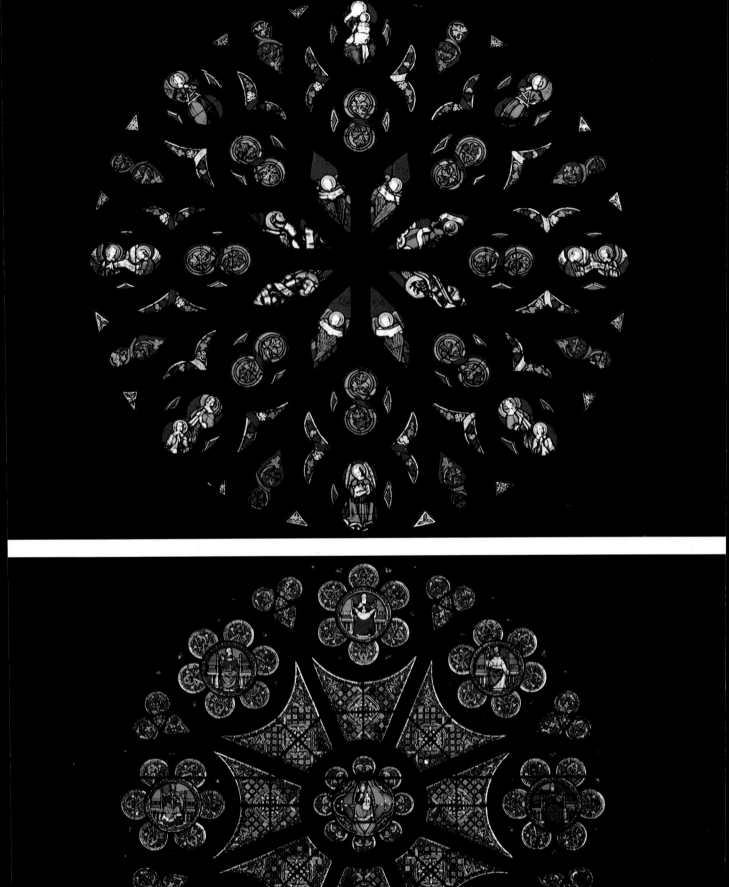

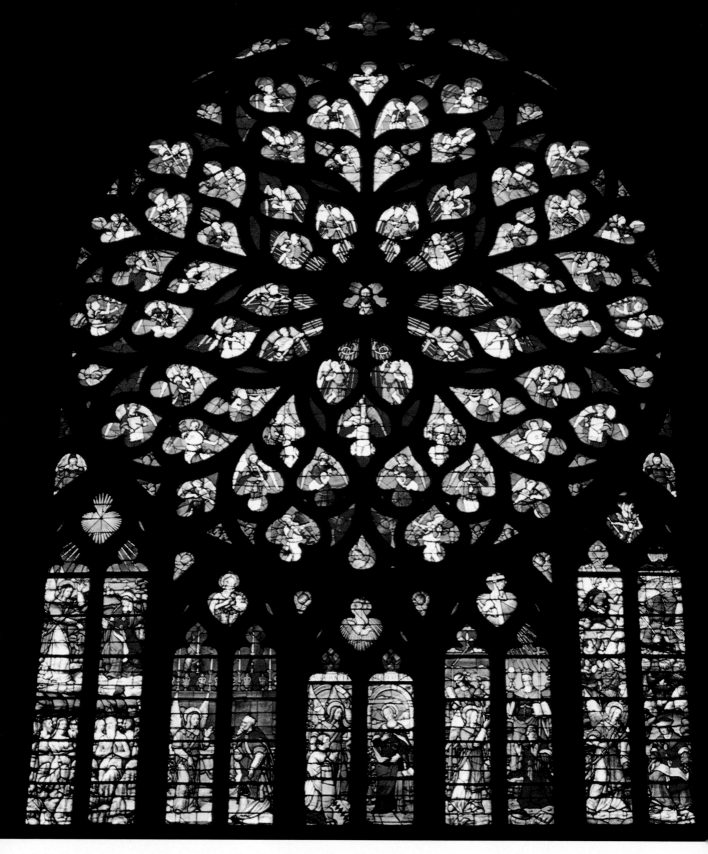

82 **Acting as a vortex** of light, the five-petalled north rose of Sens is a paean to God. All the instruments of Psalm 150 are employed to praise God in His sanctuary. Sixty-two angels play trumpets, psaltery, harp, timbrel, stringed instruments, organs, loud cymbals and high sounding cymbals: all join in the dance of the cosmos. (Sens north, early 16th c.; see 72)

83 **Spiralling to the centre**, this small rose window is in the Chapelle des Bourbon in Lyon cathedral. (Lyon, 16th c.)

84 **Each rose window transmits to** man beauty in light – 'enough to fill the mind with wonder' in the words of Henry Lincoln. This exquisite rose by Henri de Nivelle features incidents from the lives of St John the Baptist and St Stephen. (Lyon west, c.1392)

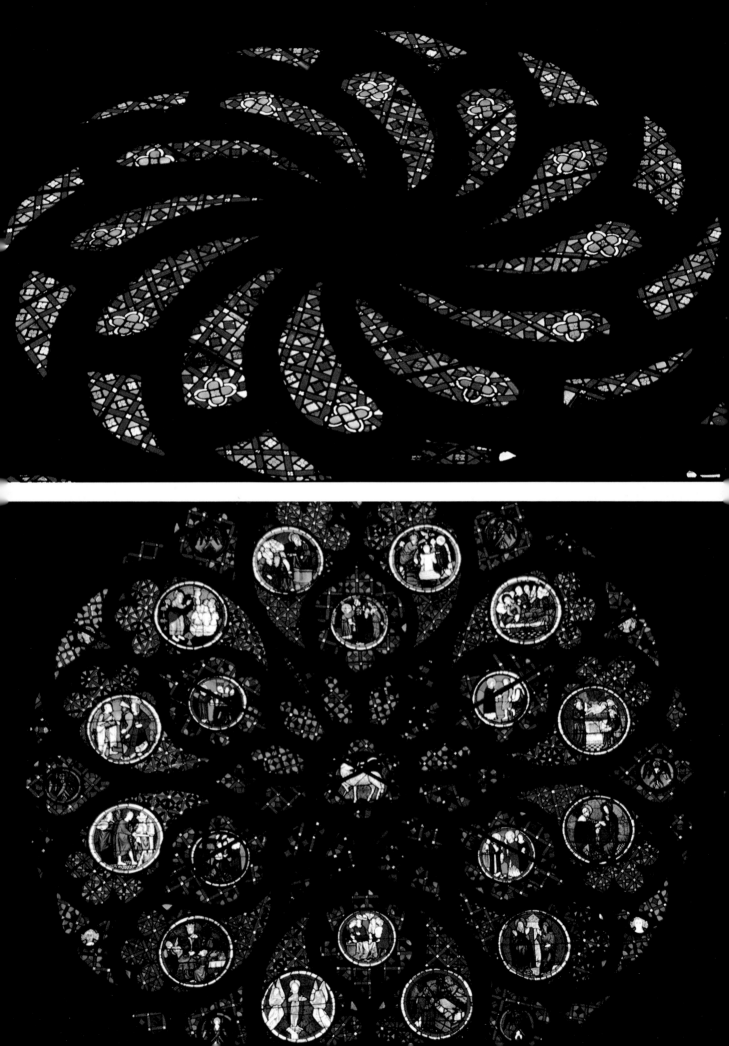

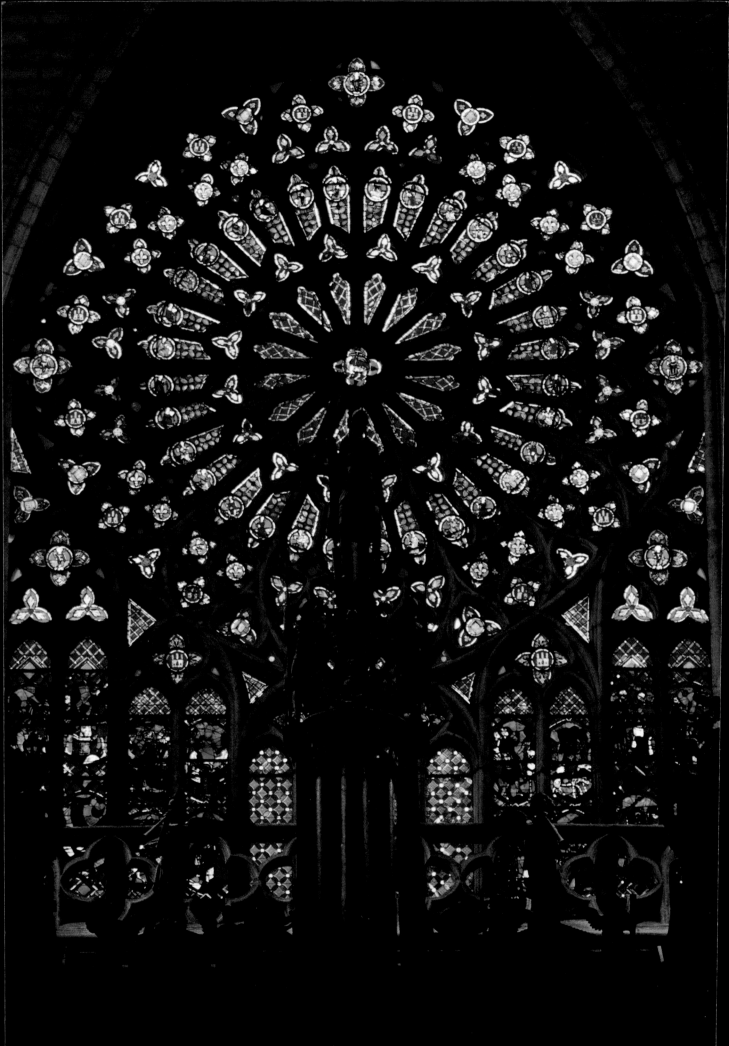

As the geometer his mind applies
 To square the circle, nor for all his wit
 Finds the right formula, howe'er he tries,

So strove I with wonder – how to fit
 The image to the sphere; so sought to see
 How it maintained the point of rest in it.

Thither my own wings could not carry me,
 But that a flash my understanding clove,
 Whence its desire came to it suddenly.

High phantasy lost power and here broke off;
 Yet as a wheel moves smoothly, free from jars
 My will and my desire were turned by love,

The love that moves the sun and the other stars.

(Dante, *Paradiso*, xxxiii.1.133–45,
translated by Dorothy L. Sayers.)[55]

85 **The creative force of the cosmos in
light streaming from its centre**
illuminates elders, angels, prophets,
martyrs and patriarchs – the 'great
cloud of witnesses' of the Christian faith.
They glow in colour surrounded by
haloes of white light in the north rose of
the cathedral of Saint-Gatien at Tours.
(Tours north, early 14th c.)

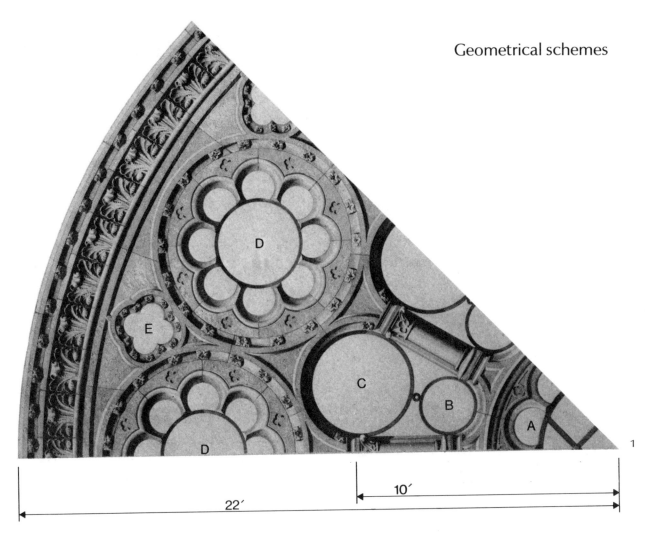

22′ 10′

1

The almost obsessive interest that medieval architects and theologians showed in geometry goes back at least to St Augustine and his concern with Pythagorean and Neoplatonic number mysticism as an expression of divine proportion. He talks about the 'anagogical' function of music and geometry, of beauty realized through figures and proportions. At Chartres, Chancellor Thierry's preoccupation with numbers manifested itself in his geometric representation of the Trinity and led to a trend of almost reducing theology to geometry that disturbed a later chancellor, John of Salisbury. Nevertheless, geometry is at the basis of all Gothic cathedrals, everything being created from basic relationships. The means of proportioning elevation from plans using regular polygons – particularly the square – was a carefully kept secret until the fifteenth century, when Matthew Roriczer of Ravensburg made the knowledge public.

Geometry – and the use of polygons in setting proportions – is fundamental to all rose windows: every one of them involves extremely careful calculation and precise construction. It operates in different ways in different windows, and in the greatest of them the satisfaction is more than visual – it is intellectual and even cosmic in its implications. Four of the greatest windows are analysed here, in order to give an insight both into how the windows were conceived and into the other, secondary geometric relationships that emerge from any perfectly designed window.

CHARTRES WEST [27, 29]

This classic rose window on the west façade of Chartres is more than a triumph of design: it is a 'tour de force, where five separate systems of proportion rhythmically pulse across the wheel, dividing the whorls from the vortex'.[57]

This quotation is from John James' article on the geometry of this window, a superb analysis which will act as the basis of this account. Working from the best drawings and measurements available, James rarely accepted an error of more than ± 2 cm in the work of establishing the relationships within this immense rose. He found it to be built up on two units, measured as shown above in Roman feet of 29.6 cm: one of 3 feet and another of 10 feet, which reduces to $\frac{2}{3}$ and $\frac{1}{3}$ to give $6\frac{2}{3}$ and $3\frac{1}{3}$ feet (an expansion of the number 3, and a division by 3, being a neat echo of Thierry's preoccupation with the geometric configuration of the Trinity). Here are the main features of this extraordinary construction:–

Figure 1
A segment of the rose – from Lassus' drawing of 1842 – shows that the 10-foot unit gives the line of centres of the middle row of lights, and the $6\frac{2}{3}$-foot unit

122

that of the inner twelve medallions. (The twelve petals of the central rose lie on the $3\frac{1}{3}$-foot circle.) These outer two circles also define the masonry joints at each end of the pillar.

Figure 2
The twelve large rosettes D are defined from the 3-foot unit by creating 6 squares of side 12 feet about the centre, and expanding them to a 24-pointed star which then creates the centres and the points of contact of the rosettes.

Figure 3
By interconnecting the centres B to form three squares the inner cornice is defined, and when the squares are expanded into a 12-sided star they meet at the centres of the small outermost lights E. This same star is also tangential to the rosettes *and* to the middle row of medallions C. Finally a hexagon around the star defines the perimeter of carved leaves, and, as John James says, 'With an elegant precision the Master placed the leaf that adorns the centre of each capital on the intersection of the arms of a star. Thus in a splendid consistency the thirds fix both leaf forms, and the three concentric rings of circlets that look like a sunflower.'

Figure 4
There is one final construction from the 3-foot unit that generates the outer circle. Around the 3-foot centre four equilateral triangles are drawn, and the three squares that enclose them are expanded into a twelve-pointed star which arrives at the perimeter on the axis of little lights.

John James takes the analysis even further, finding that a series of 'expanding pentagons' from the central 3-foot unit confirm certain points in the structure, although I find this less convincing. James finds many more subtle interrelationships and the use of a second unit, the *pes manualis*, $\frac{6}{5}$ Roman foot; between the two units, 'every minor element and every moulding reflects one or another of the basic measures. In careful geometry everything is made a part of everything else; nothing stands alone. Thus it was with God's universe, thus it should be in man's efforts in praise of him.[58]

2
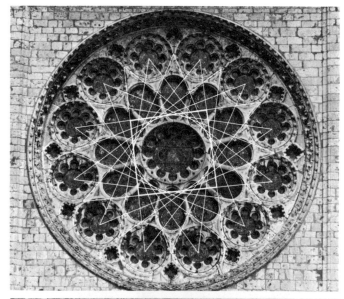

3
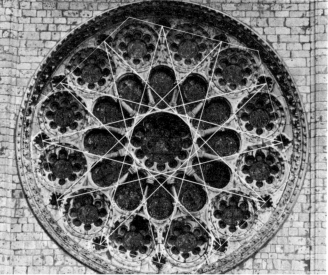

4
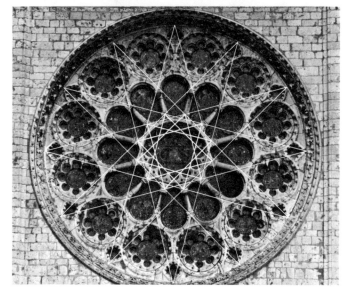

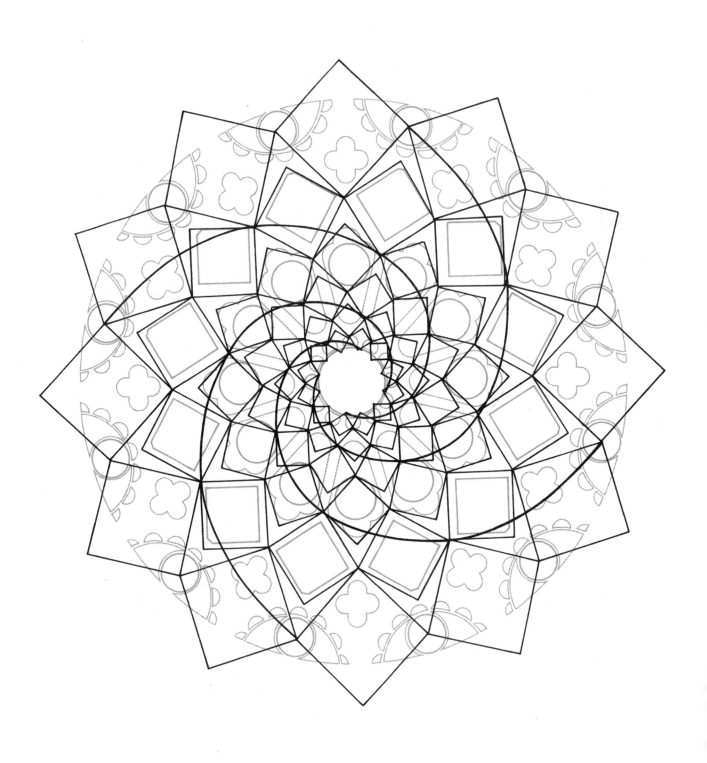

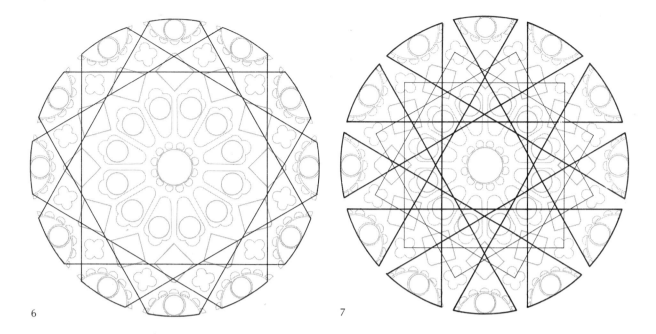

6

7

CHARTRES NORTH [6, 7]

The glorious Rose de France in the north transept of Chartres has been used in this book to illustrate many differing aspects of rose windows; its divine geometry is amongst its finest glories. Everything in the window is generated from the properties of the square within the circle.

The twelve squares set at angles to the radii are the most striking features of this window. They can easily be related to three interpenetrating squares that contain the smaller ones; the eye can pick these up unaided. These squares suggest that there is a very subtle underlying geometry that is based on the spiral, and the eye seems to sense the window's sunflower form that spirals out of (or into) the centre. In fact the set of squares that creates the true spiral geometry is more closely related to the outside stonework. It is the centres of the small outer circular lights that create a geometry of expanding and diminishing squares that takes in the square lights. By joining every second and every third of these the sequence of squares can be drawn, and they very neatly focus down to the central rosette with its twelve little petals (see figure 5).

This series of squares can also be related to the Golden Section, for the intersecting points of the two sets of

squares lie on a spiral whose points are governed by the Fibonacci series (a series in which each term is the sum of the two preceding ones). The underlying geometry and mathematics of this relationship is explained in Peter S. Stephens' Patterns in Nature.[59] Briefly, the points through which the spiral passes are laid out so that the circular arc between any two consecutive points is $137.5°$, which is $360° \times (3 - \sqrt{5}) \div 2$, or $360° \times \phi^2$, where ϕ is the golden section 0.618. 'In terms of the Fibonacci series it approximates $360°$ times one term in the series [1,2,3,5,8,13 etc.] divided by the term directly after the next succeeding one.'

It is this system that governs the system of growth in a number of flowers – notably the sunflower, daisies and in a related but more complex way the rose. Certainly the Golden Section must have been known to the School of Chartres through their studies of Euclid. Fibonacci (Filius Bonaci – 'son of good nature') published his work in Liber abaci in 1202 – some thirty years before this window; it was, according to H. E. Huntley, widely known and may well have come to the attention of the Chartres mathematicians.[60]

In this window at Chartres there are

twelve groups of spirals following this law, four of which are drawn in figure 5. Thus the lights of the prophets on the outer circle bind into the key points in the structure, pass through the twelve kings, angels and doves to give birth to the Logos at the centre. The Creative Logos of the universe, the law of nature, is followed by man to give perfect beauty.

There are three other structural relationships in this window, independent of this sunflower arrangement. The first two are in figure 6, which demonstrates the network of equilateral triangles built up from the semicircles around the edge. They create three interlocking squares around the centre, the corners of which define the centres of the twelve innermost circles. Another system of squares interlinks the twelve little square openings with the twelve quatrefoils – shown by the light lines in figure 6. In figure 7 another system of squares interconnects the outer semicircles to the diagonals of the twelve little squares – yet another demonstration of the subtle nature of this remarkable rose. Further studies on this window may well reveal that, like the west window in the same cathedral, it is built up from units of measure which are equally subtle and ingenious.

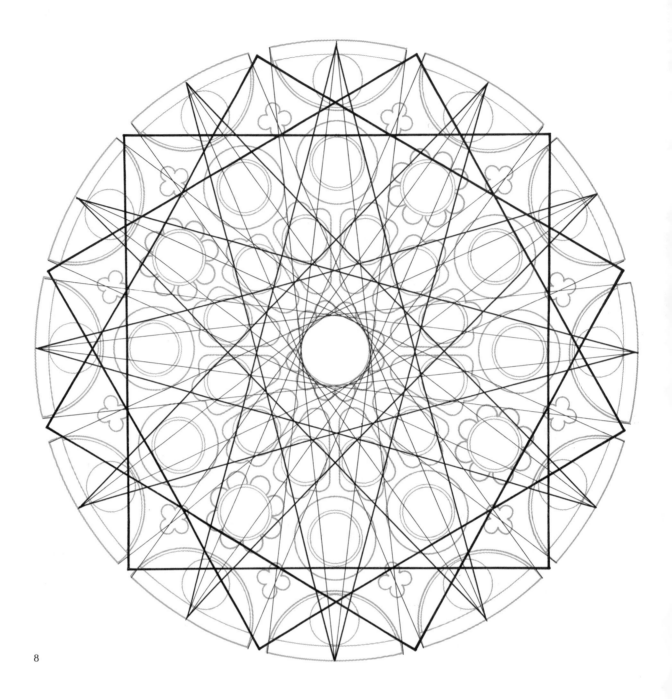

8

CHARTRES SOUTH [10, 35–37, 41]

Figure 8 shows a scheme for the south rose window of Chartres. Doubtless there are other schemes more subtle than this, but this one shows some interesting relationships that the eye probably picks up unconsciously. The semicircles around the edge suggest a 'focusing' mechanism which leads the eye to the centre: the thin lines in the diagram drawn from the extremities of each of the outermost semicircles to a point at the centre of the opposite semicircle define perfectly the central medallion that encloses Christ. (And each one picks up the little quatrefoils en route, thus defining their centres.) Any line drawn from the centre of one semicircle to that of another, five windows away, is tangential to no less than four of the twelve central medallions – a remarkable alignment! Furthermore, a set of three squares inscribed in the rose is tangential to the middle row of the largest windows. This same system of three squares may well generate further subtle relationships built up from the properties of three squares; but this will have to be the subject of another study.

The north rose window of Notre-Dame de Paris, sometimes called the supreme example of a rose window built up from a lattice of invisible geometry. *Figure 9* shows how the geometry creates and defines each concentric layer in a logical progression.

The starting point is the centre of any one of the thirty-two outermost lights. By joining it to another, eight windows away, and continuing the process, an endless line is generated that takes in all of these outer lights. At the same time it creates a series of tangents to a circle which contains the centres of the next layer of thirty-two medallions. A similar operation repeated on this new layer – but this time by joining every eleventh window – creates two interlocking sixteen-pointed stars; and these in turn define the centres of each of the sixteen central windows containing the prophets. From these centres four interlocking squares can be drawn, which in turn tangentially produce the heavy red and gold halo around the Virgin and Child at the centre. Finally a sixteen-pointed star from this circle creates the opening for the central lights – and the size of the openings that form the border of this central rosette.

Thus the geometry relates every part to every other part and the totality to the point of focus – the centre. The window is full of other subtle relationships which the reader can verify for himself with a ruler: a different scheme for example can be created by joining every seventh of the outer windows – or every tenth window in the middle layer.

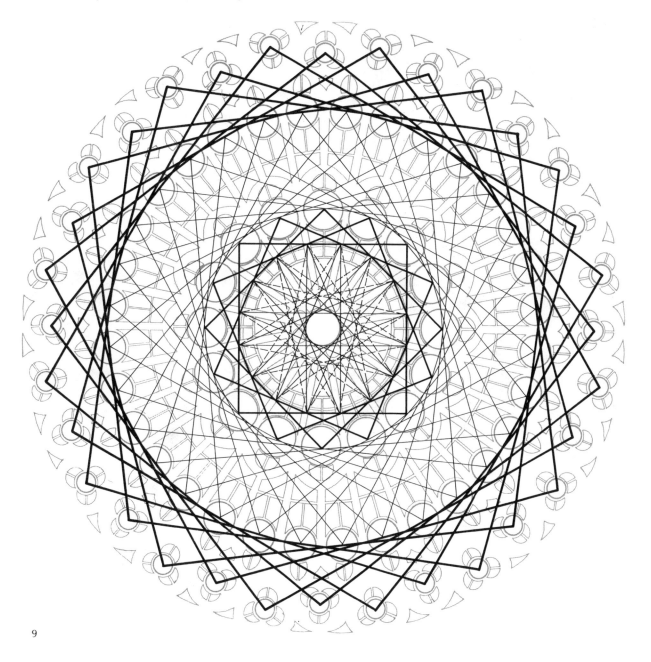

9

Creation

LAUSANNE [38, 39, 68, 69]

'The glass in the windows, through which pass the rays of light, is the mind of the doctors, seeing heavenly things as in a glass darkly' (Honorius of Autun). This medieval *imago mundi*, or schema of the Creation and the created, dates from about 1225–35. Its imagery represents the culmination of cosmological speculations that go back to Greece and Rome. Its sources of inspiration can be traced to Pliny, Aristotle, Solinus, Isidore of Seville and the Venerable Bede – and possibly even the Prester John legend. Its immediate source is probably Honorius of Autun, the medieval encyclopaedist, and its scale of conception and construction is clearly linked to the School and cathedral of Chartres; the style of

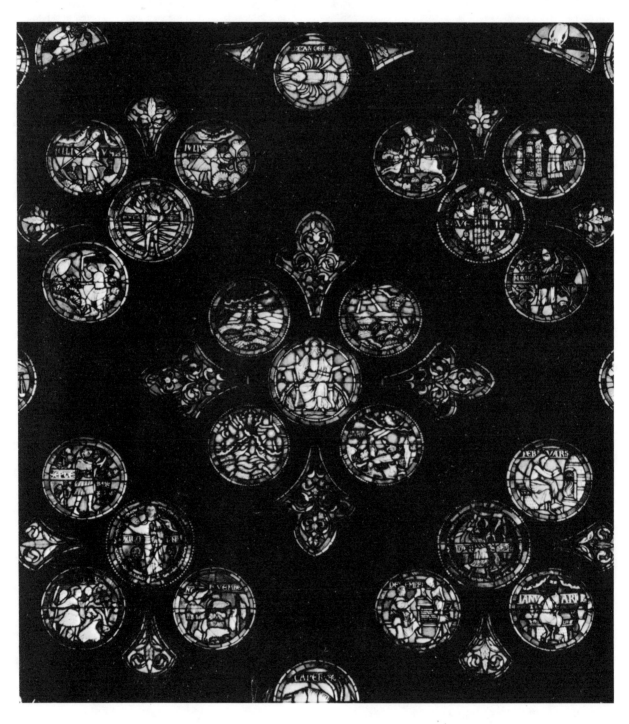

the glasswork, however, is that of Picardy.

The rose as it exists today contains 105 panels, of which 61 are figured; and of these 17 are replacements dating from 1894–99, when Edouard Hosch restored it from its then dilapidated state. There is some dispute concerning the nature of the original iconography: some observers have suggested that God was at the centre, surrounded by the four Evangelists instead of the Creation. But the more likely scheme is that suggested by Ellen Beer, having 'The Year' at the centre (1) surrounded by light and dark, sun and moon (2–5). This would then have meant that geomancy and hydromancy (prophecy by earth and water) would have had places in the scheme (38, 39), which would be more logical and consistent. It would also mean that things temporal and earthly were always shown within a square, things eternal and celestial within a circle or part of a circle (see also p. 84).

Central portion of the Lausanne rose, depicting the Creation, the Seasons and the Months

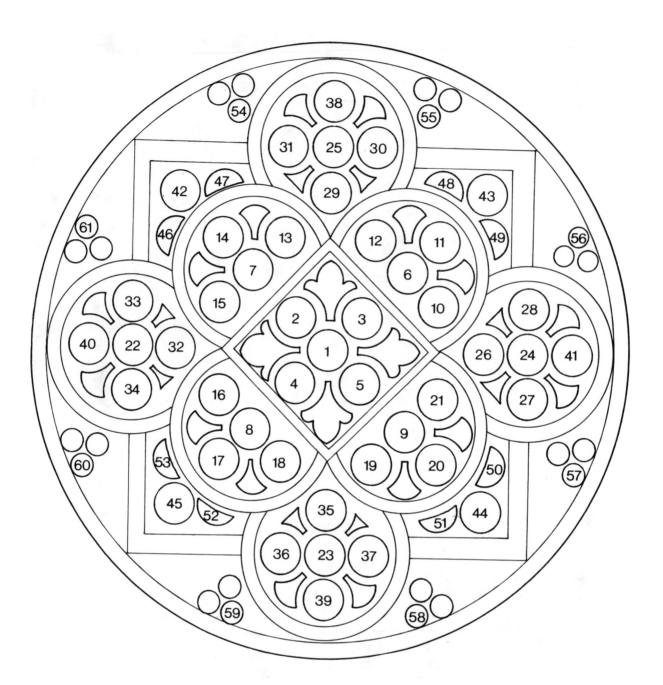

Here is the present disposition of the Lausanne rose. Panes asterisked are nineteenth-century replacements.

1 God the Father.*

Matter: in the small square

2 Light and dark.*
3 Land and sea.*
4 Fish and birds.*
5 Animals and men.*

Time: in the four semicircles

6 Spring, a man surrounded by flowers and leaves and holding a flower.
7 Summer, red rays warming the blue sky.
8 Autumn, amid the red and white grapes.
9 Winter, dressed in white and hooded, weathers a storm of icicles.
10 March, wearing a cotton turban-like hat, pruning the vines.
11 April, wearing a toque, flowers in hand, opens the door to his garden.
12 May, on a white horse, carries his falcon to the hunt.
13 June, inaccurately labelled IULIUS, cuts the hay.
14 July, reaps the harvest with a sickle.
15 August, stripped to the waist, threshes the harvest under a baking sun.
16 September, harvesting the grapes.
17 October, tending his pigs while they eat acorns (and hunt for truffles?).
18 November, the month of cattle and pig slaughter.

19 December, raising his glass to death, symbolizes the year that has gone.*
20 January, a double-headed Janus figure, with one half holding up his cup to the bountiful year ahead, the other looking at the year that has passed.
21 February, warming his hands.*

The elements and the Zodiac, formative and beyond time

22 Earth, a woman surrounded with ears of corn.
23 Water, breast-feeding a fish.
24 Air, doing likewise to a dragon.
25 Fire, feeding a salamander.
26–37 The signs of the Zodiac portrayed in usual medieval style; 27, 29, 34 and 36 are replacements.
38 The sun with a fiery halo being drawn across the sky in a chariot.
39 The moon being drawn likewise but with only two horses.
40 Aeromancy, surrounded by seven doves by whom she foretells the future.
41 Pyromancy, foretelling the future from the flames of the fire.

Paradise and the lands of myth

The four rivers of Paradise portrayed as bearded men pouring their waters across the four corners of the earth:

42 The Geon (Nile).
43 The Tigris.
44 The Phison (Ganges).
45 The Euphrates.
46 Ethiopians, with four eyes to help the accuracy of their archery.
47 Gangaridae, inhabitants of the Ganges who supposedly lived off the sweet smell of fruit – and died in the presence of any foul odour.
48 Acephali, creatures with no heads and with eyes in their bodies.
49 Cynocephali, dog-headed men, thought to live in India.
50 Pygmies, also thought to inhabit India, here fighting a crane.
51 A Satyr, a small hook-nosed creature with horns and goat-like feet.
52 Sciapodes, creatures that lived in the desert and had only one foot, which they used as a sunshade.*
53 Cephi, elusive creatures detectable only by their human-like footprints.

The eight winds of the cosmos

54 Auster, the south wind.
55 Euroauster, the south-south-east wind.
56 Subsolanus, the eastern wind of the Levant.
57 Vulturnus, the south-east wind.
58 Septentrion, the north wind.
59 The north-west summer wind.
60 Zephyr, the west wind.
61 Austerozephyr, the south-west wind.

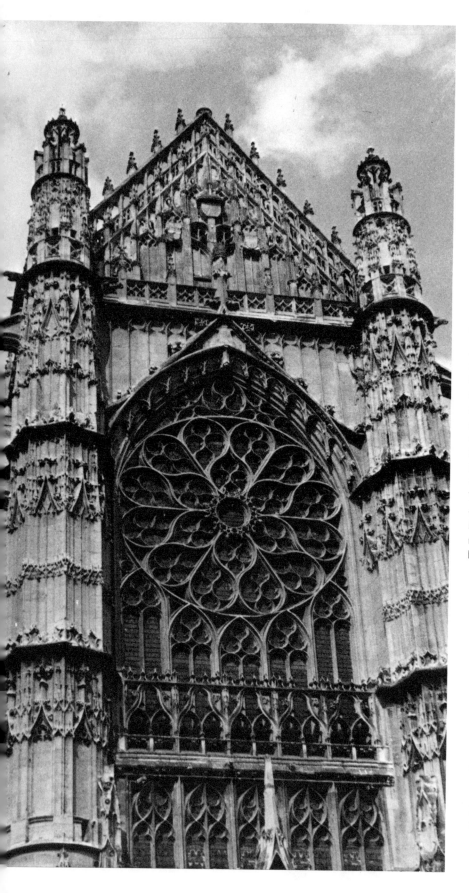

BEAUVAIS SOUTH [77]

A much later, more traditional representation of the Creation was chosen for this cathedral. It is nevertheless full of subtleties and hidden meaning and exploits to the full the opportunities offered by the concentric structure of this Flamboyant rose. It portrays the Creation according to Genesis in the innermost six petals and then a sequence of stories starting with the Temptation in the Garden of Eden and continuing up to the beginning of Exodus, where the wandering Israelites receive manna from heaven. Here is a brief description:

1 At the centre, God the Father, represented as an old man with a long white beard, white halo and yellow nimbus.
2 The sun, moon and stars in classic fifteenth- and sixteenth-century style, the sun and moon with faces and the stars five-pointed.
3 The creation of birds.
4 The creation of trees and plants; represented as a pristine forest.
5 The creation of animals; sheep, an ox and a deer identifiable.
6 The creation of fish; an eel and a mullet join the others swimming towards the centre.
7 The four winds of heaven.
8, 19 The Celestial Paradise: in the angelic realms, two red and green, elegant young men (seraphim) can be seen close to the stars.

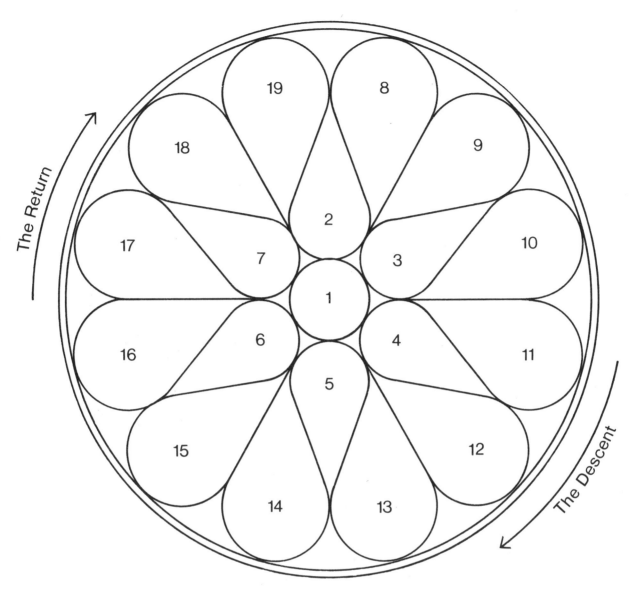

The Return

The Descent

9 The Earthly Paradise; Adam relaxing under a tree while Eve, watched by the snake, offers the forbidden fruit.
10 Adam and Eve being driven out of paradise by an angel with a sword.
11 Adam tilling the ground while Eve spins.
12 The Flood, with a dove bringing three ears of wheat to the ark.
13 The Tower of Babel.
14 Abraham about to sacrifice Isaac; an angel interposes.
15 The benediction of Isaac; Rebecca waiting behind.
16 Joseph being lowered into the pit by his brother Reuben.
17 The burning bush; Moses learns how he will deliver the Israelites into the land of Canaan.

18 Manna, in flakes white as snow and large as saucers, falls from heaven to the Israelites in the desert.
19 See 8.

The window relates the Creation, but symbolizes man's intimate connection with nature. The right side of the rose represents the descent of mankind from the angelic and spiritual realms, from Paradise, through disobedience to his lowest point in matter which destroys all but the most faithful, Noah and his sons. The attempt to build the tower of Babel symbolizes the futility of trying to reach heaven without faith. The return is initiated, however, through Abraham's act of faith, and thereafter his descen-

dants move up the left side of the rose through trials and tribulations until manna from heaven in the desert begins to echo the conditions under which man received food in paradise.

Throughout the window the motif of nature – of constant creation – is present: the angels above the firmament descend to Paradise and send down manna into the desert; the birds in panel 3 look to Paradise and seem to be flying out of the trees underneath them; the deer seems to await the moment when he can spring into the forest.

The glasswork is known to be by either Nicholas le Prince or Nicolas le Pot; façade and stonework designed by Martin Chambiges and Michael Layle, c. 1500.

Roses for the Queen of Heaven

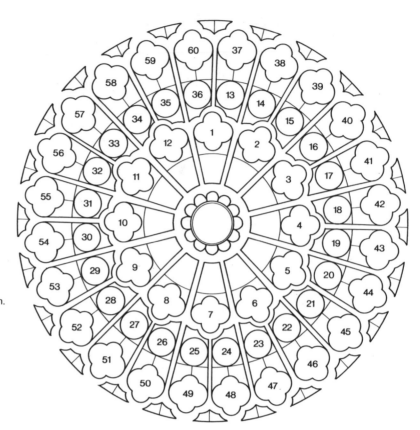

PARIS WEST [9]

The west rose at Paris is dedicated to Our Lady, although it is not certain that this was originally so. It has undergone numerous restorations, particularly in the sixteenth and nineteenth centuries, when some of the panels were completely renewed. Those marked * are sixteenth-century restorations, those marked ** are nineteenth-century, and those marked (n) are modern.

The upper half of the outer circle contains the virtues, and the corresponding vices are in the next inner layer; in the lower half of the outer circle are the months, corresponding to the zodiac signs in the inner layer. The innermost layer contains twelve prophets. At the centre is the Virgin.

1 Prophet (n)
2 Prophet (n)
3 Prophet (n)
4 Prophet
5 Prophet**
6 Prophet*
7 Prophet (n)
8 Prophet*
9 Prophet (n)
10 Prophet*
11 Prophet (n)
12 Prophet (n)
13 Anger**
14 Despair**
15 Ingratitude**
16 Discord**
17 Rebellion**
18 Cowardice
19 Capricorn*
20 Sagittarius**

21 Scorpio**
22 Libra**
23 Virgo
24 Leo**
25 Cancer
26 Gemini**
27 Taurus*
28 Aries**
29 Pisces**
30 Aquarius
31 Pride*
32 Folly (n)
33 Lust**
34 Avarice
35 Inconstancy (n)
36 Idolatry**
37 Patience**
38 Hope (n)
39 Gentleness
40 Peace**

41 Obedience**
42 Strength
43 December (n)
44 November**
45 October
46 September (n)
47 August*
48 July (n)
49 June*
50 May (n)
51 April (n)
52 March**
53 February (n)
54 January**
55 Humility**
56 Prudence**
57 Chastity**
58 Charity
59 Perseverance
60 Faith (n)

Built on the geometry of the number 16, this rose window is the ultimate in sheer delicacy, the ratio of stone to glass having been reduced to an absolute minimum. The underlying geometry is as spectacular as the rose itself (see p. 127), and shows many fundamental and subtle relationships.

The rose portrays the Old Testament, with prophets (p) in the innermost circle, kings (k) and judges (j) in the next, and kings and high priests (hp) in the out-ermost. They all surround the Virgin Mary who, with the Christ child on her knee, represents the culmination of history before the coming of Christ.

The sixteen primary and thirty-two secondary divisions of the rose are further subdivided by the ironwork to give nearly 700 panels made up of an estimated 50,000 pieces of glass. The subjects marked with an asterisk in the following list have undergone some restoration.

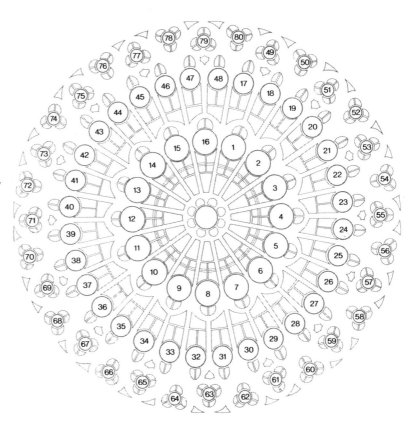

1 Micah (p)
2 Jonas (p)*
3 Malachai (p)*
4 Daniel (p)*
5 Zachariah (p)
6 Ezekiel (p)
7 Pharaoh's Dream*
8 Zephaniah (p)*
9 Elias (p)*
10 Habakuk (p)
11 Jeremiah (p)
12 Nahum (p)
13 Elias (p)*
14 Ageus (p)*
15 Isaiah (p)
16 Hosea (p)
17 Solomon (k)*
18 Jair (j)*
19 Othoniel (j)*
20 Joachaz (k)
21 Hezekiah (k)*
22 Samuel (j)
23 Hely (j)*
24 Ahialon (j)
25 Jeroboam (k)*
26 Asa (k)
27 Joram (k)
28 Ochosias (k)

29 David (k)*
30 Moses (j)
31 Abraham ?*
32 Ahiud ?(j)
33 Nadab (k) (modern panel)
34 Amon (j)*
35 Aod (j) (modern panel)
36 King*
37 Ahaz (k)
38 Joshua (j)*
39 Amasias (k)*
40 Abimelech (j)
41 Jephtha (j)
42 Abdon (j)
43 Josaphat (k)
44 Joas (k)*
45 Judge ?
46 Saul (k)
47 Ozias (k)
48 Deborah (p)*
49 Achias (hp)
50 Zadok (hp)*
51 Eliachim (hp)*
52 Azarias (hp)
53 Manasses (k)
54 Achitob (hp)*
55 Meraioth (hp)
56 Joachaz (k)

57 Saraias (hp)*
58 Aaron (hp)
59 Zedekiah (k)*
60 Heli (hp)
61 Amarias (hp)
62 Achitob (hp)
63 Zadok (hp)
64 Jehoiada (hp)
65 Abiathar (hp)
66 Azarias (hp)
67 Amarias (hp)
68 Jonathus ? (hp)*
69 Jeddoa (hp)*
70 Bocci (hp)*
71 Achab (k)
72 Achimelech (hp)*
73 Jechonias ? (hp)
74 Phineas (hp)
75 Sellum (hp)
76 Ozi (hp)
77 Eliacim ? (hp)
78 Zaharias (hp)
79 Helcias (hp)*
80 Josias (k)*

In the bottom left panels outside is the death of Antichrist. And on the right Antichrist decapitates Elias and Enoch.

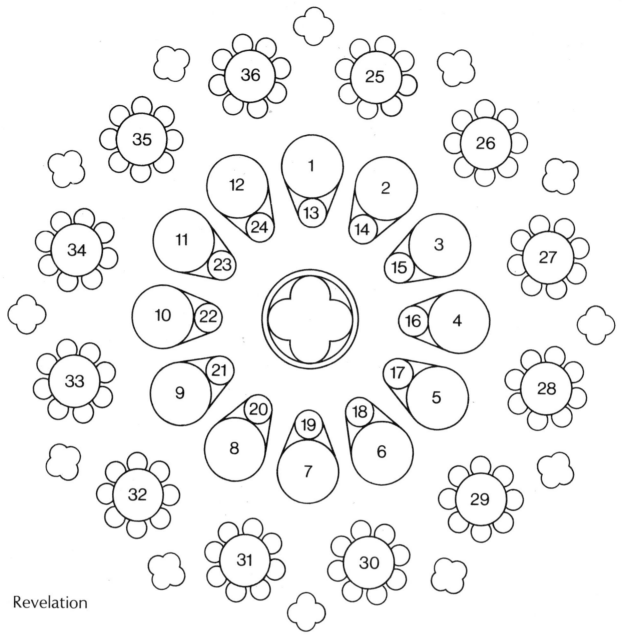

Revelation

CHARTRES WEST [27, 29]

The west rose of Chartres, probably the greatest and most widely acclaimed rose window of all, features the Last Judgment. The end of the world was predicted to occur in 1200 by St Hildegard of Bingen; even though it did not happen, the idea remained prominent in medieval iconography and appears vividly in a number of west rose windows.

Here at Chartres the rose of 1216 portrays Christ at the centre showing the wounds of the Crucifixion. He is surrounded by twelve small lights containing eight angels and seraphim and the four symbols of the Evangelists: The lion of St Mark (22), the bull of St Luke (16), the eagle of St John (13) and the angel of St Matthew (19). Above and below Christ in the outer lights are the souls divided by St Michael (7), the good ascending to the bosom of Abraham (1), while the bad are led off by devils (6 and 30) to another devil who gloats over three souls roasting in the flames of the mouth of hell.

The twelve apostles are arranged in pairs in windows 3, 4, 5, 9, 10, 11, and in 10 St Peter can be identified holding a huge green key. Above Christ are six-winged cherubim carrying the instruments of the Passion, the Cross (36) and the Spear (25). The dead can be seen rising from their tomb, as prophesied by St John in Revelation, and looking to Christ (28, 29, 32, 33). To the left of St Michael are three souls being led off by an angel (8), while an envy-green-faced devil waits for others (7). To complete the scene, angles blow huge curved trumpets (26, 27, 34, 35), and two cherubim, second in rank to the seraphim next to God, with eyes in their wings and containing all knowledge, look down (1, 2).

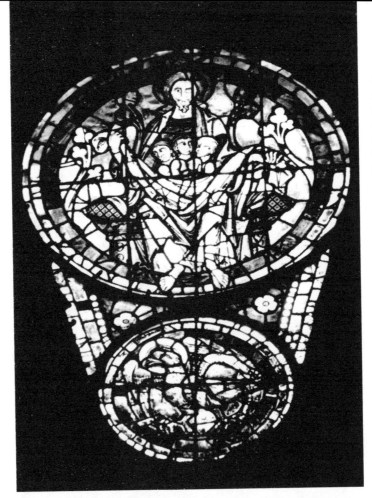

The 'Bosom of Abraham' and the 'mouth of Hell', which looked at upside-down reveals a veritably devilish face. Both from the Last Judgment west rose at Chartres

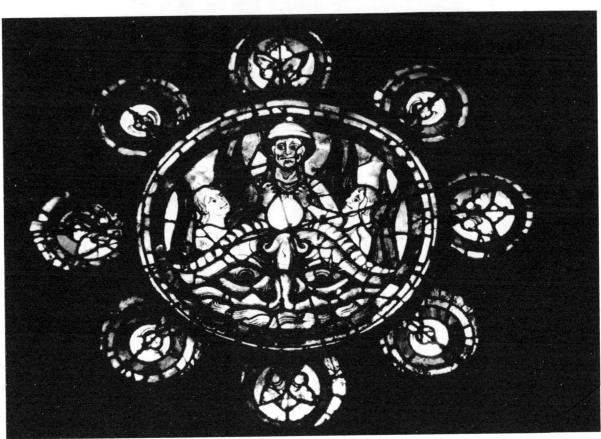

The fifteenth-century rose window of the Sainte-Chapelle in Paris is one of the most remarkable Last Judgment windows ever devised. It is a replacement of an earlier thirteenth-century window which would have been contemporary with the building itself, and in the *Très Belles Heures* of the Duc de Berry the Sainte-Chapelle is depicted with this original rose.

The iconographic programme of the existing window is thought to be the same as the original, although the style of the imagery pertains to the fifteenth century. It is not a generalized scheme of Last Judgment as in the case of most other windows (as for example at Chartres), but is an illustration of the main features of the whole of St John's Revelation – from chapter 4 right up to the New Jerusalem of chapter 21.

Of the eighty-five major panels, nine are complete nineteenth-century restorations (marked with an asterisk) and a further nine are fairly extensively restored (double asterisk). The numbering of the panels in the diagram follows the order of the description in Revelation.

1 At the centre is Christ enthroned on a rainbow surrounded by seven golden candlesticks and the seven churches of Asia. In His mouth is the sharp two-edged sword. His hair is white as snow-white wool, His eyes flame like fire and His face like the sun in full strength. Above His right hand are the seven stars (1.11–16).
2 Some of the twenty-four elders with musical instruments (4:4–10).
3 Twenty-four elders together with the angel of St Matthew and the lion of St Mark (4:10).
4 God on his throne with the closed book of seven seals (5:1).
5 More elders, the bull of St Luke and the eagle of St John (5:5).
6 The book is given to the lamb (5:6).
7 The lamb with seven horns and seven eyes opens the book. Note the 4 Evangelists' symbols (5:7).
8 The elders, with harps and phials of perfume, prostrate themselves (5:8–10).
9 Angels chanting (5:8–12).

10 Opening of the first seal, with the angel of Matthew (6:1).
11 A man on a white horse with a bow and crown (6:2).
12 Opening of the second seal, with St Mark (6:3).
13 A man on another horse (not red, as in the text) with a sword to take peace from the earth (6:4).
14 Opening of the third seal, with the bull of St Luke (6:5).
15 Another horseman (his horse not black as in the text) carrying the scales to measure the wheat and barley (6:5).
16 Opening of the fourth seal, with the eagle of St John (6:7).
17 The pale horse with the grotesque figure of Death, armed with a javelin and vipers. He is emerging from the huge green mouth of hell with its red eye. Beneath the horse in the mouth can be seen the 'Venetian' two-toned glass representing the flames (6:8).
18 Opening of the fifth seal (6:9).
19 The souls of the martyrs under the altar of Christ (6:9–10).
20 The souls being arrayed in white robes by angels (6:11).
21 Opening the sixth seal: 'The great day of his wrath'. The ruin created by earthquakes, the sun with a black sackcloth of hair, and the moon turned to blood (6:12–17).
22 Angels holding back the wind from the land and the ships of the sea (7:1).**
23 The multitude before the throne of God, in white robes carrying palms (7:9–12).**
24 The lamb before the throne, between the four sacred living creatures (7:9–12).
25 St John and an elder (7:13).
26 Opening the seventh seal (8:1).
27 The seven angels before God being given seven trumpets (8:2).
28 An angel giving incense to the altar (symbolizing the prayers of the saints) (8:3).
29 The prayers of the saints reaching God (8:4).
30 An angel taking the altar fire and casting it upon the earth (8:5).

31 The sounding of the first trumpet. Hail and fire descend (8:6–7).
32 The second trumpet; a burning mountain descends into the sea (8:8–9).
33 The third trumpet; the star Wormwood falling on to the waters (8:10–11).
34 The fourth trumpet; sun, moon and stars darkening, and the eagle as the angel crying Woe, Woe, written beneath it (8:12–13).
35 The fifth trumpet; the star falls from heaven, the key to the bottomless pit, and a huge locust (9:1–6).
36 Locusts as horses prepared for battle, with heads like men, hair like women and tails like scorpions (9:7–10).
37 Abaddon or Apollyon, the angel of the bottomless pit (9:11).
38 The sixth trumpet (9:13).
39 The four angels of the Euphrates unbound (9:14).
40 Some of the two hundred thousand thousand warriors destroying a third part of humanity (9:16–19).
41 An angel (on a rainbow) giving St John an open book (10:1, 8).
42 The heads of the seven thunders (in a blue cloud) and St John being forbidden to write (10:3–5).
43 St John measuring the Temple of God with a reed (11:1).
44 The two witnesses are put to death – with a turbaned figure looking on (11:3–11).
45 The resurrection of the witnesses and their ascension (into the blue clouds) whilst the lookers-on are amazed (11:11–13).
46 The seventh trumpet; the elders prostrate themselves before the throne (11:15).
47 The woman clothed as the sun, the moon under her feet and twelve stars in her nimbus (12:1).
48 The dragon with seven heads and ten horns and a 'third part of the stars' (12:3–4).
49 'War in heaven'; St Michael conquers the dragon (12:7–8).
50 The dragon persecutes the mother of the man-child; but she has wings with which to fly into the wilderness (12:13–14).

51 The beast with seven heads comes out of the sea (13:1).

52 The dragon gives power and authority to the beast (13:2–3).

53 Adoration of the dragon (13:4).

54 The beast makes war against the saints (13:7).

55 Adoration of the beast (13:8).

56 Another beast with ram-like horns calls down the fire from heaven (13:11–14).

57 The lamb on Mount Sion with the 144,000, redeemed (14:1–5).*

58 The angel announces the hour of Judgment (14:6–7).

59 Two angels, one announcing Babylon is fallen, the other carrying the wine of the wrath of God (14:8–11).*

60 The time of harvest. The son of man with a sickle on a white cloud (note the Venetian glass in the red and white spirals of the pillar on the right) (14:14–16).

61 The gathering of the grapes with the sickle (14:17–18).*

62 The elect singing the song of Moses (15:2–4).*

63 One of the four beasts gives the seven angels the vials of the wrath of God (15:5–7).*

64 The first vial is poured upon the earth (16:2).*

65 The second vial is poured upon the sea – which turns to blood (16:3).

66 The third vial is poured upon the rivers and streams (16:4–6).**

67 The fourth vial is poured upon the sun, scorching men (16:8).**

68 The fifth vial is poured upon the seat of the beast – a fauteuil Dagobert – his subjects gnawing their tongues for pain (16:10).

69 The sixth angel pours his vial upon the Euphrates (16:12).*

70 Unclean spirits like frogs, coming out of the mouth of the dragon, subsequently go to the great battlefield of Armageddon (16:13).*

71 The seventh vial is emptied, as a yellow liquid, into the air (16:17).

72 The great earthquake and hailstones as heavy as coins (16:18–21).

73 The seven-headed beast carries the whore of Babylon with a golden cup in her hand (17:3–5).**

74 A mighty angel casting a great millstone into the sea (18:21).

75 'Faithful and true', the king of kings on a white horse, with two other warriors behind (19:11–16).

76 The kings of the earth making war against the beast (19:19–20).

77 The seven-headed beast and the two-horned beast being cast into the lake of fire burning with brimstone (19:20).

78 The angel with the key of the bottomless pit binding the dragon Satan for a thousand years (20:1).

79 The New Jerusalem, coloured fine-gold, an angel at each door, with all manner of stones in the walls and the lamb on the throne in its midst (21:10–24).

God in Majesty is in the right-hand trefoil outside the rose, and opposite is the beast with seven heads. Unfortunately both these panels are extensively restored. The rest of the window contains the royal arms (80, 81, 83) and the initials of Charles VIII (82, 84, 85).

Fallen angel, Lyon north

Source References

1 Quoted by E. Panofsky, *Meaning in the Visual Arts*, London 1970, p. 162.
2 Rodin, *Cathedrals of France*, translated by E. C. Geissbuhler, London 1966, p. 35.
3 C. G. Jung, *Collected Works*, vol. 10, Princeton and London 1964, p. 803.
4 W. McNamara in *Transpersonal Psychology*, London and New York 1975, p. 411.
5 H. Adams, *Mont Saint-Michel and Chartres*, New York 1959, p. 100.
6 K. Clark, *Civilisation*, London and New York 1969, p. 56.
7 D. Macaulay, *Cathedral*, London and New York 1972, p. 77.
8 Quoted in R. L. Poole, *Illustrations of Medieval Thought and Learning*, New York 1962, p. 102.
9 F. Heer, *The Medieval World*, London 1974, p. 112.
10 Ibid., p. 114.
11 N. Haring, 'The Creator and the Creation of the World According to Thierry of Chartres and Clarenbaldus of Arras', *Archives d'histoire doctrinale et littéraire du moyen-âge*, vol. XXII (1955), C. 36, p. 196.
12 J. van der Meulen, 'A Logos Creator at Chartres and its copy', *Journal of the Warburg and Courtauld Institutes*, vol. 29, p. 90.
13 M. M. Marcia, 'The Logos as a Basis for a Doctrine of Divine Providence', *Medieval Studies*, vol. v (1943), pp. 75–101; J. M. Parent, *La Doctrine de la Création dans l'école de Chartres*, Toronto 1938.
14 Van der Meulen, op. cit. note 12, p. 88.
15 Rodin, op. cit. note 2, p. 9.
16 Adams, op. cit. note 5, pp. 38–39.
17 See E. Viollet-le-Duc, *Dictionnaire raisonné de l'architecture française du XIe au XVe siècle*, 10 vols. Paris 1854–69.
18 Rodin, op. cit. note 5, p. 56.
19 E. Mâle, *The Gothic Image*, translated by Dora Nussey, New York 1958, p. 14.
20 Ibid., p. 24.
21 Plato, *Timaeus and Critias*, translated by Desmond Lee, Harmondsworth 1965, p. 74.
22 J. K. Wright, *The Geographical Lore of the Time of the Crusades*, New York 1965, p. 265.
23 Mâle, op. cit. note 19, p. 15.
24 K. Critchlow, 'Chartres Maze', in *Architectural Association Quarterly*, vol. 5 no. 2, pp. 11–21.
25 Quoted from E. Wilkins, *The Rose Garden Game*, London and New York 1969, p. 86.
26 Mâle, op. cit. note 19, p. 96.
27 C. G. Jung, *Letters*, vol. 2, Princeton and London 1977, p. 260.
28 H. Whone, *Church, Monastery, Cathedral*. London 1977, p. 62.
29 E. Neumann, *The Great Mother*, Princeton 1963, p. 2290.
30 J. Ruskin, *The Works of John Ruskin*, London 1903–12, vol. 11, p. 22.
31 T. S. Eliot, 'The Dry Salvages', *Four Quartets*, London 1944.
32 T. S. Eliot, 'East Coker', *Four Quartets*, London 1944.
33 J. E. Cirlot, *A Dictionary of Symbols*, London and New York 1962.
34 T. S. Eliot, 'Burnt Norton', *Four Quartets*, London 1944.
35 O. von Simson, *The Gothic Cathedral*, New York 1962, p. 51.
36 Wilkins, op. cit. note 25, p. 113.
37 Adams, op. cit. note 5, pp. 272–73.
38 Wilkins, op. cit. note 25, p. 26.
39 See Critchlow, op. cit. note 24, pp. 11–20.
40 H. Daniel-Rops, *Cathedral and Crusade*, London 1927, p. 607.
41 Quoted in P. Frankl, *The Gothic*, Princeton 1960, p. 175.
42 E. Jung, *The Grail Legend*, London and New York 1961.
43 Ibid., p. 122.
44 Ibid., p. 159.
45 Ibid., p. 100.
46 W. von Eschenbach, *Parzival*, ed. H. M. Mustard, New York 1961, introduction, p. xliv.
47 E. Jung, op. cit. note 42, p. 163.
48 E. Matchett and G. Trevelyan, *Twelve Seats at the Round Table*, London 1976, p. 13.
49 Frankel, op. cit. note 41, p. 175.
50 Quoted by E. Jung, op. cit. note 42, p. 107, referring to L. J. Ringbom, *Graltempel und Paradies*, Stockholm 1951.
51 Ibid., p. 222.
52 Ibid., p. 158.
53 Adams, op. cit. note 5, p. 234.
54 Dante, *The Divine Comedy (3): Paradise*, translated by Dorothy L. Sayers, London and Baltimore 1962, p. 145.
55 Rodin, op. cit. note 2, p. 116.
56 Dante, op. cit. note 54, p. 145.
57 J. James, 'Medieval Geometry', in *Architectural Association Quarterly*, vol. 5, no. 2 (1973), pp. 4–10.
58 Ibid., p. 6.
59 Ibid., p. 9.
60 P. S. Stevens, *Patterns in Nature*, London and New York 1976, p. 161.
61 H. E. Huntley, *The Divine Proportion*, New York 1970.
62 J. Harvey, *The Medieval Architect*, London 1972, p. 220.
63 E. J. Beer, *Die Rose der Kathedrale von Lausanne*, Berne 1952.

Further Reading

Aubert, Marcel, *Le Vitrail français*, Paris 1958

Aubert, Marcel, Louis Grodecki *et al.* (eds), 'Notre-Dame de Paris and Sainte Chapelle' *Corpus vitrearum medii aevi*, Paris 1959

Barber, Richard William, *The Knight and Chivalry*, Harlow, New York 1970

Child, Heather, and Dorothy Colles, *Christian Symbols Ancient and Modern. A Handbook for Students*, London 1971

Clerval, Jules Alexandre, *Les Ecoles de Chartres au moyen âge (du Ve au XIe siècle)*, Mémoires de la Société Archéologique d'Eure-et-Loir, tome 11, Chartres 1895

Cook, Roger, *The Tree of Life: Symbol of the Centre*, 'Art and Imagination' series, London 1974; publ. as *The Tree of Life: Image for the Cosmos*, 'Art and Cosmos' series, New York 1974

Copleston, Frederick Charles John Paul, *A History of Medieval Philosophy*, London, New York 1972

De Wulf, Maurice, *Philosophy and Civilisation in the Middle Ages*, Princeton 1922

Florival, Ad. de, and Etienne Midoux, *Les Vitraux de la cathédrale de Laon*, Paris 1882–91

Frankl, Paul, *Gothic Architecture*, trs. from the German by Dieter Pevsner, Pelican History of Art, Harmondsworth, Baltimore 1963

Fulcanelli (pseud.), *Les Mystères des Cathédrales: Esoteric Interpretation of the Hermetic Symbols of the Great Work*, trs. from the French by Mary Sworder, 2nd edn, London 1971

Gillet, Louis, *La Cathédrale vivante*, Paris 1936

Grodecki, Louis, *Chartres*, 'Musée des grandes architectures' series, Paris 1963

Harvey, John Hooper, *The Master Builders. Architecture in the Middle Ages*, London 1971, New York 1972

Hopper, Vincent Foster, *Medieval Number Symbolism: its Sources, Meaning and Influence on Thought and Expression*, Columbia University Studies in English and Comparative Literature, no. 132, New York 1969

Huysmans, Joris Karl, *The Cathedral*, trs. from the French by Clara Bell, London, New York 1925

Jung, Carl Gustav, Marie-Louise von Franz *et al.*, *Man and His Symbols*, London 1964, New York 1968

Lafond, Jean, *Le Vitrail*, 'Je sais, je crois' series, Paris 1966

Lee, Lawrence, George Seddon and Francis Stephens (contributing eds), *Stained Glass*, London 1976

Mann, Aldon Taylor (Tad), *The Round Art*, London 1978

Matchett, Edward, *Creative Action: the Making of Meaning in a Complex World*, London 1975; *The Journeys of Nothing in the Land of Everything*, London 1975

Panofsky, Erwin, *Abbot Suger on the Abbey Church of St Denis and its Art Treasures*, Princeton 1946; *Gothic Architecture and Scholasticism*, London, New York 1957

Pevsner, Niklaus, *An Outline of European Architecture*, new edn, Harmondsworth, New York 1948

Phenomenon Publications: *The Phenomenon Book of Calendars*, 1973, 1974, 1976–77, 1977–78, 1978–79, London, various dates

Schmemann, Alexander, *Of Water and the Spirit, Liturgical Study of Baptism*, Crestwood 1974, London 1976

Sencourt, Robert, *The Consecration of Genius. An Essay to Elucidate the Distinctive Significance and Quality of Christian Art by Analysis and Comparison of Certain Masterpieces*, London 1947, Port Washington 1970

Sherril, Charles Hitchcock, *Stained Glass Tours in France*, London, New York 1908

Simson, Otto Georg von, *The Gothic Cathedral. The Origins of Gothic Architecture and the Medieval Concept of Order*, London 1956, Princeton 1973

Sitwell, Sacheverell, *Gothic Europe*, London, New York 1969

Swaan, Wim, *The Gothic Cathedral*, London, New York 1969

Warner, Marina, *Alone of All Her Sex: Cult of the Virgin Mary*, London, New York 1976

Westlake, Nathaniel, *A History of Design in Painted Glass*, London 1879–94

Worringer, Wilhelm, *Form in Gothic*, trs. from the German, London, New York 1964

Zaehner, Robert Charles, *Mysticism, Sacred and Profane. An Enquiry into Some Varieties of Praeternatural Experience*, New York, Oxford 1961

Index

Figures in italic are plate numbers